THIS FERTILE LAND

Signs + Symbols in the Early Arts of Iran and Iraq

Edited by **Margaret Cool Root**

with the assistance of Anastasia Tsibulsky

Contributions by

Kathleen Davis, Suzanne Davis, Karen Johnson, Lori Khatchadourian
Hima Mallampati, Jane Rempel, Margaret Cool Root, Andrew Wilburn

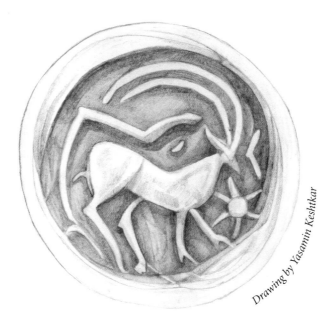

Drawing by Yasamin Keshtkar

Kelsey Museum Publication 3

Ann Arbor, Michigan, 2005

Published in conjunction with the special exhibition *This Fertile Land: Signs + Symbols in the Early Arts of Iran and Iraq*, held February 4–September 30, 2005, at the Kelsey Museum of Archaeology, 434 South State Street, University of Michigan, Ann Arbor, Michigan 48109-1390

ISBN 0-9741873-1-3

Front cover image: A view of the Zagros Mountains, 1950s (George Cameron Archives, Kelsey Museum of Archaeology), with drawing of the impression of cat. no. 85 (by Yasamin Keshtkar) superimposed.

Back cover images: Cat. no. 108 surrounded by (clockwise from top) cat. nos. 29, 11.h, 53, 21, 31, 23, 11.g, 11.f.

This book is available direct from
The David Brown Book Company *and*
PO Box 511, Oakville, CT 06779, USA
(Telephone 860-945-9329; Fax 860-945-9468)

Park End Place, Oxford OX1 1HN, United Kingdom
(Telephone 01865-241249 Fax 01865-794449)
www.oxbowbooks.com

Dedicated to the memory of

Ernst E. Herzfeld (1879–1948)
Pioneering Scholar of Late Prehistoric Art and the Archaeology of Ancient Iran

Jane Ford Adams (1900–1990)
University of Michigan Class of 1925, Historian of the Button,
and Purchaser of the Herzfeld Collection of Iranian Stamp Seals

Elizabeth F. Henrickson (1952–2002)
Archaeologist and Interpreter of the Seals and Sealings from Seh Gabi, Iran

Contents

vi

Acknowledgments

This publication has been supported generously by the Freer Fund of the Department of the History of Art, University of Michigan. The exhibition to which it relates has been supported by the Kelsey Museum; the College of Literature, Science, and the Arts; the Museum's Associates; and a private donor. We gratefully acknowledge additional assistance in the form of subventions of special public programming relating to the exhibition from the Center for Middle Eastern and North African Studies; the College of Literature, Science, and the Arts; and the International Institute—all in conjunction with the Winter Term 2005 College Theme Semester, "Cultural Treasures of the Middle East."

Many students have offered inspiration toward the ultimate production of this effort over several years. Two Ann Arbor natives began work on the project while at Pioneer High School and continued with it into their college years at Haverford and Tulane respectively: Benjamin Cool Root (digital imaging and database) and Yasamin Keshtkar (interpretive drawings).

University of Michigan undergraduates have worked on the Adams (ex-Herzfeld) seals for research projects, providing extraordinary insights. Three UM undergraduates from the earlier years who maintained involvement after graduation are Lauren Gugala, Molly Klais, and Jessica Lutz.

In Winter 2004, a combined graduate and undergraduate seminar on This Fertile Land enlisted the fine minds and sparkling creativity of the following students: Jennifer Boan, Lisa Cakmak, Erin Cassard, Nora Dunlop, Ui-Jong Eom, Jane Gu, Lori Khatchadourian, Nancy Keough, Hima Mallampati, Lauren Mardirosian, Alanna McKelvey, Wendy Pflug, Anupama Reddy, Emily Squires, Thomas Thompson-Flores, Anastasia Tsibulsky, and Minjeoung Yoo. I am deeply grateful for their contributions to the exhibition and to the research for this publication. Nora Dunlop, Nancy Keough, Alanna McKelvey, and Anastasia Tsibulsky deserve special recognition for ongoing work.

Several current and former University of Michigan graduate students of Anthropology, History of Art, Archaeology, and Information Sciences have contributed far beyond the confines of outstanding seminar efforts: Kamyar Abdi, Seth R. Button, Julie Coons, Jennifer E. Gates, Sirida Graham, Karen Johnson, Mariana D. Giovino, Lori Khatchadourian, Karen Johnson, Hima Mallampati, Jessica Moore, Jane Rempel, Ann Sinfield, and Andrew Wilburn.

We offer special thanks to the Department of Geological Sciences. Early on, Professor William Farrand provided consultation on how we might go about analyzing the minerals making up the ex-Herzfeld seals. Then in 2004, Jesse Ortega, an undergraduate concentrator, pursued an intensive special studies unit to help initiate the materials analysis of the ex-Herzfeld seals in the Kelsey

Museum. Under the direction of Professor Eric Essene, his work explored protocols for Scanning Electron Microscope (SEM) and X-Ray Diffraction (XRD) analysis. He conducted studies of a set of the artifacts through the good auspices of the R. B. Mitchell Electron Microbeam Analysis Laboratory, run by Professor Essene with the support of Dr. Roland Rouse and Mr. Carl Henderson. Another undergraduate, Samantha Sands, also contributed to these trials.

Our conservator at the Kelsey Museum, Suzanne Davis, has participated intensively in the SEM and XRD trials and has also pursued an analysis based on Raman Spectroscopy. Here she has collaborated with Geological Sciences doctoral candidate Kathleen Davis and Professor Lars Stixrude, with the benefit of access to Professor Stixrude's Raman Spectroscopy Laboratory.

I am overwhelmed with gratitude for the collegial support and spirited collaboration of key staff members: Suzanne Davis (Conservator), Robin Meador-Woodruff and Sebastián Encina (Collections Management), Terry Wilfong (Curatorial Exhibition Liaison), Scott Meier (Exhibits Preparator), Peg Lourie (Editor), Lorene Sterner (Graphic Artist), Laurie Talalay (Academic Outreach) and Todd Gerring (Public Programs, Graphic Design, and Security), Beau Case (Kelsey Librarian), Vladislav Miskevich (Computer Systems Consultant), and John Cherry (Curator for Publications). All of our efforts would have been impossible without the graciously efficient collaboration of the administrative staff, led so well by Helen Baker: Jackie Monk, Jennifer Nester, Michelle Biggs, Alex Zwinak. For this book specifically, Peg Lourie has been an absolutely extraordinary colleague.

The background work on Jane Ford Adams has been facilitated most graciously by Evelyn Gibbons of Gibbons Antiques in Dixboro and by office-holders of the Michigan State and the National Button Societies: Barbara Dixon, Lois Pool, and Jean Speights.

The map in this catalogue was generated with the patient assistance of Adam T. Smith, Assistant Professor of Anthropology at the University of Chicago. We extend our thanks to him for sharing his data and his expertise in GIS software.

Finally, the Kelsey Museum extends its appreciation to the following institutions and individuals for loans and special services: Carol Bier and the late Lionel Bier; Buffalo Museum of Science: Elizabeth Peña; Freer Archive, Freer Gallery of Art, Smithsonian Institution: David Hogge, Martha Smith, John Piper, Linda Raditz and her predecessor in the Archive, Colleen Hennessey, and Ann C. Gunter; Iranian Center for Archaeological Research and Dartmouth College: Kamyar Abdi; Musée du Louvre: Agnès Benoit, Annie Caubet, and Françoise Demange; University of Michigan Museum of Anthropology: Karen O'Brien and Henry T. Wright III; University of Michigan Fine Arts Library: Katherine Kuehn and Deirdre Spencer; University of Michigan Museum of Art: Maribeth Graybill and Lori Mott; University of Pennsylvania Museum of Archaeology and Anthropology: Shannon White, Juana Dahlan, Lynn Grant, Julia Lawson, and Richard T. Zettler.

Margaret Cool Root
Exhibition Curator and Acting Director
October 2004

PART I

Introduction

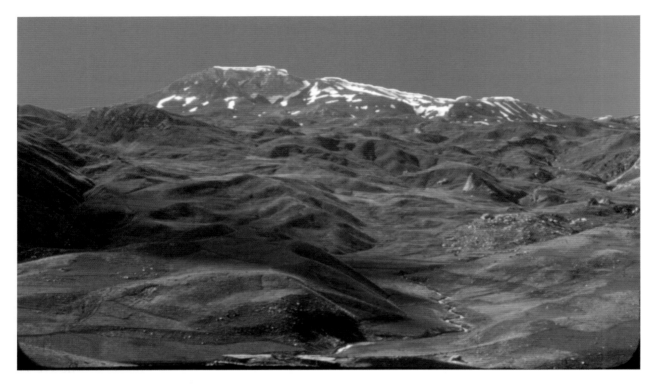

Fig. 1.1. Cat. no. 118.

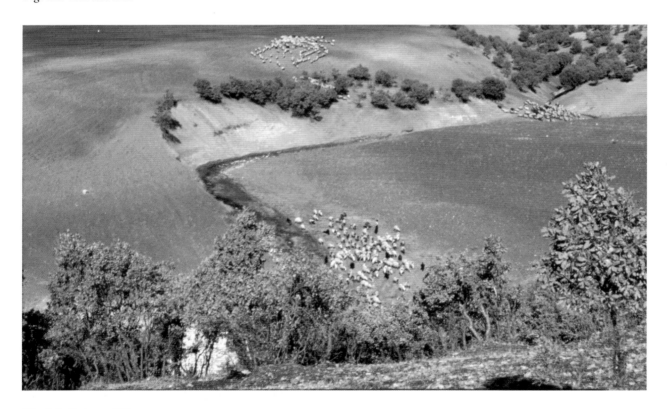

Fig. 1.2. Cat. no. 121.

1
This Fertile Land

Margaret Cool Root

SETTING THE STAGE IN ABOUT 4000 BCE

The Time

Late prehistory, around 4000 BCE (as early as 4500 and as late as 3700 BCE). With reference to the standard terminology of Mesopotamian archaeology, we are spanning the Ubaid and the early Uruk periods. In terms of the Iranian site of Susa, we are in the pre-Susa I and the Susa I phase. In terms of technological development, we have moved from the Neolithic period to the Chalcolithic (copper-stone) period, when copper fashioning has made tremendous strides alongside well-established stone-working skills.

This is a time before writing. A time before written expressions of belief, mythology, identity, or administrative documentation as we think of the written statement. But a time of ripened recourse to other visual strategies of communication that set the stage for writing as we conceive it.

The Place

The lands today known as Iran and Iraq, before hegemonic mappings of borders and intents inexorably and repeatedly turned land into "turf"—from antiquity to the present. More specifically, our stage is the region of western-central Iran north-south along the Zagros Mountains (fig. 1.1) and westward along the natural roadway yielding east-west cultural communication between Iran and northeastern Iraq. This arena was not homogeneous in its physical topographies or social responses. But despite many distinctive traits, significant shared expressive visions were realized across the Zagros at this time.

The Social Context

People and their animals operating within social structures where hierarchies of status, wealth, and institutional authority were beginning to emerge. Where increasing motivation for administrative controls generated an expansive need for communicative systems. A social setting of sedentary farmers in built communities as well as mobile pastoralists rotating between camps with the seasons. A setting in which cultivation and exploitation of the land and its waters, tending of animals, and working in sympathy with the codes of the natural world were paramount (fig. 1.2). An environment in which shamans could mediate the dangers of existence, give shape to the mystical experiences of nature and cosmos, and enhance the fertility of the land. In which we may see the glimmers of the priest-kings and gods of slightly later times taking shape out of the shaman's dance.

The Ultimate Issues at Stake

(1) A lack of widespread awareness today of a fascinating pivotal moment in human development.

(2) A rapid deterioration in our potential to imagine the place of our inquiry as a space reaching to creative horizons. A deterioration systematically reinforced by contemporary Western rhetoric that reduces the landscapes of our place to a sinister setting where "mountain" means treacherous cave-hideout and "desert" means parched and uninhabitable wasteland.

The Goals

(1) To offer an introduction to the art of late prehistory in Iran and Iraq for a wide readership.

(2) To envision this contested region as the locus of extraordinary ancient legacies of distinct but also intertwined pragmatic, aesthetic, and spiritually expressive energy. To reimagine the evocative ancient terrains of mountains, valleys, and deserts, of marshes, rivers, salt lakes, and highlands. To see them as sites of majesty, beauty, fertility; as sound-and-silence realms of flora inhabited by animals and people—guided by bright skies along time-paths of sun and moon.

The Strategy

To bring together a range of expressive visual tools of late prehistory—from seals, sealings, and painted pottery. To ask questions of this material as a means of approaching possible social meanings.

The Cast of Characters (often disguised as signs and symbols)

Farmers
Herders
Maleness and Femaleness
Shamans (humans with special powers)
Divine agents (gods-in-the-making)
People Doing Business
Goats—domesticated and wild (the ibex)
Sheep—domesticated and wild (the mouflon)
Snakes
Scorpions
Tortoises and frogs
Lions
Boars
Birds
Water
Earth
Sky

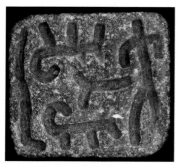

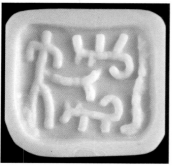

Fig. 1.3. Cat. no. 5.

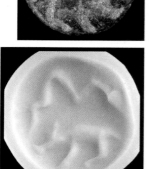

Fig. 1.4. Cat. no. 11.h.

SYNOPSIS OF THE PLAY

An Inclusive Discourse on Late Prehistory

Most books about ancient Near Eastern art and archaeology focus on Mesopotamia—the land defined by the Tigris and Euphrates rivers, roughly equivalent

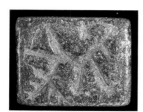

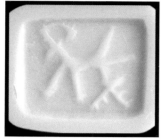

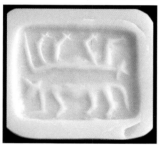

to modern Iraq. Little, if any, space is offered to neighboring Iran just to the east. When considered at all, Iran has tended to be understood as the secondary cultural recipient of initiatives developed to the west. The picture is more complicated than that—not least for the realm of late prehistory with which we are concerned.

Here instead we will look at this region more inclusively. Indeed, we will focus particularly on the Iranian material and then inquire how it relates to a larger realm of social life and social connections in Greater Mesopotamia. Important archaeological work has occurred in recent decades, enabling us to treat the Iranian scene with more of the assertiveness it deserves. Although this agenda can only be taken so far here, we hope it will be a useful step forward.

Most broad studies of the cultural record of the ancient Near East focus either on earlier prehistoric periods or on the protoliterate and fully literate periods of city-states. This book instead focuses on the often-overlooked late prehistoric era. It works particularly with evidence from seals and sealings ("glyptic" evidence)—an area of cultural study where Iranian material has received significant recent specialist attention in conjunction with Mesopotamian material. We add to this a consideration of Iran's extraordinary tradition of late prehistoric painted pottery, interweaving approaches from anthropology, archaeology, and art history—from cognitive psychology, communications, and studies of magical and religious thought.

Seals
Seals are artifacts carved with imagery rendered in the negative so that, when pressed into a malleable surface of damp clay, they produce positive designs that seem to spring forth dynamically from the clay (figs. 1.3 and 1.4). Sometimes more than one side of a seal was carved—yielding an artifact that could produce completely distinct impressed images (figs. 1.5 and 1.6).

Fig. 1.5. Cat. no. 78 a and b.

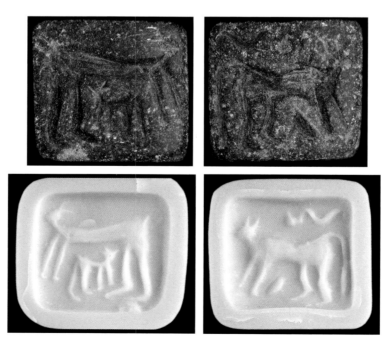

Fig. 1.6. Cat. no. 80 a and b.

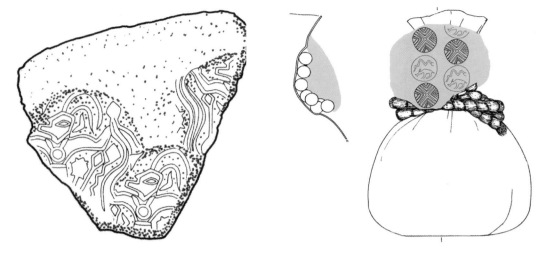

Fig. 1.7. Cat. no. 114.

Fig. 1.8. Cat. no. 15.

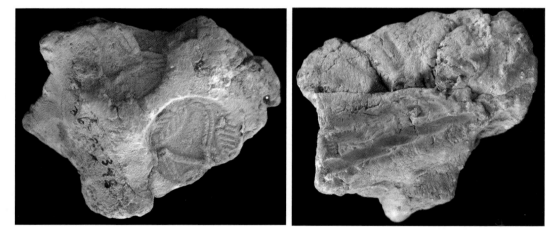

Fig. 1.9. Cat. no. 87.

In the ancient Near East seals served multiple functions, often simultaneously. They were perforated so that they could be suspended from a cord, leather thong, or metal fitting and thus worn on the person. Seals so displayed might perform as protective magical amulets warding off danger and disease or as talismans to court good fortune (fig. 1.7). They might serve as markers of individual or group identity or as emblems of the prestige, status, and societal role of that individual or collective. They also served as administrative tools for locking, labeling, or verifying through the rendering of impressed images onto damp clay affixed to a wide variety of things.

Seals from excavated contexts are frequently (but not exclusively) found interred with their owners in graves. Often antique seals were redeployed in later times in deposits intended to lend an aura of ritualized legitimacy to a place. Such evidence, combined with abundant textual references in literate times to the profound significance of seals, shows us that seals (and the imagery on them) were powerful social agents (Goff 1963; Hallo 1983; Marcus 1994).

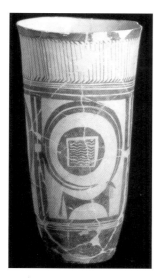

Fig. 1.10. Cat. no. 109.

Fig. 1.11. Cat. no. 4.

Sealings

Sealings are the ancient clay remains of the process of locking, labeling, and verifying with the aid of seals. Sealings not only preserve the impression of one or more seals; they also prove that the types of images impressed on them were indeed sometimes deployed as administrative tools in addition to their other less tangible social uses. In many cases, the evidence preserved on the backs of sealings can indicate the type of things onto which the clay was once affixed. Such items range from rope- or cord-bound reed baskets, leather bags (figs. 1.8 and 1.9), and clay storage jars (fig. 1.7) to door closures and the collars of livestock. In these capacities, the symbolic possibilities inherent in the other functions of seals merge with the practical functions of an increasingly control-oriented society. Thus, for instance, the magical properties of seals in general could combine with two other features: the specific message force of a particular image carved on the seal and whatever code of individual or corporate identity/legitimacy might also be embedded in the image. All of this together yielded a labeling, locking, or verifying function of multiple efficacy.

Sealings of prehistoric times are usually found in different contexts from the seals that produce them. Often they are retrieved from garbage pits or wells after having been discarded in the sweepings of a storeroom. Other times they are found still in the room where they once sealed doors or commodities. Usually in this case they are found no longer attached to these items but as debris left over after having been broken in the process of gaining access to the sealed item. A door sealing must logically have been made at the site where it was retrieved archaeologically. A sealing from a container might, by contrast, have been made either locally or at a place far distant from where the container was finally broken open—its sealing cracked apart.

Painted Pottery

The Chalcolithic era of the Near East produced a range of painted pottery traditions. None is as spectacular and refined as what we see in Iran at Susa and in the Susiana plain around 4000 BCE (fig. 1.10). Thousands of examples of this ware were discovered in sets composed of a tall beaker, an open bowl, and a small jar. These sets were deposited in graves at Susa, where they served as ritual funerary offerings for elite members of the community who may have perished as a result of a catastrophe (Hole 1990; 1992). The pottery from the Susa cemetery is made of a fine but rather porous clay fashioned into very thin-walled vessels. In some cases, the shapes have been dramatically distorted under pressure of burial. Ill-suited for practical functions as containers, the Susa cemetery corpus may have been produced exclusively for ceremonial deposit.

The same pottery tradition does, however, appear also at other sites in the Susiana plain. Two fragments of a Susa-type beaker from Sharafabad, for instance, share the decorative format of some of the cemetery beakers from Susa and reveal a vessel of more refined proportions and draftsmanship than some examples from Susa itself (compare figs. 1.11 and 1.12).

The painted ceramics from Bakun to the southeast are related to the Susa tradition, sharing hallmark themes and modes of presentation—particularly in the dramatic emphasis on animals with wonderfully exaggerated horns combined with geometric devices such as crosses (fig. 1.13). Yet the Fars pottery

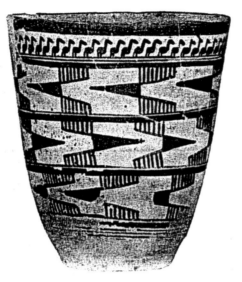

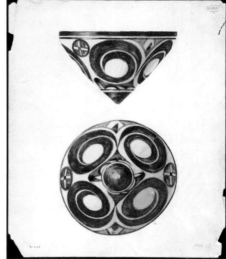

Fig. 1.12. Squat beaker from Susa with flying vultures. Corpus Vasorum Antiquorum *1925: 2.23.*

Fig. 1.13. Cat. no. 108.

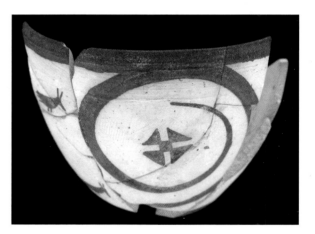

Fig. 1.14. Cat. no. 3.

is distinctive in its shapes and compositional structures. We tend to consider this material specific to Bakun. Actually, however, 246 sites had been identified in Fars by the 1970s with clear links to the painted pottery tradition of the Susiana plain (Sumner 1977). Similarly in the Deh Luran plain north of Susiana at Tepe Farukhabad, we see a painted ceramic tradition closely related in imagery to the Susa paradigm but by no means slavishly dependent upon it (fig. 1.14).

Painted Pottery in Dialogue with Seals and Sealings

Because there is so much of it, the majority of the Susa cemetery corpus is unpublished or published only in the most basic form in early 20th-century documentary volumes (Mecquenem 1912; *Corpus Vasorum Antiquorum* 1925). A perusal of the storeroom of the Département des Antiquités Orientales of the Louvre in Paris, where most of the pots reside today, reveals aspects of this material that one could never glean from study of the limited group of pots usually

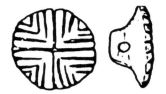

Fig. 1.15. Cat. no. 2.

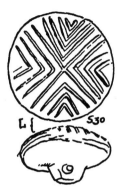

Fig. 1.16. Chevron-filled cross seal from Susa. After Herzfeld 1933: fig. 14.

singled out for publication and display. The fascinating array of motifs of the Susa cemetery repertoire cuts across workshop manners ranging from elegant to (comparatively) rather clumsy. The controlled diversity of motifs exhibited in compositional programs that exist within quite definite parameters is also remarkable when seen in the context of the entire corpus.

A similar cohesiveness within a wide range of combinable compositional formulations (as well as within a range of qualities of workmanship) can be seen on seals of the same era. And as with the pottery, numerous seals are near twins. This is the case with seals from the same site as well as seals brought together from diverse sites on our contextual stage (figs. 1.15, 1.16, and back cover).

Expressive meanings were surely embedded in the painted ceramics of Iran as well as in the glyptic corpus (the combined evidence of seal artifacts and their use patterns gleaned from sealings). It is our contention that the glyptic and ceramic systems of visual communication were intertwined, reflecting allied aspects of the same cultural context. They can be placed in direct dialogue with each other on art historical terms that privilege the potentials of symbolic thought in the service of visual agency.

A SEMIOTICS OF LATE PREHISTORIC ART

Semiotics is the study of the meanings of signs and symbols. A sign is a visual device that stands for a thing or an idea in a fairly specific, direct way. A symbol is a visual device that transmits wider associations of meaning. Signs and symbols are often intimately related, the line of definition rather fuzzy (Part III this volume).

One project of this book is to explore the evidence and the methods we can use to approach an understanding of the role of visual imagery (of signs and symbols) in late prehistory. This period is of profound, if little appreciated, significance to the history of communicative systems and, ultimately, to the history of notions of writing. Exciting work has probed the uses of signs and symbols in the art of seals on the very brink of the emergence of the world's first writing systems around 3100 BCE (Pittman 1994b). At the same time, provocative efforts have been made to understand the prehistoric use of geometrically shaped three-dimensional tokens as conceptual as well as formal precursors of cuneiform (wedge-shaped) writing (Schmandt-Besserat 1992; 1996a). But the significance to communication studies of *visual imagery* production and deployment—specifically *before* the protoliterate period—has remained elusive.

There are several reasons for this. Most importantly, ancient Near Eastern studies has been a field motivated largely by the interests of text-based philology. Thus, scholars have devoted a great deal of attention to the imagery on cylinder seals at the time of the emergence of writing and literature. These cylinder seals provide a complementary set of visual evidence used in tandem with the written record toward understanding aspects of religion, administration, and personal identity in increasingly complex eras of historically documented cultures (e.g., Frankfort 1939; Van Buren 1945; Porada 1948; Goff 1963; Collon 1987).

By contrast, comparatively few scholars have systematically studied the earlier stamp seal tradition of late prehistory. Furthermore, efforts have primarily focused on classifying and documenting types of stamp seals.

In the early 20th century, when the material we examine in this book was just beginning to emerge from the ground, some scholars did make tentative suggestions about the meanings of the imagery on stamp seals, particularly with an eye toward linking a small number of specific signs and symbols with later symbolic attributes of Mesopotamian deities or with forms of cuneiform signs (e.g., Pottier 1912; Pézard 1913; Herzfeld 1941; Hertz 1929; Pottier 1932). Pierre Amiet, an eminent historian of ancient Near Eastern art, carried elements of this early agenda into the second half of the 20th century, asserting the importance of early stamp seals within a discourse on the developments of Greater Mesopotamia in historical times (Amiet 1980). Another giant in the field, Briggs Buchanan, also saw the importance of this effort (Buchanan 1967; 1981; Buchanan and Moorey 1984). Even so, there has been a persistent lack of interest in probing the possible nuances of meaning in the signs, symbols, and compositional landscapes of stamp seals. Geometric and linear motifs, for instance, continue almost universally to be dismissed as mere "filler ornaments" devoid of meaning.

Discussions of the possible meanings of painted pottery produced at the same time as the stamp seals have also been rather limited—especially considering the compelling visual interest of the material. Since the early years of commentary, when these painted wares were first emerging (Root 2005), anthropology has offered the primary voice engaging with their programs of decoration (Hole 1983; 1984; Pollock 1983; 1989, with differing perspectives). This work deserves to be taken further and in some new directions. It deserves more systematic overarching review from a 21st-century art historical perspective than we can offer in the present context. The most striking of the pots have been illustrated repeatedly in handbooks but discussed analytically so rarely that a pedestal syndrome has set in. The finest examples of the pottery simply (and beautifully) *are*, but they cease to be part of a dialogue with the other elements of the culture that produced them.

The exhibition catalogue, *The Royal City of Susa: Ancient Near Eastern Treasures in the Louvre*, established new possibilities of awareness through its juxtaposed essays on the Susa pottery (Hole 1992) and the late prehistoric stamp seal assemblage from Susa (Aruz 1992).

SAGAS OF RETRIEVAL AND COLLECTING

Another project of this book is to explore some of the challenges posed by the history of archaeological and collecting practices that have conspired to obscure the significance of this understudied phase in ancient Near Eastern civilization. Often these challenges relate to the biographies of political adventurers, scholars, antiquities dealers, and collectors. Sometimes these biographies intersect in unexpected and curious ways on a stage of extraordinary world events of war and politics. In all of this, the life cycles of the artifacts being circulated deserve as much attention as the cast of characters.

In our particular narrative we will deal with the unlikely convergence of two individuals: Ernst E. Herzfeld (1879–1948) and Jane Ford Adams (1900–1990). Herzfeld was the greatest early 20th-century scholar of ancient Iranian art and archaeology (Gunter and Hauser 2005). Mrs. Adams, a University of

Michigan alumna of the class of 1925, was a major figure in the realm of histori-
cal scholarship on buttons (Root 2004).

The intersection of these two figures (who never actually met) is a par-
able of sorts about archaeology and the art market—not to mention the seren-
dipity of life. It relates very closely to the problems posed by the study of late pre-
historic stamp seals and the potentials for reinvigorating that field in the future.
The saga of Herzfeld and Adams revolves around a large, seminal collection of
these seals that wends its way from Iran to New York, to California, and finally
to Michigan (with small portions split off in other directions between Europe
and the United States).

Many of Herzfeld's seals (sold to Mrs. Adams in 1947 as the "earliest but-
tons ever known") derived from his harvesting forays in 1928 at the site of Tepe
Giyan in Iran. Their eventual acquisition by the Kelsey Museum inspired this
project. The ex-Herzfeld Adams Collection of prehistoric stamp seals forms the
core material of our exhibition and publication.

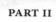

Iran in the System of Things

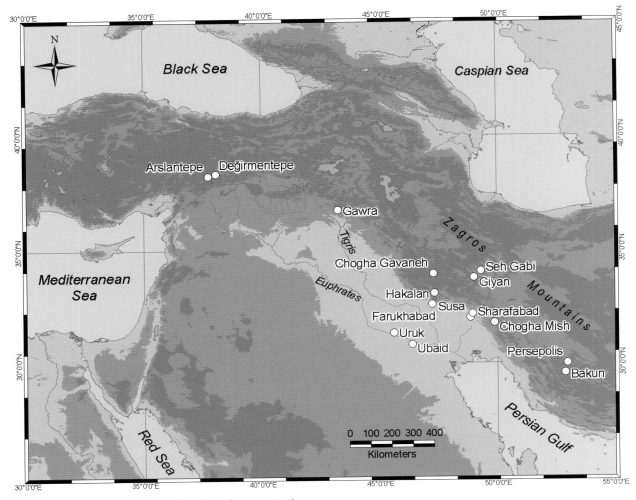

Fig. 2.1. Map of the ancient Near East (cat. no. 116).

Fig. 2.2. Cat. no. 117.

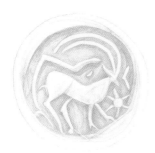

2
An Overview of Place and Space

Lori Khatchadourian
Margaret Cool Root

SITES AND ECOLOGIES

The ex-Herzfeld seals from Tepe Giyan provide a large body of material with a known provenance (a documented background and point of origin). These seals had formed the core of Herzfeld's own seminal study of the early stamp seal (Herzfeld 1933) and continued to figure in his more general presentations on the prehistory of Iran (Herzfeld 1941). When they resurfaced for scientific scrutiny in 1991 after more than forty years in the possession of Jane Ford Adams, they offered the exciting possibility of insertion into current agendas of art history and archaeology—agendas not imagined in Herzfeld's lifetime.

Tepe Giyan, Seh Gabi, and Chogha Gavaneh
Thus, Tepe Giyan is a major player in our discussions here. The comparative material from other sites is excavated rather than harvested. It enables the seals from Tepe Giyan to be seen in the context of evidence for sealing practices, social settings, and larger frameworks of art production and symbolic systems.

Tepe Giyan and Chogha Gavaneh are in the Central Zagros highlands. So, too, Seh Gabi and Hakalan. This region is a rugged terrain of wooded valleys and fertile plains nestled amidst the dramatic landscape formed originally by massive collisions of the earth's tectonic plates. Tepe Giyan (and the modern village of Nihavand) in the Nihavand valley and Chogha Gaveneh in the Islamabad plain are part of a constellation of sites strategically disposed between the resource-poor region of northeastern Iraq and the resource-rich highlands to the east in Iran (Henrickson 1994: 86–87). The choppy geography of the Central Zagros poses challenges for large-scale agriculture. But the land is good and well watered. It is eminently hospitable to forms of pastoralism, involving the herding of large flocks.

Tepe Gawra
Moving westward, Tepe Gawra is across the mountains, in the foothills of northeastern Iraq. Just 24 kilometers north-northeast of the Tigris River, it is near one of the few natural passes that link the lowland plains of northeastern Mesopotamia and the highlands of Iran. Its location combined with its rich piedmont soils to ensure that Chalcolithic Gawra played an important regional and inter-regional role (Rothman 1994b: 100).

Değirmentepe
Farther west still, the site of Değirmentepe once lay on the Euphrates River beyond the modern border of Iraq in eastern Turkey. It has now been flooded by

the Karakaya Dam project. Like Chogha Gavaneh, Seh Gabi (and Hakalan), Değirmentepe figures as an archaeological touchstone for comparison with our featured material.

Susa and Susiana

From the vantage point of the Tepe Giyan–Tepe Gawra axis in the north, Susa seems distant indeed. Situated in the lowlands north and east of the Persian Gulf, it is some 640 kilometers south of Tepe Gawra. It shares the southwestern Iranian province of Khuzistan with other sites in the beautiful Susiana plain (such as Sharafabad and Chogha Mish).

This region is geologically part of the alluvial zone of southern Mesopotamia. Three rivers (the Karun, Diz, and Karkheh) flow south from the mountains, emptying into the area where the Tigris and Euphrates rivers merge near the Persian Gulf. Although the sun is hot in the summer, the winters are mild. Furthermore, the abundant water supply enhances the attractiveness of the area. Rich, well-watered soil and an expansive terrain made this a perfect place for large-scale agriculture in antiquity.

Susa and its locale held a central position between the agriculturally based villages of the plain and the highland pastures with their nomad herders (Pollock 1989: 283). Furthermore, the siting of the Susiana plain made it a cultural fulcrum between the Central Zagros (and thence westward into northern Mesopotamia) on the one hand and the Iranian region farther south and east of Susa on the other hand. While Susa had direct access to southern Iraq through the porous zone of the alluvial plain, we are concerned here with the conditions that specifically encouraged a different trajectory of cultural exchange.

Tepe Farukhabad

Farukhabad, north of Susa in the Deh Luran plain, exemplifies the effectiveness of this cultural connectivity. It lies between the Iranian highlands and lowlands in a topographical setting conducive to the growth of trade routes along the Zagros linking Susiana (and points southeast) with the Central Zagros and hence with northern Mesopotamia (Wright 1981). Indeed, the site was initially selected for excavation because it promised to help elucidate this feature (fig. 2.2).

Tal-i Bakun

The prehistoric settlement of Tal-i Bakun is about 500 kilometers southeast of Susa in the Marv Dasht plain of the Iranian province of Fars. It is near the Persian imperial capital of Persepolis founded around 515 BCE and thus was actually called Persepolis by Herzfeld when he first worked there in the 1920s. The Marv Dasht plain was yet another zone of vast, lush agricultural prosperity.

ART V. ACTUALITY

Several factors have altered the landscapes of our scene since late prehistory. Changes in climate during the 4th millennium made the maintenance and channeling of water supplies a primary human preoccupation in many areas. Before that, there had not been such widespread need for authoritative governance of

the rich land to ensure its yields of plenty. Massive deforestation over the entire course of the successive historic eras has also made its mark here, as elsewhere in the developed world. Along with that has come the gradual decrease or extinction of some of the wildlife that once populated the mountains and plains (Harrington 1977).

Can the art of late prehistory tell us about the ecologies of this remote past? Yes and no. To be sure, the evocative visualizations on seals and pottery create a primary record of how human beings related to the fertile land they occupied and the animals they tended. This is, however, quite different from suggesting that this art records actual circumstances that can supplement archaeologically retrieved data on botanical, faunal, climatological, and geological conditions at the time. The art must be understood as more than (or less than) a descriptive documentary. The more or the less will depend on one's frame of interest. For a cultural historian, the art encodes levels of meaning that work with the descriptive but occupy realms of transcendent agency. Our ability today to interpret the art of late prehistory with reference to archaeological data on actual ecologies of the time offers special new analytical opportunities.

Detailed discussions of late prehistoric micro-ecologies and settlement patterns of the regions discussed here are particularly interesting (Abdi 2002; 2003a; 2003b; Wright 1981; Nealy and Wright 1994; Wright and Carter 2003; Kouchoukos and Hole 2003; Alizadeh 2003; Alizadeh et al. 2004; Wilkinson 2003). They exemplify what modern archaeological method including survey can potentially yield toward understanding the complex natural features that combined to make these areas dynamic hosts for the cultural developments and interactions we are examining.

17

3

Seals and Sealings: Archaeological Perspectives

Lori Khatchadourian

ARCHAEOLOGICAL APPROACHES AND CHALLENGES

The Typological Trend

Archaeologists have used a variety of approaches in the study of late prehistoric stamp seals, attempting to situate them within wider disciplinary trends that have framed the study of the Near East. The earliest archaeologists sought to make sense of these small artifacts through typological methods. They classified and gave names to the many shapes and subshapes of the objects; they described the colors of the rocks from which the shapes were carved (sometimes suggesting mineralogical identifications based on visual examination); they described and grouped the repertoires of images carved on them.

Only to a very limited extent, however, did they develop strategies for second-level typological analyses based on large data sets that might possibly interrogate relations between classes of imagery and shape, or classes of imagery and carving style, for instance. As we have already seen, the iconographical study of late prehistoric stamp seals did not develop a following among archaeologists working from an art historical perspective. Work on cylinder seals from a wide range of approaches took flight, while work on the early stamp seal languished in its rudimentary documentary mode.

We will return to the story of trends in glyptic study below.

Time Telling

Even in the area of classification according to schemes of absolute date, archaeologists have encountered severe difficulty with prehistoric stamp seals. A number of broad challenges have plagued efforts to reach a consensus on absolute chronologies for the prehistoric Near East in general terms. In addition, many groups of prehistoric seals are from unstratified contexts even when they are at least nominally excavated. Intersite comparisons are extremely difficult (Root 2000: 11), with cultural change occurring at different rates in different places (Voigt and Dyson 1992).

Furthermore, many of the early stamp seal motifs remained active in the repertoire for a very long time. It is, for instance, dangerous to postulate, as some have, that geometric patterns were an early, "simple" form that was superseded by figural representation. Some of the geometric designs had real staying power, persisting in glyptic traditions long after the end of prehistory. A glance at two-sided seals from Tepe Giyan and Tepe Gawra offers an important warning in this regard: A geometric pattern may occupy one side of a seal that also bears a "sophisticated" representational image on the other side (figs. 3.1 and 3.2).

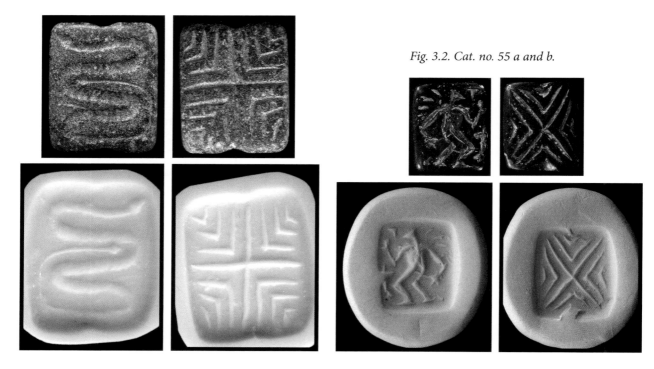

Fig. 3.2. Cat. no. 55 a and b.

Fig. 3.1. Cat. no. 73 a and b.

The degree to which seal artifacts were passed down from generation to generation is another potential hazard in suggesting rigid definitions of periodicity within bodies of this material. Thus, one of the major traditional agendas of archaeology—to produce chronological schema—has been frustrated by the prehistoric stamp seal.

So fraught is the issue of absolute dating in the arena of our analysis here that we will use absolute dates only as very general markers of time.

ARCHAEOLOGICAL HISTORIES

The late 1920s and 1930s were banner decades for the archaeology of the Chalcolithic period. It was in these years that Tepe Gawra, Tepe Giyan, and Tal-i Bakun were investigated, with the involvement of such well-known scholars of Near Eastern studies as Ernst Herzfeld, Roman Ghirshman, and Ephraim Speiser. Their discoveries in turn provided new comparanda for the glyptic finds from the contemporary site of Susa, which had been under investigation by French archaeologists since the late 19th century (Amiet 1972; Harper, Aruz, and Tallon 1992).

World War II and the ensuing two decades brought about a lull in Chalcolithic archaeology. By the 1960s and 1970s, however, fieldwork meant to interrogate the Chalcolithic was under way again; controlled excavations at key sites such as Seh Gabi (Henrickson 1988), Farukhabad (Wright 1981) and Değirmentepe (Esin 1989) further broadened the corpus of Chalcolithic seals and sealings.

The mound of Değirmentepe was first recorded through a surface survey conducted in 1977 as part of a salvage project in the area of the lower Euphrates. Excavations were carried out from 1978 to 1986 by archaeologists from the University of Istanbul. The Chalcolithic level at the site, where stamp seals

and sealings were found, is characterized by rectangular and tripartite mud-brick building complexes with storage facilities, main rooms, and open courts. The numerous clay sealings are for the most part rather different from the actual seals also found at the site. This suggests that Değirmentepe was a small colony participating in trading networks that involved the import of sealed commodities from other contemporary centers in Mesopotamia and Iran (Esin 1989: 137–138).

One such contemporary center was Tepe Gawra. Preliminary excavation of the mound there began in 1927 under the directorship of Ephram A. Speiser, who organized full-scale excavations in 1931 and 1932 (Speiser 1935). Speiser paid little attention to the natural stratigraphy of the site. His careless recording methods resulted in unreliable locus assignments. Fortunately, the methods of his immediate successor, Charles Bache, were more rigorous. In his four seasons at Tepe Gawra, Bache recorded meticulous information about locus and stratigraphy (Tobler 1950). This proved exceedingly valuable for future scholars working with the sealings from the site (Rothman 1997: 183; 2002).

Moving east into Iran, we come to Tepe Giyan. Herzfeld investigated this site in 1928. At that time he harvested a large quantity of the seals (perhaps numbering in the hundreds) from the mound and through purchases from the villagers of nearby Nihavand. He viewed this as an urgent salvage operation in the wake of widespread looting. But the seals he gathered there became part of his private collection. Tepe Giyan was excavated from 1931 to 1932 by Georges Contenau and Roman Ghirshman (Contenau and Ghirshman 1935). Although there were still some stamp seals remaining to be uncovered in graves by the French mission, these were stratified only by their depth from the surface. Their find spots are not chronologically informative (Caldwell 1976: 233). Tepe Giyan as a context is disappointing in comparison to the wealth of seals that we know came from the site. Present evidence does not allow us to see the ex-Herzfeld seals in combination with a body of sealings from the site; and by far the majority of late prehistoric stamp seals from Tepe Giyan are those retrieved by Herzfeld without any archaeological context whatsoever.

In contrast, seals from nearby Seh Gabi, excavated in the 1970s by the Royal Ontario Museum, have secure archaeological contexts. Additionally, the site offers a mix of seals and sealings. At present it provides the only significantly sized and well-stratified Chalcolithic glyptic corpus in highland western Iran (Henrickson 1988: 1). Belgian excavations at the site of Hakalan from 1965 to 1979 also add a small number of seal comparanda of great interest to the ex-Herzfeld corpus from Giyan—beginning to establish a web of related excavated material from the region against which to view the Giyan seals (Haerinck 1996). The Hakalan evidence is particularly interesting in relation to the provocative motif of the "displayed female" that is clearly represented prominently in the Giyan corpus (chapter 8 this volume).

Excavations at Susa formally began in the late 19th century and continued under French direction until 1990, interrupted by the two world wars and the Islamic revolution of 1979. The early levels that concern us here were excavated by Jacques de Morgan from 1897 to 1908. Morgan worked mostly on the Acropolis mound, employing methods that "tended to further speed at the expense of accuracy" (Le Breton 1957: 80). He was succeeded by R. de Mecquenem, whose methods were equally slipshod, particularly with regard to mud-brick

architecture (Carter 1992: 22). It was not until the late 1960s, when Jean Perrot directed the Susa excavations, that careful stratigraphic methods were employed at the site. Various members of Perrot's international team were charged with revisiting the work of their predecessors in an attempt to refine an archaeological and cultural sequence and contextualize the earlier discoveries (Carter 1992: 24).

Tal-i Bakun in Fars was first explored by Herzfeld in 1928, when he conducted test excavations on one of its two mounds (Herzfeld 1932). He directed full-scale excavations on the western mound in 1932, operations that were effectively supervised by Langsdorff and McCown. Erich F. Schmidt continued the work at Tal-i Bakun from 1935 to 1937, but only the first season's excavations were published (Langsdorff and McCown 1942). Fortunately, Langsdorff and McCown's recording and excavating methods were scrupulous, making it possible for later scholars to study the site's stratigraphy and to offer interpretations of the evidence of the retrieved seals and sealings (Alizadeh 1988). As a result, Bakun can be understood today as a nexus of interactions between nomadic and settled populations. Mobile pastoralists seem to have played a critical role in socioeconomic developments at the site by creating administrative demands relating to the exchange of manufactured goods for the agricultural surplus produced by the settled communities on the plain (Alizadeh 2003: 89). The Bakun A administrative area first excavated in 1932 has been totally destroyed over the years so there is no chance to revisit it for further documentation (Alizadeh et al. 2004: 97). It is indeed fortunate that the early work at this site recorded so much of the glyptic evidence.

EARLY INTERPRETATIONS OF CHALCOLITHIC GLYPTICS

For the first several decades of the 20th century, most studies of Chalcolithic seals recovered from these excavations were typological, as mentioned above. The descriptive, apparently atheoretical approach to the archaeological study of glyptics was in keeping with the broader tenor of traditional archaeology. In establishing typologies, scholars drew attention to the commonalities and differences as part of an effort to distinguish among cultural groups. Thus, M. Rutten, in an article entitled "Early Seals: Glyptic Types," revealed the priorities of the first half of the 20th century when he wrote: "The glyptic art of prehistoric Iran, while it has little aesthetic value, is interesting because it so clearly exemplifies [the] cultural distinctions and interrelations [between Mesopotamia and Iran]" (Rutten 1938: 286).

Working with the large collection of glyptic evidence from Tepe Gawra, Arthur Tobler, who in 1950 published Bache's excavations there, devised a classification system for seals based on types of motifs, which was adopted by other scholars after him (e.g., Goff 1963). Contenau and Ghirshman also published the seals from Tepe Giyan as a series of "type" seals (Contenau and Ghirshman 1935: 47–48), as did Le Breton in his discussion of the seals from Susa (Le Breton 1957: 103). Related to the focus on typology, early scholars also commented upon possible symbolic meanings of clusters of motifs (Herzfeld 1933; 1941; Ackerman 1938; Goff 1963). When sealings were discussed at all, it was only in relation to the motifs they revealed through the seal images impressed upon them.

The functions and importance of seals and sealings were not fully appreciated by the early excavators. Herzfeld posited that the stamp seal, with its perforation in the back, developed out of buttons, which, for some unexplained reason, began to be used as marks of ownership (Root 2000; 2005). This notion of the "button seal" caught on; Speiser adopted the same interpretation for the seals from Tepe Gawra, saying little more than that the "buttons" functioned for the "identification of property"—a garment fastening ornament that doubled as a device to represent the wearer (Speiser 1935: 119).

Tobler rejected the button idea, positing instead that stamp seals developed out of pendants, though he agreed with the general consensus that stamp seals served to identify ownership (Tobler 1950: 177). Contenau and Ghirshman were similarly vague on the matter of seal function, stating only that they must have been used to impress the personal mark of the owner on objects (Contenau and Ghirshman 1935: 48). Langsdorff and McCown came closer to recognizing an important clue to the function of sealings when they noted that "the labels were rarely found scattered but more usually were in groups in the various rooms." They also turned their attention to the backs of the sealings, which were "covered with a confused series of very fine line impressions of hair." But they stopped short of proposing an application for these clay "labels," stating only that "their interpretation is not very certain" (Langsdorff and McCown 1942: 66).

A seminal article published in 1976 by David Caldwell marked a transition in the study of Chalcolithic glyptics. Caldwell addressed a specific nexus of glyptic associations by comparing the seal assemblages from three sites—Tepe Gawra, Tepe Giyan, and Susa—in order to explore questions of stylistic influence and long-distance trade. He was not the first to bring together the glyptics from a number of contemporary Chalcolithic sites. Briggs Buchanan had done the same in an article entitled "The Prehistoric Stamp Seal: A Reconsideration of Some Old Excavations" (Buchanan 1967). But, like his predecessors, he focused on laying out the typologies of prehistoric stamp seals from across the Near East, and this descriptive approach left unanswered many questions about the function of the seals, the symbolism of the images they carried, and the priorities and preferences of the societies that produced them. Caldwell, by contrast, recognized that a study of seals could inform broader debates about the late prehistoric Near East.

In focusing on trade, Caldwell situated himself within a discourse on ancient long-distance exchange that arose in the 1970s. This trend came about in part because of advances in archeometry (the scientific study of materials), which enabled archaeologists to distinguish imported from locally produced artifacts at a given site. The interest in trade also emerged from the increasing attentiveness to the notion of trade as a form of culture process (Kohl 1978: 463). The agendas of "New Archaeology" were well served by the trade discourse. It was Colin Renfrew's 1969 study of the obsidian trade in the Near East that largely heralded a disciplinary interest in ancient exchange (Renfrew 1969), and Renfrew's article was followed up by a flurry of studies on exchange in the 1970s.[1]

[1] The list of studies on ancient Near Eastern trade (let alone the wider scholarship on ancient trade globally) published in the late 1970s and up into the early 1980s is too extensive to detail here. Some examples in addition to Renfrew 1969 include: Leemans 1968; Herrmann 1968; Crawford 1973; Larsen 1974; Davidson and McKerrel 1976; Levine 1977; Foster 1977; Kohl 1978; Alden 1982.

24

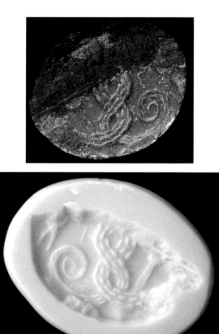

Fig. 3.3. Cat. no. 84. Fig. 3.4. Cat. no. 72. Fig. 3.5. Cat. no. 74.

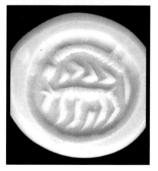

Fig. 3.6. Cat. no. 6.

Informed by this wider disciplinary conversation on trade, Caldwell's article represents a transition in glyptic studies from the typological and formal analyses that prevailed until the 1960s to approaches that became prominent in the 1980s. Like his predecessors, Caldwell was still interested in seal image, shape, and design. To the extent possible, however, he analyzed the stratigraphic relations among Tepe Gawra, Susa, and Tepe Giyan in order to reconstruct developments in glyptic design across this broad geographic horizon. Caldwell noted similarities in seal shapes and styles from the different levels at these three sites and, occasionally, from Tal-i Bakun as well. For example, he identified what he termed the "Luristan style," characterized by cross designs (figs. 1.15–1.16 this volume), animal hunting scenes, and snakes (figs. 3.3–3.7), which influenced seal craftsmen from across the region and may have been carried widely through trade.

Caldwell attempted to trace the chronological and geographic origins of these various shapes and styles in order to observe the directional movement of stylistic influences. He also noted the presence of possible imports from one or the other site, which he regarded as the forgotten vestiges of merchant traders. Caldwell concluded that Giyan was an innovative center in seal design. He posited that its products and ideas were disseminated to the west and south because it held a pivotal position on two main trading routes. One of these ran east-west between northern Mesopotamia (Tepe Gawra and beyond) and Afghanistan, far to the east of Giyan and the source of the increasingly coveted lapis lazuli stone. The other ran north-south, connecting Giyan to Susa (and Sumer) and thence also to Tal-i Bakun and other settlements in Fars (Caldwell 1976: 234).

Fig. 3.7. Cat. no. 75.

Caldwell's analysis of seals pointed to a complex relationship marked by mutual stylistic influences between these points. In his emphasis on *mutual* influences Caldwell implicitly cast doubt on traditional understandings of the "Uruk expansion," often framed in terms of a "core-periphery" model in which a more dominant Sumerian culture imposed itself unidirectionally upon its Iranian neighbors. Later intensive studies of ceramics corroborated Caldwell's proposition, advancing the notion of balanced trade and accommodation between Mesopotamia and the Zagros rather than a relationship based on a Sumerian hegemony in the middle Chalcolithic (Henrickson 1994).

An understated theme in Caldwell's article is that long-distance trade requires organization. Although certainly intimating it, Caldwell did not explicitly link the organizational demands imposed by long-distance trade to forms of complexity, despite the fact that the literature on urbanism and state theory had long recognized the important role of long-distance exchange.[2] In other words, Caldwell stopped short of articulating how seals could inform questions of social organization. Buchanan had also (somewhat quaintly) posited that seals were linked to social complexity when he observed, "it is clear that a more thorough knowledge of the stamp seal could vastly enhance our understanding of the stages prior to the beginning of civilization" (Buchanan 1967: 535); however, he too stopped short of elaborating precisely how. It was not until priorities in the study of the Chalcolithic period shifted that glyptics would be regarded as administrative artifacts.

THE ANTHROPOLOGICAL TURN:
SEALS AND SEALINGS AS ADMINISTRATIVE ARTIFACTS

Throughout the 1950s and early 1960s, as we have noted, little archaeological investigation had been carried out on Chalcolithic sites. This meant that Caldwell had had to rely heavily on the pioneering though archaeologically problematic investigations of the first half of the 20th century (Negahban 1967). Yet by the 1970s the middle Chalcolithic period became a renewed object of focus for archaeologists of the prehistoric Near East. The upsurge in interest in the middle Chalcolithic period emerged out of a recognition of the gap between the burgeoning study of the preceding Neolithic period and the equally flourishing scholarship on the subsequent high Uruk (protoliterate) period. From an evolutionary perspective, further study of the Chalcolithic period was envisioned as helping to explain much about the transition from the "Neolithic Revolution" to the "Urban Revolution" (Henrickson and Thuesen 1989: 11).

The 1970s ushered in a new phase in the study of ancient Near Eastern seals in general—one that began to consider the purposes that seals served in the economic management of the societies that produced them. One hallmark publication made a strong statement on the new interest in combining the study of seals known through impressions affixed to ancient documents with the study of seal artifacts (Gibson and Biggs 1977). Although this book did not explicitly

[2] A few examples of relevant studies that address the relation between trade and urbanism are Renfrew 1969; Lamberg-Karlovsky 1972; Johnson 1973; Adams 1974.

include prehistoric stamp seals within its purview, it was responding to impulses being felt simultaneously among scholars of prehistory. Furthermore, it helped energize the field of glyptic studies and lent the weight of historically based Near Eastern scholarship to the work simultaneously emerging from archaeologists of prehistory.

Prehistorians began to consider early glyptics as administrative objects that could inform questions of social and political organization. The anthropological discourse of state formation found its way into glyptic studies, just as the study of seals began to interest scholars of early complex societies. In an article about early state formation in southwestern Iran for *American Anthropologist*, Henry Wright and Gregory Johnson discussed the importance of seals and sealings as symbols of authorization (Wright and Johnson 1975: 272). This new line of inquiry into the function of seals as administrative artifacts emerged in connection with the increased interest in exploring the origins of the unprecedented social complexity of the late Uruk period, when state-level societies first emerged. The "Urban Revolution" of the mid-4th millennium, it was realized, could be better explained if the economic and political structures of pre-state societies, often described as chiefdoms, were better understood. In recent decades, scholars have begun to marshal glyptic evidence to illuminate early forms of social hierarchy.

This new approach to glyptics was heralded in large part by the work of Erika Fiandra and Piera Ferioli, who were among the first to advocate for the intensive study of clay sealings from a functional perspective (Fiandra and Ferlioli 1981; Ferioli et al. 1994). Furthermore, Fiandra and Ferioli proposed that sealings should be studied in relation to the spaces in which they were found. Through such analysis, for example, storage areas (where sealed commodities were kept) could be distinguished from archival areas (where backlogs of removed sealings were kept as records of activity around the commodities). This combination of a functional and distributional study of sealings could in turn reveal levels of administration and forms of bureaucratic organization. The use of seals to control commodities and spaces in a given society suggests that social interaction in this society was no longer coordinated by consensus but by social actors with the authority to make decisions for others about the production and consumption of resources (Rothman 1994b: 97).

Fiandra and Ferioli applied their approach to the newly excavated seal corpus from Arslantepe in eastern Turkey, which dates to the late Uruk period just beyond our temporal focus. Other excavations conducted in eastern Turkey in the 1970s, such as those at Chalcolithic Değirmentepe, also yielded glyptic assemblages that have been studied with questions of social organization in mind. Thanks to new excavations such as these, the corpus of Chalcolithic glyptic materials has grown considerably. These excavations have been carried out with greater care for stratigraphy, thereby endowing newly found seals and sealings with not only a site provenance but in many cases a specific find spot. New excavations have also expanded the geographic limits of this shared glyptic tradition beyond the Gawra-Giyan-Susa triad that was the focus of Caldwell's study.

Using Fiandra and Ferioli's methods, scholars have also revisited seals that were excavated earlier in the 20th century. These excavations had been carried out by archaeologists with research agendas quite different from those of

today. Thus a major challenge of the past few decades has been to ask new questions of data sets that were created in order to answer different questions. In many cases, for example, early excavation reports offer little, if any, detailed description and illustration of the backs of sealings. Fiandra and Ferioli recognized early on that the functional approach to sealings can be applied most profitably to bodies of glyptic evidence for which at least two forms of data are available: information about the sealings and the specific archaeological context in which they were found (Fiandra and Ferioli 1981: 127).

PROSPECTS

At Susa, Tal-i Bakun, and Tepe Gawra the excavation and recording methods of the early archaeologists have, to varying degrees, enabled work to proceed on new agendas using old archaeological records. At Tepe Giyan, however, the absence of both sealings and an archaeological context for the existing seals has impeded a contextual study. Nevertheless, it is possible that some insight into social organization could be gleaned from an intensive provenance study of the raw materials from which the Giyan seals were made. Long-distance sources might suggest the presence of institutions that could harness the resources to acquire and process these materials. In other words, a return to a focus on trade might be appropriate in the case of Tepe Giyan, assuming detailed stone sourcing is even possible. Materials analysis of the ex-Herzfeld seals is currently under way (Part V this volume).

In any event, although the Tepe Giyan seals unfortunately do not lend themselves to a contextual study, the nearby site of Seh Gabi can inform this region of the Zagros highlands. The excavations of Seh Gabi were conducted in the 1970s by the Royal Ontario Museum under the directorship of Louis D. Levine. The seals and sealings were largely unpublished until 1988. Seh Gabi therefore was not included in Caldwell's study; however, the seals found at the site are part of the same glyptic tradition as at Susa, Tal-i Bakun, and Tepe Gawra. Note, for example, the very same "Luristan style" cross, identified by Caldwell, on seals from Seh Gabi (chapter 4 this volume). Such comparisons reinforce Caldwell's vision of cultural connections based on east-west trade routes between the eastern Central Zagros highlands and northern lowland Mesopotamia in late prehistory (Henrickson 1988: 8).

At present, only four of the seven mounds at Seh Gabi have been partially explored, and the seals from the period under consideration here come from only two of these partially excavated mounds. The total number of seals and sealings from the first half of the 5th millennium is a mere six—five seals and one possible sealing (Henrickson 1988: 6). All of these seals were found in houselike structures. The architectural layout of Seh Gabi suggests that it was a village, although in the early 4th millennium level there is evidence for a larger building that contrasts with the disjointed houses in other parts of the site. The presence of this larger construction implies at least the early stages of socioeconomic hierarchy (Henrickson 1988: 10). In any event, with only one sealing at hand it is understandable that the scholar who published these seals, Elizabeth Henrickson, focused on the search for comparanda in order to situate the Seh

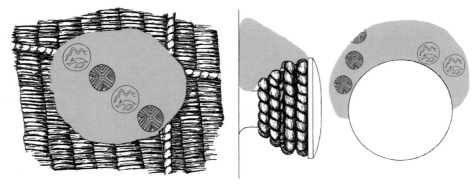

Fig. 3.8. Cat. no. 16.　　　　　*Fig. 3.9. Cat. no. 14.*

Gabi assemblages in context with contemporary collections rather than attempt the sort of social-historical study that has been undertaken in the analysis of seals from Susa, Tal-i Bakun, Tepe Gawra, and Değirmentepe. It is to these that we will now turn.

Susa

An archaeological study of the seals and sealings from Susa is exceedingly difficult given the absence of a clear stratigraphy and specific contexts for the finds. Without vertical and horizontal distributions of seals within a site, there are limits to what can be said about their role in administration. Nevertheless, Petr Charvát has applied Fiandra and Ferioli's methods in his reexamination of a portion of the Susa corpus. Charvát has relied on the stylistically based chronologies constructed by Le Breton and Amiet in his attempt to construct a diachronic picture of the development of control mechanisms at Susa. Although he focused partly on later material than ours, his approach is of interest.

Charvát observed that the impression created by a seal represents a relationship between the object sealed and the human agent, whether acting individually or on behalf of an institution (Charvát 1988: 57). Depending on where the sealings were applied, whether on mobile containers or door locks, different forms of administration and control can be postulated. Charvát scrutinized the backs of a percentage of the Susa sealings, noting changes in seal types and functions over time. In the earlier group of material in his study corpus, sealing backs bear the imprints of textile, leather, or wickerwork surfaces, which indicate that stamp seals were applied to mobile containers such as sacks, pots, and baskets (fig. 3.8). Charvát reasoned that the practice of sealing mobile containers signals, at a minimum, that these containers had traveled across a property boundary. This may suggest one side of a reciprocal economic structure (Charvát 1988: 60). In the subsequent chronological phase of his investigation, the sealing of clay bullae with both stamp and cylinder seals, combined with the introduction of door lock sealings (fig. 3.9), indicated to him a more complex situation. He postulated here a redistributive economy, with Susa acting as a central authority where elites could account for inflows of goods and control restricted spaces (Charvát 1988: 60).

Although he considered only a small percentage of the Susa sealings,

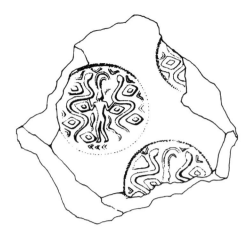

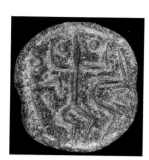 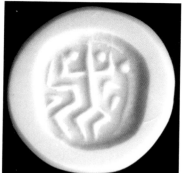

Fig. 3.11. Cat. no. 30.

Fig. 3.10. Cat. no. 115.

Charvát illustrated how an examination of sealing backs may inform questions about social organization, and in particular the "socially engineered movements of material goods" (Charvát 1988: 57). Charvát did not incorporate the late prehistoric Susa I material into his analysis. Only a small number of sealings from this phase remain, and their ascription to Susa I is not certain in every case (Amiet 1972: 24). Nevertheless, it should be noted that there are remarkable and distinctive seals in the Susa I corpus, some of which are clearly parallel to the ex-Herzfeld Tepe Giyan seals (figs. 3.10 and 3.11). In addition, it is to this Susa I period that the painted pottery from the Susa cemetery dates.

The pots from the Susa cemetery provide another avenue for exploring the question of sociopolitical organization during Susa I, through an analysis of the stylistic modes and social messages they convey (see Pollock 1983). Before proceeding with a series of case studies that focus exclusively on seals and sealings, it is worth remembering that these objects are not by any means the only artifacts that can inform social complexity.

Tal-i Bakun

In the same year that Charvát published his analysis of the Susa sealings, Abbas Alizadeh did the same with the glyptic materials from Tal-i Bakun A. Alizadeh reexamined the sealings from Bakun in order to shed new light on the political and socioeconomic complexities in this pre-state society, long thought to be nothing more than a simple village (Alizadeh 1988: 17). Unlike the situation at Susa, detailed archaeological levels had been thoroughly documented at Tal-i Bakun. The largest number of artifacts at Tal-i Bakun, including clay sealings, was recovered in a level of the site that also contained a complex of rectilinear buildings suggestive of architectural planning. Alizadeh examined the architectural layout of buildings in the northern section of the site and noted their common architectural features, such as back rooms and access points to a common central hall. He observed the consistent location of the sealing deposits in or near these back rooms and concluded that the buildings were used as warehouses or storerooms. In contrast, sealings were entirely absent in the central and southern portions of the site, where architectural units were less carefully planned. Instead there were higher concentrations of unworked and half-finished items in these areas, suggesting that they housed workshops dedicated to local industry. Alizadeh

ultimately was able to tabulate the distribution of various seal designs and types according to their find spots in specific spaces (Alizadeh 1988: 21).

This new analysis of the Bakun sealings and their spatial distribution offered several fresh insights into levels of socioeconomic complexity at the site. Like Charvát, Alizadeh examined the backs of the seals and observed various categories of objects to which the sealings were affixed, such as bags, sacks, "tablets" (or some other object with a flat surface), or jars. In other words, as at Susa, many of the Bakun sealings were applied to moveable objects. Like Charvát, Alizadeh assumed that the presence of sealings on such movable objects indicates some level of socioeconomic institutionalization. These sealings imply a social contract: if the seal is not respected, presumably some form of punishment results (Alizadeh 1988: 25).

The appearance of door sealings at Bakun A suggests a fairly complex form of administration. The ability to restrict and allow access to spaces suggests a stratified society with authorized and unauthorized individuals. Insofar as such individuals represent institutions, these locked spaces signal the presence of a controlling or dispatching agency. The ability to exert control over the flow of commodities in turn reflects a higher degree of complexity than the ability only to safeguard the contents of portable objects.

Alizadeh took the Bakun evidence one step further still, examining not only the sealing backs but their fronts as well. His focus was not the symbolic content of the seal images but rather the incidence of certain seal impressions in various buildings. Alizadeh's tabulations of spatial distributions indicated that certain seals were applied repeatedly in the same buildings and more frequently than other seals. From this he postulated a hierarchical structure within the circle of authority at Bakun; not only were there institutions of control, but these institutions were themselves differentiated, with the individuals or institutions behind some seals possessing greater authority than those behind other seals (Alizadeh 1988: 26).

Tepe Gawra

A few years after the Susa and Bakun studies were published, Mitchell Rothman presented his work with the sealings from Tepe Gawra, in which he postulated even more nuanced forms of complexity on the basis of seals. Like Alizadeh, Rothman also considered the function of seals as institutionalized control mechanisms. In particular, he was interested in evidence of centralization at Chalcolithic Tepe Gawra. Through a study of seals and sealings, Rothman examined what he termed the horizontal and vertical extent of control at different periods in the site's history. By *horizontal control* he meant the number and kinds of activities that central authorities controlled; by *vertical control* he meant the degree of hierarchy within the society, determined by the presence or absence of independent constituencies and of multiple administrative units themselves subject to higher authorities (Rothman 1994b: 98). Thanks to the sound stratigraphic techniques employed by Bache at Tepe Gawra, Rothman was able to explore horizontal and vertical control at three different levels of the site—levels XI, X, and VIII. These three levels span the first half of the 4th millennium.

Level XI at Tepe Gawra seems to have been an economically and socially segregated town (Rothman 1994b: 103). A wide number of activities, including

ritual, storage, and manufacturing, were evidenced at the site and were segregated into specialized buildings. Many of the specialized buildings, such as the temple, the woodworking shop, and the so-called fortress or chiefly residence, had their own storage facilities. The fact that sealings were found in each of the specialized areas on the mound indicates to Rothman the presence of one or more controlling authorities overseeing these activities. Level X exhibits many of the same features, including a specialized temple and chiefly residence; however, certain forms of craft production were no longer segregated. Instead, some kinds of craft production seem to have taken place in domestic spaces. This suggests that, while religious and chiefly authority remained intact, specialization diminished. The occurrence of sealings in those domestic spaces where craft production took place points to a decentralization of control. Another change occurs in level VIII. Chiefly and religious oversight continues, and specialized craft activities become important again, as they were in level XI. Craft production no longer seems to take place in domestic areas, suggesting a return to specialization and segregation. Complementing this picture, sealings from level VIII are no longer found in domestic spaces. Instead they reappear in specialized institutions (Rothman 1994b: 108). Thus, throughout the first half of the 4th millennium at Tepe Gawra horizontal control extends across ritual and social functions, but craft functions fluctuate between being highly specialized and segregated in levels XI and VIII and being domestic and widespread in level X.

To understand the vertical structures of control at Tepe Gawra, Rothman turned to seal design. He distinguished among geometric, simple figural, and complex figural designs and assumed that each design code carries information that is readable by different audiences (Rothman 1994b: 110). The different audiences in a society like Gawra might include members of the chiefly lineage group, specialists, and off-site clients. Rothman posited that since complex figural designs can carry a great deal of very specific information—with each added element in the design narrowing the referent of the code—they are more likely to be accessible to only a small circle of administrators and specialists. Therefore, seals bearing such complex designs are most likely used for managing internal operations. In contrast, seals with simpler designs, and in particular geometric designs, would be more suitably used for external, off-site audiences who might not be familiar with the narrow referent contained in the complex designs. Insofar as seals are markers of social identity, complex seals might suggest individualized authority, while geometric seals with their standardized images might reflect group or institutional membership (Rothman 1994b: 111).

If these assumptions are sound, Rothman reasoned, sealings found in the center should bear impressions of figural seals. These sealings would be used to communicate to internal bureaucratic audiences involved in such activities as packaging, storage, or disbursement. In contrast, there should be few geometric sealings at Gawra; these should instead be found off-site, at other places that participated in the wider Gawra economic network. The geometric seals should, however, be found on-site—in areas where export products are stored or produced (Rothman 1994b: 111).

Rothman's predictions proved correct. Door sealings from storerooms at all levels were consistently stamped with figural seals. From all contexts in level XI more figural sealings were found than any other type of seal or sealing. Also

from this level, most geometric seals were found in areas associated with production and export, and few geometric sealings were found at all. From level XI Rothman also observed that of the figural design seals, two complex designs in particular seem to reappear in spaces dedicated to particular activities and that these two designs do not occur together. He deduced that administrators with horned animal designs on their seals controlled administrative and religious activities, while administrators with dog predation scenes oversaw craft production (Rothman 1994b: 114). This suggests at least two controlling authorities, or what Rothman calls a "bifurcation in authority," with each group overseeing a limited number of activities (Rothman 1997: 184).

In level X, figural sealings still predominate, and there is a lower proportion of geometric seals and sealings, perhaps suggesting a decrease in craft production for export, as is also implied by the absence of specialized craft production areas in this period. At the same time, the proportion of sealings with the horned animal design increases in relation to the dog predation design, which seemed to be associated with craft production in level XI. The existence of the horned animal seals suggests that control was limited to religious and some administrative activities. Finally, in level VIII, figural sealings continue to dominate; no geometric sealings at all were found in this level. Most notable in level VIII is the use of a single seal, with a bull, dog, and snake design, whose impressions are for the first time found across the site, in ritual, administrative, and craft production contexts. This suggests to Rothman a new degree of vertical centralization at Gawra, in which production, storage, and disbursement functions are controlled by a single authority represented by this seal design (Rothman 1994b: 115).

Rothman's study is an excellent illustration of how glyptic evidence can shed light on developing forms of complexity in a middle Chalcolithic society for which there is sound stratigraphy. In his analysis of the shifting horizontal and vertical structures of administrative control Rothman also reveals, at the micro level of a particular site, the dangers of strict evolutionary understandings of the path to state-level complexity.

Two cautionary points are, nevertheless, in order. The first is made possible by the comparative information available from Tal-i Bakun. Although the two sites are geographically far apart, they do seem to be part of a single glyptic tradition. It is therefore worth noting that, regardless of uneven preservation and recovery techniques, the vast majority of door sealings found at Tal-i Bakun A are geometric in design, casting doubt on Rothman's hypothesis that geometric seals addressed an off-site audience. Root has rightly pointed out that the absence of figural imagery on seals from Tal-i Bakun is peculiar in light of the abundance of figural painted pottery at the site. She suggests that this oddity may relate to the focus of the excavations on a particular administrative area of the site (Root 2000: 28).

This challenge to the proposed contrast between geometric and figural designs leads to a broader question about the semiotic systems behind seal imagery. Both Rothman and Alizadeh have focused on seal imagery only insofar as it addresses issues about relations among groups or institutions. Both inquiries exist beyond the realm of the symbolic importance of the seal image itself—what it means, as well as how and by whom it is produced and manipulated. Yet it is

unlikely that seal imagery is encoded only to mark the rank and social identity of the bearer (Pittman 1994a: 122). Just as the Great Seal of the United States stands for freedom in the eyes of some observers, it may stand for oppression in the eyes of others. In other words, prehistoric seal imagery may also have had multiple referents in addition to the social identity of the institution or individual represented by the seal. At its simplest, seal imagery may refer somehow to the object or commodity being sealed. More complex referents may include social values, beliefs, and concerns. Understanding how the images on seals worked as symbols is no simple task, but integrating an art historical line of inquiry into the discourse on social complexity may yield interesting results.

Değirmentepe
It is with this concern for the multiple referents and meanings embedded in seal imagery that we turn finally to Değirmentepe. The assemblage of twenty-four stamp seals and 450 sealings from this site dates to the late 5th and early 4th millennia. Like Charvát, Alizadeh, and Rothman, Ufuk Esin (who published the seals from Değirmentepe in 1994) was also interested in their functional importance.

Esin, however, postulated that seals and their images may have served other functions besides indicating the social identity of their owner. She suggests, for example, that seals with floral and faunal motifs—particularly domesticated animals—may refer to the commodities being stored, while seals decorated with nondomesticated animal imagery, such as eagles, scorpions, lions, or snakes, may have had religious referents. In these cases, the seal image may have been an attribute of a deity whose presence on a seal endowed that seal with protective capacities (Esin 1994: 63).

At the same time as the image may have referred to a deity, Esin also suggests that the seal may have referred to the seal owner's social identity, perhaps as a priest or other individual of important rank who was authorized to employ, as part of the mechanics of control, iconography that had spiritual significance for the entire community. Here Esin has in effect illustrated an important claim made by Root, that "'administration' or 'control' need not be specifically economic (such as control of commodities) in order to be part of the discourse. It might, for instance, relate to 'administration' of rites in the domain of cult, magic and the healing arts" (Root 2000: 25).

Esin made deductions about social hierarchies—the vertical axis of control—from the symbolism of the images themselves rather than from the spatial distribution of a particular seal impression. Whether Esin was correct in further suggesting that the use of sacred imagery indicates the beginning of a theocratic state is disputable. Her relegation of seals with geometric design to the realm of private control by individuals is also open to question and depends in large part on the detailed spatial distribution of geometric sealings. Nevertheless, her point that seals may have referred to something more than the social status of the owner is an important one and can be supported by the fact that Değirmentepe has yielded multiple sealings with roughly the same imagery that were clearly made from different seals. If seal images conveyed first and foremost the individuated identity of the owner, presumably these images would need to be sufficiently distinct to allow the viewers of the images easily to appreciate their distinctiveness. The presence of impressions with the same motifs but derived from different

seals supports the proposition that seal images may have referred to the specific commodity being sealed or the protective realms attributed to different deities in whose name the commodities were sealed (Esin 1994: 79). That said, we cannot rule out the possibility that a single institution or individual had multiple seals, which would also explain the many impressions with similar motifs made by different seals. Either the commodities sealed were the same, or the agent behind the seals was the same. In any event, Esin introduced into a functional study of seals a focus on the seal imagery itself.

CONCLUSION

The study of glyptics has come a long way since the typological agendas of traditional archaeology. The New Archaeology of the 1970s created the intellectual space for new inquiries in the study of the Chalcolithic Near East revolving around ancient trade and its relation to state formation. These were inquiries to which glyptics had much to offer. The anthropological turn continued in the 1980s and 1990s, when stamp seals and sealings came to be regarded less as *objets d'art* than as administrative artifacts that could speak to the socioeconomic dynamics among and within the precursors of later state societies. The glyptic evidence for social complexity is but one archaeological clue to how political and economic relations within societies are organized, alongside many others, such as monumental buildings; planned architecture with segregated residential, administrative, and production areas; population size; and settlement patterns.

Similarly, the function of sealings is but one variable in the administrative aspect of glyptics. Many of the recent studies of glyptics as administrative artifacts have ignored the role of seal images—their symbolic content and meaning, not just their spatial distribution—in administration. "The results of these studies," Pittman writes, "suggest that the act of sealing rather than the image itself was of primary significance in the administrative process" (Pittman 1994b: 3). But what if information related to the administrative process were embedded within the images on the seals? It seems that in historical periods seal imagery related not directly to the administrative event authorized by the application of the seal but to the social identity of the owner or user of the seal, who was specifically identified through a written inscription (Pittman 1994b: 4). But in the absence of writing in the prehistoric periods, the imagery on seals may have had specific bearing on the administrative act itself (Dittmann 1986). As matters now stand, studies of seals as administrative tools cannot confirm that the occurrence of different images in different spaces necessarily indicates multiple units of authority. Once we accept that seal imagery can refer to something more than social rankings, assumptions about the vertical axis of control will be called into doubt, until we can explain how hierarchies may be expressed through image. If there is anything known for certain from the geographical distribution of a common seal design repertoire across the Near East, it is that the symbolic system behind seal imagery was clearly not random.

Signs and Symbols

Fig. 4.1. Exterior view (a) and interior view (b) of section of the Farukhabad envelope (cat. nos. 7, 45, and 100).

Fig. 4.2. Modern business envelope.

4
The Chevron-Filled Cross and Early Communicative Systems

Jane Rempel

SYSTEMS OF INFORMATION STORAGE

Administrative systems in prehistory centered on methods of accounting, recording movement and distribution of commodities, labeling and designating of such commodities, regulating access to commodities, and perhaps signification of ownership or proprietary involvement. The key word here is *systems*. It acknowledges multiple visual tools and cues simultaneously interacting in projects aimed at the storage and tracking of multiple types of information—and all before the invention of writing.

The act itself as well as the informational importance of applying seals within these systems is established for late prehistory. That said, the protocols and social mechanics underlying the act and the retrieval of information supplied by the act remain difficult to reconstruct. Here we isolate one element of this issue for experimental exploration: How (if at all) did the images on seals relate differentially to the processes represented by such preliterate systems? As one way into this question, we will look at the seal device of the equal-armed cross with chevron-filled quadrants. First, some background.

TOKENS, BULLAE, ENVELOPES, SEALS

The work of Denise Schmandt-Besserat has brought attention to prehistoric accounting systems through the exhaustive documentation and interpretation of three-dimensional clay tokens, or "calculi," of various geometric shapes that have been found at many sites all over the ancient Near East from remote preliterate times in the 9th millennium BCE down into the era of fully developed writing (Schmandt-Besserat 1992; 1996a). Schmandt-Besserat postulates that the clay tokens were used as part of a recording system, as mnemonic devices for information storage, registering tabulations of specific types of goods—such as herd animals, agricultural products, or worked commodities.

These tokens were plain—unarticulated by incised markings—for the first 4,000 years of their use. They were in some contexts originally attached with string to blobs of clay ("bullae") that bore seal impressions. Then, around the middle of the 4th millennium or (as we shall see) somewhat earlier, tokens began to be used in conjunction with hollow round or egg-shaped clay envelopes (fig. 4.1). (In the literature, some scholars refer to these items as "bullae" also.) These envelopes bore exterior markings indicating what would be found inside in the form of three-dimensional tokens. Thus we see a system of deliberate redundancy,

allowing the records contained inside the envelope to be verified through markings on its exterior for immediate reference (Schmandt-Besserat 1996a: 57).

Conventions still in place for modern mail are very vestigial forms of the same concept of deliberate redundancy. The return address in the upper left corner of a modern paper envelope iterates the same basic information about the sender that will in some form be repeated in the document contained within. In many cases of business mail the return address on the envelope will also offer clues to the topic of the communication that will be explicated on the document contained inside (fig. 4.2).

NUMERICALLY ANNOTATED ENVELOPES

Some of the exterior markings on the ancient clay envelopes included clear notations of numbers. A single round depression stood for the number ten, for instance. Two such depressions stood for twenty. Depressions of an elongated triangular form stood for one. The numerical meanings of these marks perpetuated an information storage system that was enacted earlier through the analogously shaped three-dimensional tokens without the redundancy of their representation on a legible surface. (A token in the shape of a sphere would mean ten, and so on.) We can thus track the precursors of early numerical notation systems on legible surfaces back to these clay envelope systems and ultimately back to the tokens used before the development of deliberate redundancy and safeguarding through the marked envelope. There is a direct continuity in the use and meaning of these numerical signs from early prehistory to late prehistory and through the protoliterate period into the era of writing.

These annotated clay envelopes were often also impressed with seals. The example from Farukhabad (cat. no. 7)—found already broken open, its tokens removed in antiquity—is certainly one of the earliest yet documented examples of such a token-filled envelope (Schmandt-Besserat 1996a: 44–45). Retrieved from a secondary discard context of protoliterate times, it quite likely, in the excavator's view, dates to the period immediately preceding late prehistory with which we are concerned here (Wright 1981 and pers. comm.). Although the actual tokens are no longer with the Farukhabad envelope, the impression of one apparently plain (unmarked) tetrahedron is clearly visible on the interior wall. On the exterior, circular depressions indicate numerical notations.

The faint impressions of two seals (one scorpion stamp seal, plus one almost completely illegible animal seal of indeterminate type) add to the information stored on the artifact. The scorpion stamp seal is right at home in the seal repertoires of late prehistory, further reinforcing the likelihood that the envelope dates a little earlier than the protoliterate period (fig. 4.3). Another archaeological context represented in our exhibition also exemplifies the connections between these plain mnemonic calculi and seals as informational tools. Numerous unmarked tokens (now separated from their clay envelopes) were excavated from the same locus as the ibex seal from Chogha Gavaneh (cat. no. 1). The excavator dates this to around 4500 BCE (Abdi 2002 and pers. comm.) (fig. 4.4).

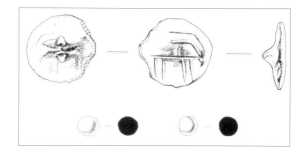

Fig. 4.3. Drawing of cat. no. 7a.

Fig. 4.4. Drawing of cat. no. 1 and selected tokens found with it. Courtesy of Kamyar Abdi.

COMPLEX TOKENS, SIGNS ON LEGIBLE SURFACES, AND PICTOGRAPHS

At roughly the same time as the envelope system emerged, the plain tokens were supplemented with "complex" tokens that were incised with linear markings. These markings indicate the need for greater accuracy and more checks and balances in record-keeping systems (Schmandt-Besserat 1996a: 16, 83).

Some of the markings on these complex tokens bear a one-to-one formal correspondence to signs in the slightly later pictographic script. These pictographs appear on clay tablets (small, hand-formed slabs of clay). Onto the legible surface of such tablets tokens were impressed along with renderings of signs closely similar to some of the imagery incised onto complex tokens. The similarities of form are so precise and so systemically related that their message content must be related as well. We are entitled to infer from the independently demonstrable meaning of the pictograph the meaning of the earlier incised sign on the complex token.

The example we use here is clear and of compelling interest for the art of late prehistory: In early pictographic writing an encircled equal-armed cross stood for "sheep." The same cross with a chevron inscribed within one of its quadrants stood for "female sheep" (the ewe) (fig. 4.5). An early tablet from Uruk (southern Mesopotamia), now in Baghdad, illustrates the phenomenon (fig. 4.6). Here, in order to record specific quantities of sheep, multiple count-

Fig. 4.5. Diagram of complex tokens and pictographs (a = lamb; b = sheep; c = ewe). Adapted from Schmandt-Besserat 1996a: 72.

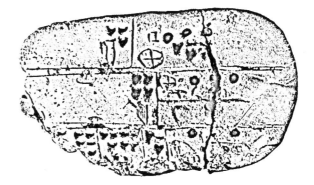

Fig. 4.6. Tablet with pictographs (Uruk W21418.4 Baghdad). Adapted from Schmandt-Besserat 1996a: fig. 25.

ing marks, including multiples of the "ten" mark, are impressed into the clay alongside multiple incised pictographs for "sheep." On other similar tablets, pictographs occur for other domesticated animals as well as for produce (such as grain) and crafted commodities (such as textiles).

EVOLUTION V. INVENTION: CONTROVERSY AND RESOLUTION

Schmandt-Besserat urged that the complex token motifs evolved directly into the early pictographs that are the first stage in the invention of cuneiform writing. It is important to note that some aspects of the token theory in relation to the invention of writing have met resistance—most importantly, the notion of an evolution from complex tokens to pictographic writing.

A modulated position on this point would posit the existence of parallel systems of communication that were employed in various geographical and chronological sequences (Shendge 1983; Michalowski 1990: 59; Talalay 1991; Zimansky 1993). The complex tokens may have been used for varied mnemonic purposes in different communication systems. These different systems probably existed side by side. Thus, we envision a related group of systems, which affected each other and shared certain features including certain sign-meanings but which were not directly dependent upon one another in an evolutionary sense.

This modulation allows for the widespread thinking among Sumerologists (e.g., Michalowski 1990) that early cuneiform writing as its own system seems to have been invented all at once rather than through a long evolutionary process. It also accommodates the different notion, held by some cuneiformists, that ancient imagery systems and the concept of writing are interrelated, with writing developing gradually (e.g., Walker 1987: 9).

Embattled on linguistic fronts as this controversy has been, it does not dispute the essential equivalence of sign-meaning between the incised tokens bearing crosses and the pictographic signs.

SEALS AS SIGNS?

What is specifically relevant to this essay, and indeed what prompted it in the first place, is Schmandt-Besserat's association of sign-meanings of certain complex token motifs with the earliest pictographs.

The introduction of complex tokens coincides with the end of the late prehistoric phase we focus on in *This Fertile Land* and what we may consider an administrative turn in society. Motifs based on the equal-armed cross are a dominant feature of late prehistoric stamp seals. We propose here to take a look at a specific subset of late prehistoric cross seals within a particular evidentiary framework. To wit: Specific geometric motifs were demonstrably being deployed on complex tokens by the end of our time period as communicative signs with conventionalized, standardized, and widely recognizable meanings. The equal-armed cross motif, with its demonstrable system inviting adjectival enhancement through signs insinuated into the quadrants, is an important example with a clear base meaning and a clear enhanced meaning.

How might that fact inform the study of seals bearing variations on the equal-armed cross motif?

The equal-armed cross on late prehistoric stamp seals might have been used as a seal device in an integrated preliterate administrative system and might help us understand how early sign systems were linked conceptually and even practically to the notion of writing. A symbolic system in this case would mean a set of recognizable visual signs that refer to specific things, positions, or places. Was the cross sign, as engraved on late prehistoric stamp seals used to produce images on clay sealings, part of a symbolic communication system?

The study of administrative systems in ancient Mesopotamia has tended to begin with the slightly later protoliterate period, when complex systems of bullae and tokens were fully developed, followed by the emergence of the tablet as a recording surface and then development of the earliest forms of writing. Even when studies of administrative systems have extended back into the prehistoric periods, most notably with Schmandt-Besserat's study of clay tokens, the use of seals within these systems has not been foregrounded.

In order to locate these seals within the context of such an administrative system, first archaeological evidence must place them in potentially administrative contexts, and secondly it must be shown that the societies in which these seals functioned were sufficiently complex to have relatively complex administrative needs. These considerations have been explicated elsewhere (chapter 3 this volume). It is a given that seals in our period were a form of "materialized information" (Charvát 1988: 57). As such, they were indispensable tools in early centralized/administrative societies, which needed a method to "restrict others' access to essential goods, to account for their distribution, and to convey authority in the physical absence of leaders or their agents" (Rothman 1994a: 104). The earliest evidence for seals used to seal jars dates about 1,000 years before the period we are focusing on here. By the late prehistoric period, seal use had expanded significantly in its functional range, serving now as a mechanism for controlling access to rooms as well as to many types of objects/containers (Magness-Gardiner 1997: 510).

Undeniably, then, the invention of sealing (of the application of reusable visual devices to entities that could be consulted later) was a "revolutionary step" in the development of administrative systems, a means of representing ownership and establishing authority in absence (Shendge 1983: 122–124). The idea of seals and sealing lay at the core of all subsequent parallel systems of communication and perhaps in this capacity was really the earliest precursor to early forms of writing (Shendge 1983: 130–134).

In what ways, if any, did the devices engraved on individual seals relate to administrative practice? Is it possible that certain seal motifs, like the tokens incised with specific patterns, carried information specific to the nature of the administrative procedure with which they were involved? Is it possible that some seal devices conveyed widely accepted, conventionalized meanings? Or were the late prehistoric seal motifs intended primarily as pleasing patterns that perhaps served to identify them with specific individuals or groups within the society—but were not, as designs, specifically coded with administrative or notational information?

Most of the work done with Mesopotamian seal motifs in the context

Fig. 4.10. Cat. no. 73b.

Fig. 4.8. Cat. no. 55b.

Fig. 4.9. Cat. no. 46.

Fig. 4.7. Cat. no. 11.g.

of administrative systems has focused on the figural motifs on cylinder seals of the late Uruk protoliterate period. For this material, conversation includes ideas about "notational signs" on the seals (Nissen 1986) and the possibility of literal messages to be "read" on the seals representing levels of the administrative hierarchies (Dittmann 1986). Pittman has posited a consistent visual system according to which the ancients distinguished administrative levels and image "values" (Pittman 1994b).

The cross motif on late prehistoric stamp seals may also have functioned as a symbolic system or part of a symbolic system in light of the complex societies and administrative contexts in which these stamp seals functioned and in light of the parallel systems of communication that developed from the concept of sealing. This probability is especially compelling when one takes into account its relation to some of the complex token motifs and, in turn, the clear visual relation of those token motifs to early pictographs.

THE CROSS WITH CHEVRON-FILLED QUADRANTS

We focus here on seals displaying the equal-armed cross with chevron-filled quadrants (figs. 4.7–4.10). The cross provides the basic design structure for numerous variant motifs on late prehistoric seals (figs. 4.11–4.14). These will be of great interest in any further analysis of the questions we pose, even though we limit our analysis here to a restricted category.

If any subset of cross seals actually functioned as tools in a symbolic system, then one would expect that a certain regularity in the depiction of the design would have been essential to the efficacy of the system. Moreover, one

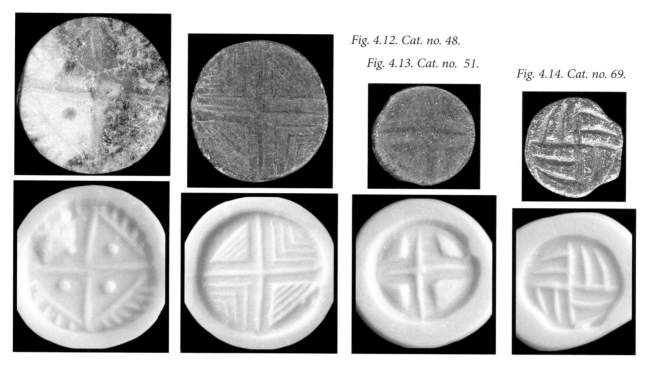

Fig. 4.12. Cat. no. 48.

Fig. 4.13. Cat. no. 51.

Fig. 4.14. Cat. no. 69.

Fig. 4.11. Cat. no. 47.

would expect that variations in the pattern would conform to their own pattern of predictability. An extended statistical analysis of several subsets of cross seal image types has lent validity to the hypothesis that these geometric motifs were constructed according to a prescribed syntax with limited and predictable variation (Rempel 1997). This analysis tabulated the number of chevrons per quadrant in the motif, the seal type and shape, the type of rock out of which the seal was made, site and dating information, and the orientation of the perforation hole in relation to the image on the seal.

The alignment-of-perforation-holes variable tested the possibility that the alignment determined the most natural angle at which the seal would have been held (on a thong or other device running through the perforation) as it was pressed into clay to produce an impression on a sealing. In that way, the perforation alignment would be a potential diagnostic on the intended "reading" of the sign thus produced within the administrative arena. To the extent that it was possible to study this factor, the consistency in alignment does suggest a regularized practice in the fabrication of these seals, regardless of whether it contributed to the reading values of the seals in a symbolic system. Limitations of available data left this and other elements of the analysis open, pending the ability to work with comparanda for the ex-Herzfeld corpus firsthand. Even comparisons of dimensions are impossible across the limited corpus without further work beyond publications. In carrying this analysis to the next level, it would also be interesting to interrogate the seals for variations in carving technique, use-wear patterns, and precise spatial micro-plottings of the carved patterns.

The motif of an equal-armed cross with quadrants filled by chevrons is numerically by far the largest variation on the basic cross pattern on late prehistoric stamp seals. Motifs based on the cross with filled quadrants are so dominant

among geometric motifs in northwestern Iran and the province of Luristan that Caldwell applied the term "Luristan cross" to the pattern (1976). It forms the largest of all groups of geometric designs on the stamp seals, and it is at the same time the one that has the most additional branches of variant image (e.g., crosses with quadrants filled by lined triangles or by dots). A body of evidence was compiled through searches, limited for the purposes of the 1997 exercise, in published material from Tepe Gawra (Speiser 1952; Tobler 1950), Tepe Giyan (Herzfeld 1933; Contenau and Ghirshman 1935), Susa (Amiet 1972; Herzfeld 1933), Farukhabad (Wright 1981), Tepe Sialk (Ghirshman 1938), Tepe Hissar (Schmidt 1937), Tepe Djafforabad (Amiet 1980), and Seh Gabi (Henrickson 1988), as well as unprovenanced seals from the Ashmolean Museum (Buchanan and Moorey 1984) and the Yale Babylonian Collection (Buchanan 1981). Other published seal collections with significant late prehistoric holdings could also be included in an expansion of the project: e.g., Gorelick (Noveck 1975); Schmitt—now in the Biblical Institute of Freiburg (Keel-Leu 1991); Wolfe Family (Amorai-Stark 1997); Erlenmeyer, now dispersed on the market (Christie's 1989).

Of thirty-seven seals grouped together from the limited search, it was possible to determine the hole orientation definitively for only ten. In seven of these ten verifiable instances the perforations were aligned with the quadrant (with the peaks of the chevrons in the quadrants). In the other three cases, the perforations were aligned with one of the crossed lines. This might mean that there was an aesthetic or communication preference for encouraging the seal user to impress the device so the cross read like an x rather than a +. But this interpretation should await the availability of more information.

Thirty-five of the thirty-seven seal faces in the research corpus are circular. That said, a variety of seal shapes and rock types are represented among the circular-faced seals bearing this motif. The two anomalies are both two-sided rectangular plaque seals: cat. nos. 73 and 55 (from Tepe Giyan and Tepe Gawra respectively). The example from Tepe Giyan displays a snake on the other side. Its cross form is an upright + formation clearly preferenced by the perforation holes and in relation to the design on the other side. The one from Gawra displays a dancing shaman on the other side. Here the cross is an x disposition, also clearly preferenced by the perforation hole and the relation to the design on the other side.

Most of the seals in the research group (thirty-one of the thirty-seven) had between one and three chevrons per quadrant. No seal had more than four chevrons per quadrant. Seventeen of the thirty-seven seals had the same number of chevrons in each of the four quadrants. In eleven of the thirty-seven seals there was either one quadrant with one extra chevron in it or one quadrant with one fewer chevrons in it. Seven of the thirty-seven seals had two quadrants with one number of chevrons and two quadrants with another number of chevrons. Only two of the thirty-seven seals displayed widely spread variations in the number of chevrons per quadrant (i.e., numbers of chevrons per quadrant varying between one and four on the same seal). Within the whole group, eight of the seals had extra additions, such as a dot or a line inserted into the chevron formations in at least one quadrant.

While this analysis does not prove that the cross seals were part of a symbolic system, it does present evidence for a high degree of uniformity and

for rather restricted codes of irregularity that form their own predictable pattern within the renderings of the motif. This view is reinforced when one examines other geometric motifs in the same research set. Other subsets also display similar proclivities toward regularity combined with very restricted and patterned irregularity. The patterns of regularity interspersed with controlled irregularity suggest a concern with legibility—where the display meant something and where small differences might signify specific nuances of that something. Notably, these cross designs are usually executed with great proficiency and care.

SIGNIFICANCE IN GEOMETRIC DEVICES?

The 1997 analysis summarized here was an heuristic exercise aimed at discovering whether patterns of regularity existed. No attempt was made to postulate specific meanings embedded in the imagery, although Root (this volume) contemplates some possibilities. Here we rest with some observations that open the door to that next step.

A widespread assumption for prehistory is that seals with geometric motifs indicated generic agencies at a low-status level of social activity. Figural motifs are generally assumed to have in some sense represented the identities and concerns of individuals or individual institutions of a high social stature. Furthermore, the idea that the geometric seals carried any specific notational or communicative meaning is rarely considered in modern scholarship. Such devices are frequently dismissed explicitly in the literature as meaningless decorative motifs.

It is important to remember, however, that some seals carried a geometric motif on one side and a figural motif on the other (cat. nos. 55 and 73). This may suggest that there were certain contexts in which cross seals were called for and certain contexts in which figural seals were appropriate. The same person or institution evidently had need to engage in both types of administrative exercises.

Both two-sided plaque seals with cross motifs in our exhibition (the only two in the research corpus of thirty-seven) show the same wear pattern. In each case, the perforation holes are abraded on the geometric side of the plaque while relatively pristine on the figural side. This suggests that these particular seals were used more to make impressions of the figural faces (leading to abrasion at the holes on the opposite side where the leather thong or other apparatus would grind away at the stone while the seal was being pressed into clay).

The quantitative prevalence of the cross motif alone suggests that it was not used on seals in order to stand for individual identity. This does not mean, however, that the geometric device was used only for low-status transactions or by low-status people/institutions. The high quality of carving seen on so many of the cross seals (e.g., fig. 4.7) is noteworthy in comparison to the sketchy carving displayed on some of the figural seals (e.g., fig. 4.15).

The question of whether the chevron-filled cross motif existed as part of a symbolic system in which the device was, in effect, a sign for something specific (be it a specific commodity, a specific office or type of person, or a specific type of place or processing or storage environment) requires further exploration. The information presented thus far argues that the image (a) was often of high

Fig. 4.15. Cat. no. 71.

production quality and carved carefully so as to clearly reproduce the precise details of the pattern; (b) was sometimes demonstrably associated with people or institutions who simultaneously had access to figural imagery; and (c) was so regular in its patterns of chevron count and subtle variations thereof that societal attunement to its nuances must have been an important aspect of its communicative function.

In sum, it was a device that on its own terms had conventionalized, and therefore interpretable, meaning. In the realm of administrative communication, conventionalized interpretability is a measure of success and efficacy. A "simple" geometric device effectively rendered is, in such a setting, a thing of high value—not an indicator of impoverished creativity.

It seems likely that the chevron-filled cross seals performed as part of a symbolic system of information storage. They take their place in a sphere in which elaborate systems of communication had developed numerous interactive mechanisms involving various tools for the production and conveyance of visualized records. Seals—perhaps even especially the nonfigural seals—were a major element in these information systems.

5
Systems of Symbolic Expression

Margaret Cool Root

SIGNS AND FLUIDITIES OF MEANING

A sign, we recall, is a visual device that stands for something else according to conventions recognized by the receiving community. A symbol is a visual device that may be a sign—but is also more than a sign. It is a device that expresses meanings beyond the simple identity of the something else stood for by a sign.

How do we decide when a sign is just a sign? When, for instance, the encircled + sign simply means "sheep" and when it is embraced by wider rings of attached meaning to become a symbol? When does a sign perhaps become a symbolic attribute of a specific deity or a stand-alone symbol of a large concept of belief that takes its place in a landscape of imagery to yield a discursive message? Here we are trying to recover the plausible intended receivership of the coding. Two rather mundane contemporary examples may illustrate the point.

CONTEMPORARY ANALOGIES FROM PARIS AND ANN ARBOR

In Paris, it seems that all the optical shops sport emblems (often done up in playful brightly colored neon light displays) that look pretty much like this: O-O (fig. 5.1). Usually the O-O sign flashes all by itself, without accompanying words, to advertise the optical shop to those near and far. In this setting, the O-O clearly and unmistakably operates as a sign standing for eyeglasses. While one could presumably derive metaphorical meanings from it—conjuring up the notion and blessedness of sight—this is a stretch beyond the straightforward intent here. What is important is that the sign is immediately and unmistakably recognizable (a) from a distance and (b) to just about anyone likely to be walking around in Paris—regardless of language or country of origin. This is a good example of an effective sign that knows its place and does not strive to reach the higher plateau of a symbol.

In Ann Arbor, the bright yellow "block M" seen on innumerable University of Michigan business communications and paraphernalia is, of course, a letter in our alphabet (fig. 4.2). As such it can be construed simply as the initial letter standing in for an entire word—a sign standing for the word Michigan. But to any Michigan resident it will be more than the first letter of a word. Its very particular formal characteristics give it a highly specialized meaning. Thus the letter has become a sign for a specific entity related to the State of Michigan: one of its universities. Even more particularly, by extension, it has also become a sign connoting the university's football team.

Fig. 5.1. Optical shops along the Boulevard Saint Michel, Paris.

Fig. 5.2. Camp Michigania coffee mug.

The block M on coffee cups produced for the university's family camp, Michigania, on Lake Walloon in northern Michigan also displays the bright yellow block M sign (fig. 5.2). Here it does double duty as the first letter of the word *Michigania* while also encoding that word with the gloss of wider block M associations. The block M sign adds something to the word beyond what would be conveyed by a simple letter M. Other signs add to a landscape of devices on the cup so that the entire display can be read as a coherent statement that might run something like this: Camp Michigania is part of the great University of Michigan. You, oh lucky owner of this cup, are a member of the Michigan(ia) family. Your family camp is a place of natural beauty. It is scented by pine forests (tree sign); it is endowed with a beautiful lake that glistens in the summer sun (water and sun signs); and, by emotive extension, it is replete with happy memories.

One lesson of the Michigania cup is that a visual sign in a representational system can be a sign device (such as a letter) in a writing system. But for a letter in a writing system to serve as a visual sign in a representational system, there must be something about it that makes it more than a mere letter. In this case, it is the specified formal qualities of the block M combined with its aura of placement that take it from letter to sign. Do the added connotations of the block M (evoking prowess on the football field, for instance) allow it to rise to the level of a symbol?

Perhaps it seems so when one moves around Ann Arbor on the day of a football game. But it would be more appropriate to say that the block M is a super-sign that displays some movement in the direction of a symbol but does not meet a standard of acquiring truly metaphorically charged elements of meaning.

Another lesson of the Michigania cup is that signs can be displayed in landscapes of representation that create a larger message than any one of the individual signs in isolation.

SIGNS AND SYMBOLS IN THE FIELD OF SEMIOTICS

Theoretical discourse on semiotics, on sign systems and symbolic thought, is complex and often contentious in its disciplinary claims. Its literature is extraordinarily vast, and it is spread across a range of academic turf, from linguistics to psychology to neurology and cognition to communications to art history to ethnography (e.g., Firth 1975; Foster and Brandes 1980; Hodder 1982; Bal and Bryson 1991; Manovich 1991; Kress and Leeuwen 1996; Potts 2003). For our purposes it is best to stay grounded in the empirical data itself rather than to use our material from late prehistory as a means of advancing any one specific analytical strategy and concomitant specialized jargon. That said, we hope that the visual record we engage with here will be provocative to those working within these debates.

Modes of discussion of signs are tied closely to the vocabulary used to discuss language—that is, *written* language. Furthermore, a correlate of semiotics is word-image theory (Schapiro 1973; Mitchell 2003). Thus, it may seem anachronistic even to consider the semiotics of a culture that existed before writing existed—before the advent of systematically imposed conventions of signs that were indexed, codified, and coordinated by behavioral rules of a written language. Yet the interpretation of the visual in art historical practice is inextricably linked to verbalizations that make use of linguistic metaphors in order to explain visual phenomena. It seems impossible to address issues of meaning for our material without stepping into this agitated arena. As Mitchell notes,

> If art history is the art of speaking for and about images, then it is clearly the art of negotiating the difficult, contested border between words and images, of speaking for and about that which is "voiceless," representing that which cannot represent itself. The task may seem hopelessly contradictory: if, on the one hand, art history turns the image into a verbal message . . . , the image disappears from sight. If, on the other hand, art history refuses language, or reduces language . . . , the image remains mute and inarticulate, and the art historian is reduced to the repetition of clichés about the ineffability and untranslatability of the visual. (Mitchell 2003: 60)

Paradoxically, the very language we use as archaeologists and art historians aggressively to assert the importance of the material and nonverbal visual record is fraught. We speak of context, of contextualization. These words

etymologically depend upon the notion of a text—a basis of information that is grounded in something written. We understand these days on some level that the etymology does not limit our deployment of such terms as they suit us. Yet in a certain way archaeology and art history do remain very tied to notions of "cultural text" and to "con-text" as that which can truly exist only once writing has been invented—or at the very least is in a clearly established proto stage of invention. Along similar lines, there has been a strong tendency in Old World archaeology and anthropology to draw boundaries of periodization and thinking about periodization that stress writing and urbanism as the criteria of "civilization" (Abdi 2003b). So we are moving in uncertain territory when we attempt to push interest in the systematic communicative intent of Near Eastern signs and symbols well back into late prehistory—before the protoliterate/proto-urban period on the very brink of writing. There are critical differences of scene between the late prehistoric phases of the Ubaid–Middle Uruk periods and the protoliterate/proto-urban phase of the Late Uruk in Mesopotamia and neighboring Iran. Yet with all those differences, there are compelling continuities and links as well. It is possible to consider the signs and symbols of late prehistory (of the late *pre*literate) as part of a tissue of connectivity, with the phenomenon of signage as a *proto*literate communication system. The latter has been engagingly discussed by Pittman (1994b: 21–27), with some attention to the possibilities of pushing the inquiry back into late prehistory (Pittman 1997: 133–134). This is our project here.

Some of the signs we identify in the body of late prehistoric art assembled in *This Fertile Land* seem to reside quite comfortably in the realm of the sign. But many of them tempt us to consider their fluidity, their capacity to vibrate back and forth across the line between a sign and a symbol.

THE EQUAL-ARMED CROSS

The cross sign (+) is a good example of this capacity for fluidity. It is a widespread sign on our seals and painted pottery. On the seals it occurs with multiple but clearly defined subgroups (chapter 4 this volume). On the painted pottery it is deployed in a variety of strong placements as a pivotal feature of the programs on the vessels.

We recall that in the complex tokens and also in early pictographic writing the encircled + sign meant "sheep." The + sign with a chevron added to one of its quadrants stood specifically for "female sheep." It is worth considering the possibility that the explicit sign meaning embedded in the +-incised complex tokens and the related early pictographs echoes or works off earlier imagery systems used on seals and then on decorative programs of painted ceramics.

Positing for experimental purposes a plausible relation of the equal-armed cross of late prehistoric art to the complex token system and the pictographic signs does not need to embroil us in controversies over the "origin of writing." Our interest here is in the ways visual devices could and surely did work as communicative media. Given the overwhelming evidence of continuities in the meaning and social relevance of some signs and symbols of late prehistory

on into much later historic times, it seems unnecessarily cautious to disclaim the influence they must have had on the mentalities and repertoires of association leading to the configuration of writing schemes in the region. The capacity of the people to work with visual signs as meaning-laden (if fluid) devices in late prehistory certainly positioned them ultimately to see and to act upon the practical urgency of the invention of writing. When the time came, these people had prepared themselves well through a legacy of encoded visual expression that we explore in *This Fertile Land*.

The + sign is complicated. It does not look at all like a sheep—whether it is on a complex token, a tablet, or a ceramic vessel. It thus may best conform to the type of sign that was called a symbol sign by the semiotician C. S. Peirce in his division of signs into three categories (Peirce 1991; Kippenberg 1990: vii–xix). In this scheme, a symbol sign represents something not through any physical resemblance to it (as does an icon sign) and not even through physical association or causal connection with it (as does an index sign). Rather, a symbol sign in Peirce's conceptualization is a sign that represents something only through the force and efficacy of a conventionalized understanding of its intent.

There may, however, be ways in which the sign for sheep actually crosses the definitional boundary erected by Peirce between a symbol sign and an index sign. When we ponder why an equal-armed cross would ever have stood for a sheep—or, indeed, for any animal—we come up with some possible scenarios. They reveal themselves for our consideration along a metaphorical horizon.

The widespread meaning of two intersecting lines as a representation that establishes a fixed point can hardly be disputed. This in turn leads to the idea of a fixed place, a fixed social space: a crossroads, a meeting place, a village, a city. In ancient Egypt, for instance, the hieroglyphic sign for city was the encircled equal-armed cross.

A fixed place in the modalities of late prehistory may have suggested wider associations that could conjoin with notions of the sheep. Such associations of marked place might include the concept of a protected spot where herded livestock were assembled for counting and sheering; where their sheered wool was allocated or stored. From there, "fixed place" might become coequal with the thing assembled for commodification in that place—the sheep. Further out in the concentric rings of metaphorical accretion, the original sign could acquire even broader meaning as a symbol for related abstractions: wealth, prosperity, and abundance.

In some manifestations, the cross sign in our particular environment of late prehistory may have come to symbolize a very specialized kind of place—a ritual place. It has been suggested that the nested (outlined) cross device that we see on some of our seals and pots is connected in some way with early monumental religious architecture—specifically the central platform at Susa, which had a stepped-in plan (Hole 1983; Wright 1994; chapter 7 this volume) (figs. 5.3–5.5). This would be an interesting hypothesis to test through a systematic examination of all nested cross images to see whether patterns of specialness emerge in any way (e.g., specialness in programmatic association on the pots; specialness of materials or other indices for seals).

The later history particularly of the nested cross (and a variant, the "Maltese" cross, with flaring arms) is interesting here in relation to the idea of

Fig. 5.3. Cat. no. 106.

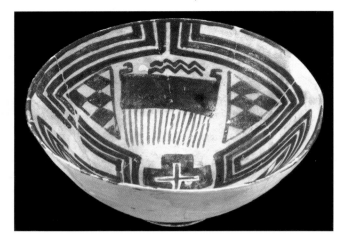

Fig. 5.4. Cat. no. 107.

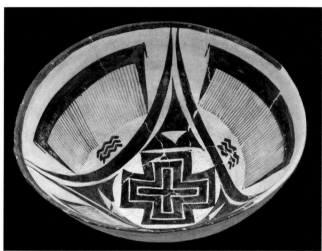

Fig. 5.5. Cat. no. 53.

early association at Susa with "ritual place." Erika Ehrenberg (2002) has offered an important study of this form of cross in Kassite Babylonian art of the 2nd millennium BCE. She has assembled evidence for the association of the cross at this time with the supreme Babylonian god, Marduk. In the process, her work has emphasized the importance of the image to Iranian tradition. In this tradition, the nested or Maltese cross was "an archetypal symbol . . . primeval and of requisite salience to serve as the sole motif of some Susa I pottery" (Ehrenberg 2002: 65). She has not probed possible specific meanings of the cross in any sense, acknowledging that its meaning remains "abstruse to modern scholarship." But she has suggested that the device came to be considered a generic symbol of divinity. She has also suggested that despite ruptures in culture and politics, the cross motif maintained a particular hold in the visual landscape of Iran—beginning in late prehistory and pushing through with renewed energy into much later times.

Although demurring on underlying referential meanings of the sign, Ehrenberg has reinforced the deep and pervasive significance of the cross in Iranian contexts through her thesis explaining how it came to be deployed in Kassite Babylonia. The Kassites had extensive dealings in war and diplomacy with

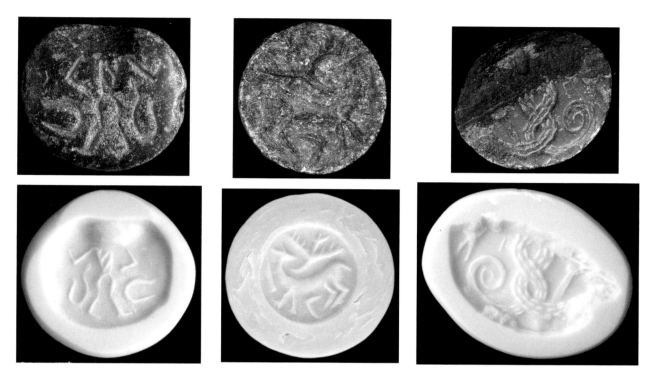

Fig. 5.6. Cat. no. 31. Fig. 5.8. Cat. no. 81. Fig. 5.9. Cat. no. 72.

Fig. 5.7. Cat. no. 44.

their contemporaries to the east who were now centered in Susa—the Elamites. Ehrenberg has made a strong case that the Kassites appropriated the nested and/ or "Maltese" cross (as a sign of divinity) from the Susian Elamites. She posits that the Babylonians attached it in a calculated manner to their supreme god, Marduk (whose traditional symbol was the spade). This cultural appropriation had clear political overtones. It specifically advertised the capacities of the supreme deity of one state (Marduk of Babylon in this case) to accrue unto himself the force of an insignium of great cultural meaning from a rival region.

CHEVRONS AND NOTCHES, ARROWS, SPADES, AND DOTS

The isolated chevron or notch is a frequent element on the late prehistoric seals. Occasionally multiples will fill the field; more commonly they are arrayed around a dominant central element, such as a shaman figure, a snake or other animal, or a displayed female (chapter 8 this volume) (figs. 5.6–5.9). There are some indications that the isolated chevron or notchlike device might have expressed some meaning related to femaleness or allied metaphorical notions. Consider the single chevron used adjectivally in one quadrant of the complex token to change the meaning of "sheep" to the meaning of "female sheep." In later signage the closely related form of an equilateral triangle (with one short interior line extending from the top angle to suggest the vulva) stood for "woman." The chevron or notch of late prehistory may already have worked as an icon-sign, suggesting the pubic triangle of the human female and from there conveying allusions to

54

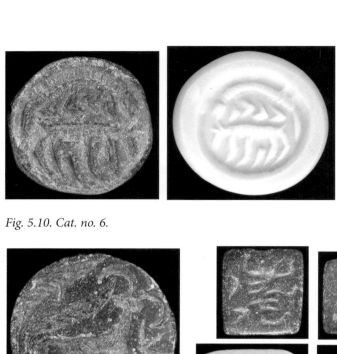

Fig. 5.10. Cat. no. 6.

Fig. 5.11. Cat. no. 89B a and b.

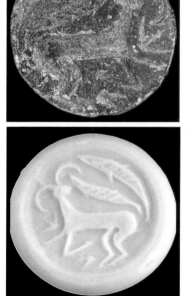

Fig. 5.12. Cat. no. 82.

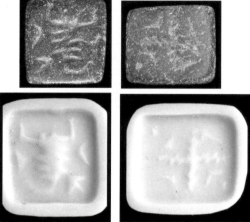

Fig. 5.13. Cat. no. 94 a and b.

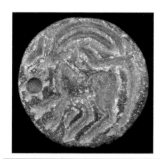

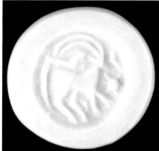

Fig. 5.15. Detail of cat. no. 112.

Fig. 5.14. Cat. no. 85.

Fig. 5.16. Cat. no. 102.

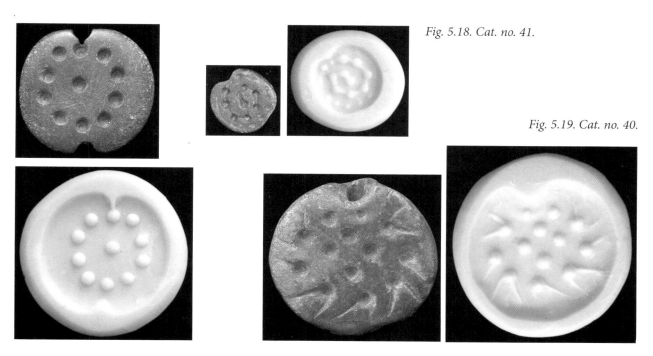

Fig. 5.18. Cat. no. 41.

Fig. 5.19. Cat. no. 40.

Fig. 5.17. Cat. no. 39.

the metaphorical female element in the project of maintaining the abundance and fertility of the land and its animals (figs. 5.10–5.11).

Similarly, devices that resemble arrows may be understood as icon-signs alluding to the male sex organ. In this they may be echoed in the cuneiform sign for "man" (Klengel-Brandt 1997: 40–41 for relevant sign lists). As with the chevron or notch, the arrow would then be an icon sign with clear potential to move along a metaphorical track. Associations here might also relate to fertility of the land. Indeed, the arrow and the notch appear sometimes in the same composition as if in programmatic dialogue with each other (fig. 5.12). The two-sided seal (cat. no. 94) showing a scorpion, arrow, and notch on one side and a cross with notch-filled quadrants on the other (fig. 5.13) is interesting as an artifact that compounds associations (chapter 8 this volume).

The arrow carries multiple associations with elements connoting fertility and prosperity. Snakes are often rendered with arrow-shaped heads so that the arrow and the snake acquire a shared presence (figs. 5.11 and 5.15). In turn, the arrow (as male organ) and the snake both relate to an image seen on a number of Susa pots, where the motif appears in a conventionalized format as a triangular element atop a shaft (figs. 5.14 and 5.16). This motif is generally seen as a prefiguring of the Mesopotamian symbol of the spade of Marduk. As an agricultural deity, Marduk's spade symbolized the earth and its cultivation. By extension, it referred to the snake who inhabits the earth and tills its soil through its underground navigations. By further extension the snake and the spade might allude to notions of life cycles, since the snake has many properties in nature that associate it with mythologies of death and rebirth, of going underground and resurfacing (Van Buren 1935–1936; 1936; 1939; Mundkur 1983; Root 2002).

Plain dots (deep hemispherical drillings into the seal face) are a fairly common sign on our seals. Sometimes they are arranged to form rings, coils, or other patterns (figs. 5.17–5.19). On certain other seals they appear as isolated

56

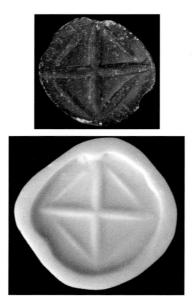

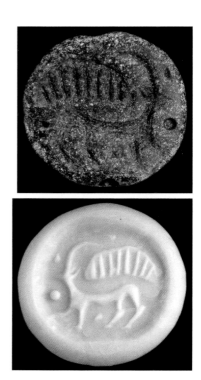

Fig. 5.20. Cat. no. 47.　　　*Fig. 5.21. Cat. no. 50.*　　　*Fig. 5.22. Cat. no. 83.*

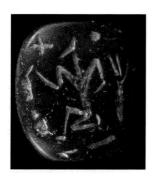

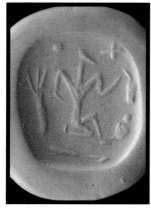

Fig. 5.23. Cat. no. 43.

signs very specifically disposed in the field. The fact that we have squared off cross seals from Tepe Giyan both with dotted quadrants and with empty quadrants raises a question of the possible additive nature of some seal devices (figs. 5.20 and 5.21). Is it possible that some seals were made as basic schema in their motif type, specifically with the potential to have certain kinds of signs added to them in due course? We see the same possibility of additive signage inherent in animal seals (fig. 5.22).

The dot motif recalls the numerical sign for "ten" in the form of an impressed hemisphere used on clay envelopes and tablets in early information storage systems (chapter 4 this volume). Once again it is plausible that we are seeing here in late prehistory a sign used as a seal tool for a form of numerical notation. A seal such as cat. no. 39 (with its eleven carefully placed dots) might conceivably signify that its owner controlled a herd of 110 sheep. Or a seal with many dots might signify something more abstract but still related to the concept of numerical notation: It might have symbolic meaning as a statement of a more generalized notion of quantity—of management or ownership of large amounts of property.

In some cases, dots are carefully placed within the field on a figural seal and suggest some particular meaning in relation to that larger figural scene. One interesting example is the seal from Tepe Gawra, where a shaman is framed by a cross and a dot on either side of his head (fig. 5.23). The best example is, however, is a seal from Tepe Giyan (fig. 5.24). Here two large dots frame the face of an ibex-headed shaman with upraised arms, who dances among snakes (chapter 6 this volume). An allusion to the bezoar stone secreted by the ibex and used as an antidote to snake poisoning is certainly possible (Porada 1990; Root 2002).

Fig. 5.24. Cat. no. 30.

It is also possible that the two dots signify celestial orbs, perhaps the pairing of solar and lunar discs.

SUN, CULTIVATED EARTH, AND BOUNTIFUL FLEECE

There are such articulated renderings of solar symbols in this glyptic repertoire that the use of a plain dot for the sun may seem less likely (figs. 5.25–5.27). It is certainly true, however, that in later times in the Near East, dots configured on seals symbolize the stars—specifically the seven stars of the Pleiades (Black and Green 1992: 162). The dot as a star may reach back into our prehistoric arena, although we have no compelling data at this point to make a case for a persistent deployment of specific numbers of dots at this early stage. At any rate, there is no seal with a cluster of seven dots in our corpus.

Other signs used in the communication systems of protoliterate times may possibly inform the signage of slightly earlier prehistory. The complex token in the shape of a circle, engraved with a series of straight parallel lines, stood for wool or a type of garment/cloth (Schmandt-Besserat 1996a: 71–80). This parallel-line device suggests a relationship with the long-haired sheep we see in schematic animal form on so many of the painted vessels from Susa (e.g., figs. 5.3 and 5.4). The motif is often called a "comb animal" on the pottery because the form resembles a comb with long teeth. The pendent parallel strands of wool hanging from these schematically rendered sheep may have been distilled into isolated parallel lines on the later incised tokens.

A complex token incised with a waffle pattern of multiple parallel lines intersecting other parallel lines at right angles stood for wool or fleece; it maintained that connotation as an element of pictographic script. We can appreciate the potential for such waffle patterns to have stretched to connote wool—carded wool that could be woven into a fabric (fig. 5.28).

Fig. 5.28. Cat. no. 60.

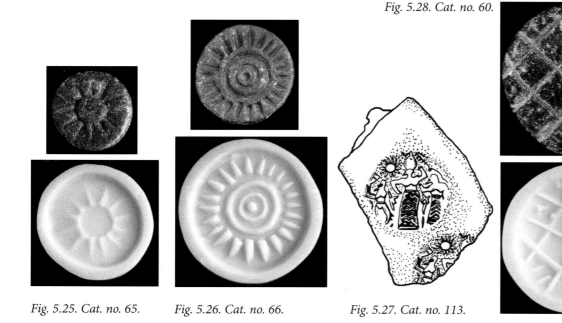

Fig. 5.25. Cat. no. 65. *Fig. 5.26. Cat. no. 66.* *Fig. 5.27. Cat. no. 113.*

58

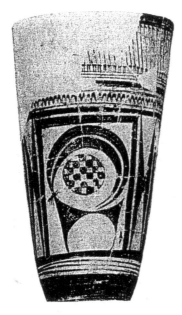

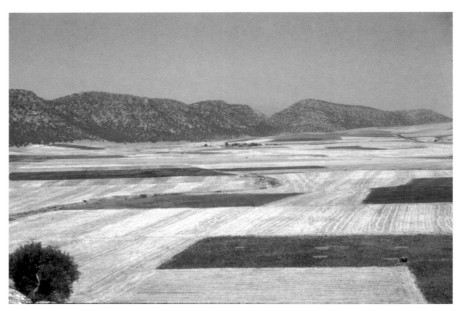

Fig. 5.29. Beaker from Susa with checkerboard emblem. After *Corpus Vasorum Antiquorum 1925: pl. 1.5.*

Fig. 5.30. Cat. no. 120.

The waffle patterns on seals may, alternatively, relate to the checkerboard patterns seen on many Susa pots (fig. 5.29). Here the motif may have signified notions of cultivated, controlled, and parceled land (fig. 5.30). Such an interpretation would also more broadly have signified human control over the land and its wealth: appropriate messages for the high ritual content of vessels destined for use in funerary contexts.

WATER SIGNS AND THE SYMBOLIC TURN

Unlike the + sign for sheep, many signs we can track in the late prehistoric Near East have demonstrably widespread if not universal human meaning value because they are based on visible and unambiguous phenomena of nature. Thus, for instance, a series of stacked zigzags or wavy lines stands for water in many cultures, ancient as well as modern; it has a direct formal relation to flowing water. This motif is a sign insofar as it simply says "water." But it also has the capacity to act as a symbol of far-reaching meaning. In the ancient Near East (including Egypt) fresh water was a precious commodity that enabled the land to yield abundance, the society to be prosperous, and the ruler to fulfill his obligations as a steward of that land (Black and Green 1992: 75, 184; Wilkinson 1994: 159–161). The Mesopotamian god Enki (Ea) was, for instance, worshiped in his capacities as provider of fresh waters and hence as a creator god and a purveyor of wisdom, magic, and (by extension) civilization itself. In the contemporaneous Elamite civilization in southwestern Iran, metaphorically charged divine agency was similarly vested in fresh water through the medium of the great god Napirisha (Miroschedji 1981; Benoit 1992).

Thus, the sign for water in this environment acquired deeper metaphorical meanings, moving it beyond the simple statement "this is water." The "water

Fig. 5.31. Cat. no. 58 a and b.

Fig. 5.32. Cat. no. 56.

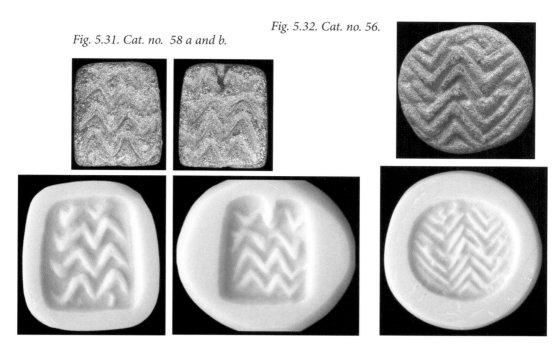

sign" (seen after the prehistoric period rendered in the form of a stream of flow-ing water) became in Mesopotamia a symbolic attribute of Enki—an element that described Enki's force field. The sign could also stand as a symbol for the idea of "life-giving force" or some similar metaphorically charged expression.

In the late prehistoric art of Iran, stacked chevrons or zigzags occur oc-casionally as main design elements on seals. Here the signs seem at once watery and snaky or insectlike (figs. 5.31 and 5.32). On the pottery, water emblems fre-quently occupy positions similar to those otherwise occupied by two different motifs: checkerboard emblems and leaf or branch patterns (compare figs. 5.29 and 5.33 with fig. 5.34). While the checkerboard may have signified cultivated,

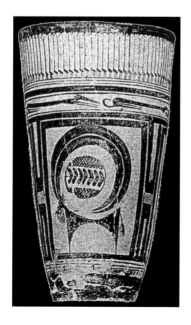

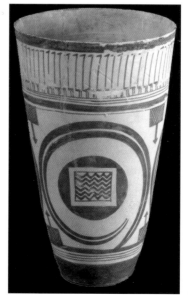

Fig. 5.33. Cat. no. 110.

Fig. 5.34. Cat. no. 104.

Fig. 5.35. Cat. no. 124 and drawing adapted from Amiet 1992: fig. 10.

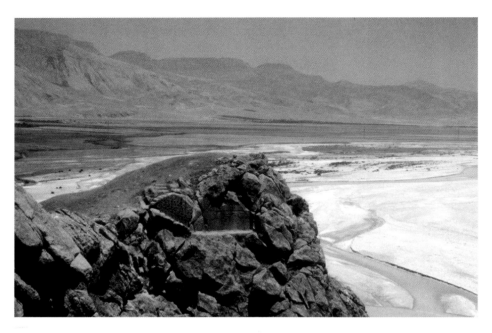

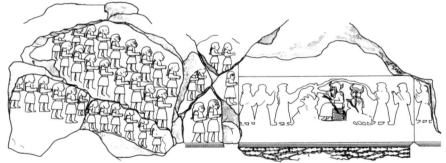

well-watered land, the leaf/stalk of grain surely signified the product of this tilled and watered land. Similarly, the skirts of stacked zigzags worn by two figures enacting a ritual on a seal known through impressions from Susa (see fig. 5.27) presage the use of skirts worn by divinities in later times to associate them with particular realms of earth—specifically with waters and with mountains.

Varied uses of the water sign strongly urge us to understand that it projected metaphorical meanings related to those attached to flowing water in historical periods. Note, for instance, a Middle Elamite rock relief dating 2,000 years after the late prehistoric era and situated near the site of Tal-i Bakun. Here the Elamite deity Napirisha holds forth ever-flowing waters toward human worshipers, while a river filled with abundant fish is rendered below. An actual river runs through the landscape of the plain from which the rocky outcrop rises up (fig. 5.35).

THE CROSS AGAIN: IN A MULTI-SIGN LANDSCAPE

The equal-armed crosses of late prehistory are frequently placed at the center of open bowls from the Susa cemetery, anchoring visual programs that often

Fig. 5.36. Cat. no. 108.

Fig. 5.37. Cat. no. 3.

include schematic renderings of the primordial long-haired wild sheep along with various additional elements suggesting habitat and animal life. The typical central positioning reinforces the indexical and symbolic aspects of the + sign. It also serves to enhance the meaning prestige of the device through association with the visual elements that complement it and seem to spin a communication off its centeredness. When the + sign is not at the center of a Susa bowl, it projects a medallionlike force in its placement around the interior walls of other bowls or within the program of exterior decoration on tall beakers. So too in the pottery of Bakun and Farukhabad, the + device has a strong presence as a medallion (figs. 5.36 and 5.37). In all of these placements it implies a declarative statement.

We have already commented extensively on possible meanings of the cross. The idea that it may stand for ideas of accumulated wealth and well-being fits within the programmatic context of the vessel landscapes. It also fits within the ritual functional environment of the ceramics. Used on the painted pottery, the emblematic cross serves a particular communicative need. The cross is also occasionally seen on seals as a small device in the field of a figural image. In such contexts, it might have performed similarly to a symbolic function on ceramics as a signifier of wealth and prosperity. This would imply a talismanic agency on the seals in question. By the same token, the placement of the cross on these figural seals might connote that generalized notion of divine sphere, of association with "ritual place," discussed above specifically for the nested cross and the Maltese cross. Two particularly interesting examples of the cross on figural seals come from Tepe Gawra. One, discussed earlier, pairs a cross with a dot as signs framing the shaman (fig. 5.23). On the other, a shaman and ibex prance with two crosses in the field (fig. 5.38).

The use of the cross in such scenic contexts on pots and seals may, in other words, resonate with metaphorical meanings that depend for interpretation upon a particular representational/functional context and a particular "readership." The cross motif deployed as a self-sustaining seal image may, in contrast, have served communicative needs as an administrative tool that were used and received quite differently (chapters 3 and 4 this volume).

Exclusive and Inclusive Signs

Some signs are meant to function as broad communication currency in the society in which they operate. Others may be meant to address subsets of a population—to include some people and to exclude others. Our humble contemporary analogies can be useful once more (see figs. 5.1 and 5.2). The Michigania cup deploys signs in an agenda of exclusivity. It deliberately appeals in code to those who will immediately recognize that the block M sign ties Michigania unequivocally to the University of Michigan. In its exclusivity there is an added layer of message—in this case a message about belonging. The O-O sign in Paris works differently. It is deliberately meant to stand alone and to address everyone inclusively.

The cross placed within representational programs on late prehistoric pottery and seals works like the block M on the Michigania cup regarding exclusivity. It suggests an aura of status and belonging in an environment where this pottery may have operated on one level to express notions of wealth and prosperity in an increasingly hierarchical society in which the capacity to commodify

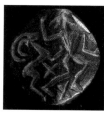

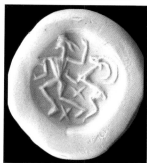

Fig. 5.38. Cat. no. 37.

large herds and tracts of land was an important element. The imagery programs on the pottery and on some representational seals served internally to validate societal concerns and positions. They were intended to address social insiders in a discourse of undoubtedly systematized meaning. Attempts to interpret the pottery in this way have served to open up the material for interesting contemplation, although there is hardly consensus on their validity (Pollock 1983; Brown 2000: 38–40). There is much more to be done.

The cross as the single self-sustaining motif on seals seems, rather, to speak to a wide-ranging audience and to be effective precisely by virtue of its universality of conventionalized signification. In this way it is more like the O-O sign in Paris than the block M in Ann Arbor.

IBEX RISING: ANIMALS IN NATURE AND COSMOS

Animals feature prominently in the early arts of Iran and Iraq. In Iran, the ibex seems to be everywhere. It appears on rocky cliffs at dawn, horns arcing in silhouette against the pale morning light. Thus, the ibex is often associated with ideas of rebirth and the new day. The mountain goat and also the wild sheep had been domesticated in the region around Chogha Gavaneh in the northwest already in the remote past of about 12,000–11,000 BCE (Zeder and Hesse 2000; Abdi 2003a: 408–409).

By the middle Chalcolithic, the tending of very large herds of domesticated and somewhat biologically altered sheep and goats was a mainstay of prosperity and accumulated wealth. Even after these creatures had been fully domesticated for many thousands of years, wild members of their species continued to exist—but at the edges of human-orchestrated nature. The ibexes we see on seals and painted pottery evoke these wild beings with their extraordinary horns, these ancestors from a now primordial past. They are, in essence, mythological creatures. Thus the simple ibex on the seal from Chogha Gavaneh acquires status as a symbol (fig. 5.39). It is more than a naïve rendering of an animal. So too all the images of ibexes on the seals and painted pottery in *This Fertile Land*. A seal known through impressions found on sealings at Tepe Gawra places a small human figure (a shaman?) amidst a sea of large ibexes, a snake, and a fish (fig.

Fig. 5.39. Cat. no. 1.

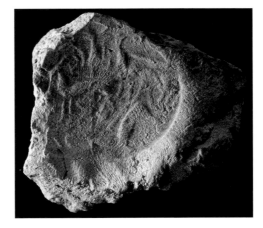
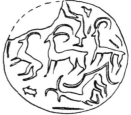

Fig. 5.40. Cat. no. 88E.

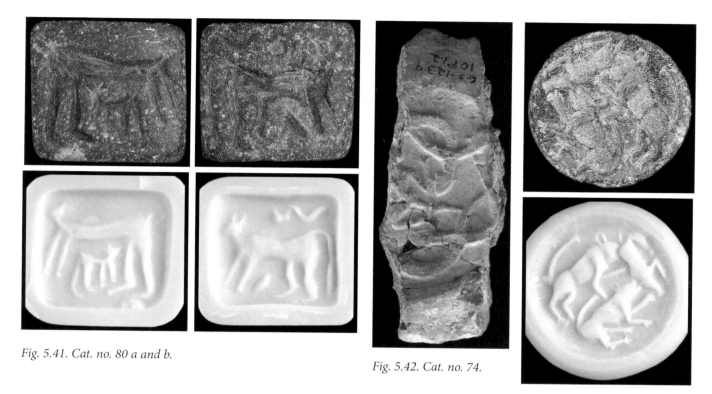

Fig. 5.41. Cat. no. 80 a and b.

Fig. 5.42. Cat. no. 74.

Fig. 5.43. Cat. no. 84.

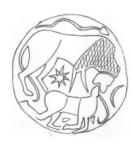

Fig. 5.44. Cat. no. 89A.

5.40). The human/shaman seems to be dancing in this animal domain with his arms upraised.

The sheep on the pottery are different. With their long hanging coats, they suggest the biological alteration effected by breeding strategies intended to yield wool (Davis 1987: 156). The sheep seem to state the importance of economic prosperity in the midst of a mythological landscape.

These animals exist along with wild creatures, such as boars, lions, snakes, and scorpions. We see the snake most often on seals in contexts that suggest its positive—even talismanic—aspects. It may writhe in the company of shamans (cat. nos. 30, 31, 32, 33, 36, 43; chapter 6 this volume). Or it may hover over or near an animal in a presentation that suggests a stable natural world—not a landscape of turmoil and threat (cat. nos. 5, 6, 71, 75, 85). A scene depicting two humans coupling also includes the snake hovering above as an apparently symbolic agent and overseeing presence (cat. no. 98; chapter 8 this volume). A two-sided seal shows an animal with the snake above on one side and an animal with suckling calf on the other. This suggests cause and effect in the realm of fertility (fig. 5.41).

Occasionally, however, the snake does appear poised to strike an animal (e.g., fig. 5.9) or a human (fig. 5.42). And occasionally as well we see scenes that describe predation in the animal world—prefiguring the animal contest imagery that becomes extremely common throughout the history of ancient Eastern art (fig. 5.43). One such scene (fig. 5.44) combines the symbolic oversight of the snake with the mauling of an ibex by a lion.

Many of the seals display quadrupeds in fairly complex settings suggestive of the natural world. Sometimes, if not necessarily always, these scenes suggest symbolically charged catalogues of notional realms of nature—rather than mere depictions of what there is to see in nature. We seem to be dealing with a creative environment in which art is reflecting upon the interactive realms of earth, water, sky; reflecting upon ecological systems. On the seals images of ibexes and birds or ibexes and leafy forms abound (cat. nos. 81, 82, 83, 87). They are related to the imagery on some of the most stunning vessels from the Susa cemetery, where there can be little doubt that the presentations are symbolically allusive (Hole 1992).

Innumerable questions of course remain open. Was a solar emblem in our area of inquiry a symbol for cosmic forces? A symbol evocative of ranges of metaphorical association? An entity we can link up with many later traditions in world cultures that demonstrate the possibilities encoded in circle- and torque-based devices (Perrot 1980)? Or was it an icon sign for "sun" pure and simple? The disciplinary sphere of cultural astronomy provides a useful backdrop for considering interfaces of animals, earth, and starry sky in symbolic thought systems in various cultures that can be observed ethnographically today (Ruggles and Saunders 1993: 1–31).

Were some of the images we have looked at here used as tools to help the human spirit transcend the mundane? Several devices in our repertoire that we have contemplated as signs and symbols bear marked similarities to devices that in some cultures are known to be used as trance-inducing visual phenomena. Nested chevrons, checkerboards, nested curves, dots, spirals, and torquing patterns are prominent examples. Perhaps we should consider the possibility that some of the imagery of late prehistoric Iran and Iraq either affectively facilitated or descriptively alluded to the transcendent agency of the hallucinatory (or at least spiritualized) state (Pearson 2002).

Such an idea does not negate meaning valences of signs and symbols. But it does raise an interesting issue about how seals and pottery may have been held, handled, and used in a tactile sense that integrated legibility and performance. Were the open bowls meant to be looked into, spun, experienced kinetically? Likewise were seals, in some settings, meditated upon, twirled, or spun? We are, after all, in the realm of the shaman.

6
Shamans, Seals, and Magic

Andrew Wilburn

SEEKING THE SHAMAN

Wonderworking, warding off dangers both real and superstitiously perceived, healing and midwifery, pacifying or appeasing the forces of nature and cosmos: all these things in late prehistory involved engagement with powers beyond the scope of ordinary humanity. In the late prehistoric Near East, seal images proliferated showing male figures (almost always clearly wearing some type of animal head-dress) performing pivotal roles in relation to a surrounding natural world and/or in the enactment of ritual activity (fig. 6.1). These artifacts are the primary testimony available for the contemplation of intertwined aspects of magical, scientific/medical, and religious thought before the availability of the written word. An intriguing aspect of this situation is that representations of the distinctive animal-headed figure disappear from the record with the advent of protoliterate and later times.

Seals from Susa, Tepe Giyan, and Tepe Gawra share a very similar vision of this exceptional individual despite variations in style and composition. We call this figure a shaman, meaning to suggest an individual who held special powers within his community relating to efficacious magic, healing, and negotiations with higher realms. But the term *shaman* demands interpretation—as does the notion of magic itself. We shall proceed here to survey representations of this figure on the seals of late prehistory and then to place the figure within a plausible interpretive framework in relation to a broad range of scholarship on magic, healing, religion, and shamanistic practices.

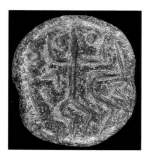

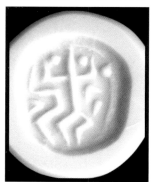

Fig. 6.1. Cat. no. 30.

WHAT THE SEALS RECORD

A male figure with the head of an ibex dominates the visual field—perhaps grasping a snake in each hand, perhaps prancing with an ibex—projecting out from the face of a stamp seal made 6,000 years ago. Who and what does this figure represent? Is he a mortal being of special training and power who dons an ibex-head mask for ritual performances? Is he a god who exists in an ancient spiritual universe as an ibex-headed man? Or is he a mortal man who is depicted as in a state of trance-induced transformation into an ibex-headed creature?

In *This Fertile Land* alone, fifteen seals (as seal artifacts or as seals preserved through impressions on sealings) directly and explicitly reflect on the idea of the shaman (cat. nos. 30, 31, 32, 33, 34, 35, 36, 89B, 101B [Tepe Giyan]; 37, 38, 43, 44, 55, 88 [Tepe Gawra]), along with didactic visuals of three others (cat. nos. 113, 114, 115 [Susa]). Many other seals brought together for the exhibition bear upon the issue even though they do not literally include a representation of the shaman.

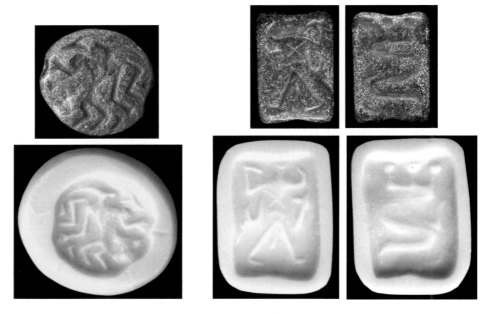

Fig. 6.2. Cat. no. 32. Fig. 6.3. Cat. no. 33 a and b.

SIGNS OF THE SHAMAN

On most of the shaman seals, the focal figure displays ibex horns and a pointed snout (fig. 6.2), although occasionally the form of the head is somewhat ambiguous or is simply not preserved (fig. 6.3). There is nothing to suggest a female form in any of these images. And in some, the male sex is explicitly indicated by the phallus as well as by the general sense of the lean bodily affect (figs. 6.3 and 6.4).

Our shaman often seems to dance—either sedately or with abandon. Even when his legs do not bend or lift off the ground, his arms project an assertive vitality. He may be rendered reductively as little more than a stick figure (fig. 6.5) or with a great deal of naturalistic vigor (fig. 6.6). But whatever the stylistic behavior of the representation, the emotive message invokes notions of energy and dynamism.

Typically the shaman appears in the company of animals. The snake and the horned quadruped (often clearly an ibex) are by far the most prevalent companions. The shaman frequently grapples with snakes or poses flanked by their writhing forms as he projects his essence in their midst. Sometimes the snakes look fairly naturalistic, and other times they are little more than squiggles or S-curves. In this aspect the shaman is the precursor of the master of animals, who appears in images of heroic encounter as a mainstay of ancient Near Eastern art and mythologized notions of the balance of natural forces throughout the millennia and across an extraordinary array of political-cultural vicissitudes (Garrison and Root 2001). These images seem to imply a power relationship in which the shaman has gained control or has achieved a harmonious and beneficial equilibrium.

The scenes associating the shaman with the ibex (or in some cases an

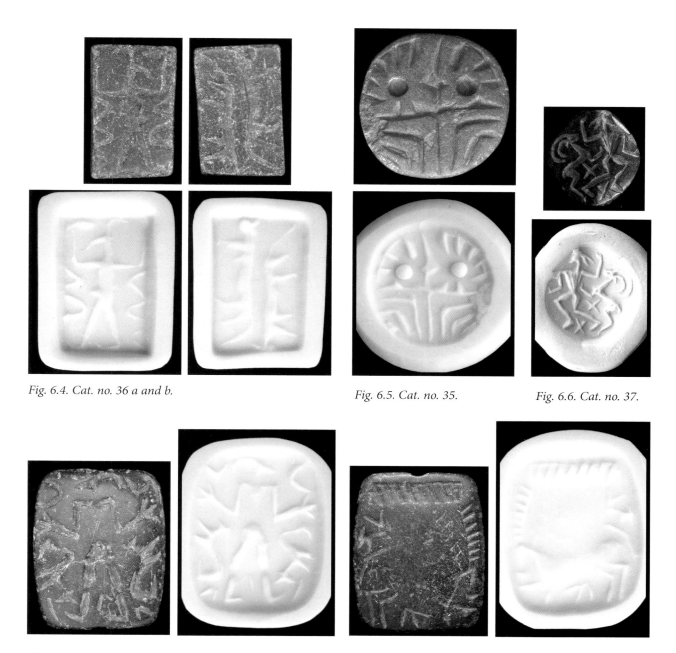

Fig. 6.4. Cat. no. 36 a and b.

Fig. 6.5. Cat. no. 35.

Fig. 6.6. Cat. no. 37.

Fig. 6.7. Cat. no. 34 a and b.

indeterminate quadruped) suggest a different valence. Here the ibex (or generically rendered quadruped) seems complicit in the energies of the shaman, reinforcing the sense of complicity achieved through the shaman's physical conflation with this animal. There are no scenes explicitly displaying the shaman in a dynamic mastery position over the ibex. On one interesting two-sided plaque seal from Tepe Giyan (fig. 6.4), the shaman with snakes on one side is balanced by two quadrupeds tête-bêche (head to tail). This seal suggests the notion of a narrative—with the drama of the encounter played out on side a and the resolution of the encounter played out in the placid arrangement of the quadrupeds on side b. On another, the shaman is balanced on the opposite side by one large ibex as imposing as the shaman (fig. 6.7).

THE SHAMAN'S AGENTS: SNAKE AND IBEX

The shaman's collaborative association with the ibex may relate to special properties of the animal. The ibex secretes a substance within its stomach (the "bezoar stone") that is an effective antidote to a number of poisons, including snake venom (Porada 1990: 71). The snakes that figure prominently on many shaman seals may be intended to show dangerous creatures now pacified specifically as a result of the healing powers of the ibex, channeled through the agency of the shaman. There were a large number of poisonous snakes in the ancient Near East (Latifi et al. 1991). And the ibex was a ubiquitous feature of the landscape. It is possible, as Root has speculated, that our cat. no. 30 (fig. 6.1) actually depicts the notion of the bezoar stone by the two large dots flanking the head of the shaman on that seal from Tepe Giyan (Root 2002: 184)

The ibex occurs in other contexts in late prehistoric art, as does the snake. Clearly both animals held a range of valences (see chapters 5 and 8 this volume). Most significantly for the understanding of shamanistic agency, both creatures have important divine associations in later historical times of the Elamite tradition in southwestern Iran. These later divine associations, seen in conjunction with the repertoire of shaman imagery on our seals, suggest an incremental accretion of symbolic meanings relating to the realms of the divine.

A protoliterate cylinder seal impressed on a tablet from Susa depicts a temple decorated with long arced horns very likely of the ibex (Pittman 1992: 52, fig. 28; chapter 7, fig. 7.5, this volume). This association of (ibex) horns with temple adornment at Susa persisted down into the 7th century BCE. At that time, historical sources record the breaking off of the horns from the ziggurat at Susa by the Assyrian king Assurbanipal when he sacked the city (Potts 1999: 284).

While the ibex seems consistently to have a beneficent meaning, the snake is more ambiguous. In addition to the many examples of shamans grasping and pacifying snakes, this animal figures prominently in three other major categories of images: (a) as a figure disposed in the field near a quadruped, apparently beneficently (chapter 5 this volume) (cat. nos. 5, 6, 11.h, 25, 70, 71, 75, 80.b, 85); (b) as a writhing, side-winding creature perhaps to display the posture of combat between rival males in mating season (cat. nos. 27, 28, 33, 73, 111); and (c) as a predatory creature devouring animals and humans (cat. nos. 72, 74).

The snake was prominent in the art of many prehistoric cultures, evoking both fascination and fear (Mundkur 1983). The slithery, sinuous form of the snake, with its side-winding, legless mobility, is one aspect of its fascination. Added to this, the semi-independent nature of the snake's spinal cord makes its body able to continue moving even after its head has been chopped off. Fear of the deadly venom of many poisonous varieties of the snake has made snake bite so dreaded that the shock induced by this fear itself, rather than the actual toxicity of the venom, has been known to be the real cause of death among many victims of snake bite (Latifi et al. 1991: 57–58).

Dualities of fear and fascination couple with another feature of the snake: its aspect as a creature of the earth and nature's tiller of the soil. Because the snake can move between the depths of the earth and its surface, it has acquired connotations of divinity and relationship to death and rebirth in many cultures. Certainly in ancient Iran from protoliterate times through the 2nd millennium

BCE the snake was a prominent attribute of major divinities. It was thought to hold sway over earth and the underground sources of fresh water (Malbran-Labat 1995: 59–61, 184, 190–192; Root 2002: 176). In historical periods of Iran, when divinities sit upon snake thrones and grasp the writhing snake that rears its head out of the coiled mass of this throne, we may be seeing a continuity of sorts with the prehistoric shaman (e.g., Harper, Aruz, and Talon 1992: 80).

Snakes and ibexes were plentiful in the natural environment of ancient Iran and Iraq. Furthermore, the seals of late prehistory seem to eschew representations of imaginary composite creatures. In this cultural context direct correlations with the visible world are apparently paramount—even as metaphorical meanings may be lodged in the representational vocabulary. This suggests that the seals reflect rather concrete notions of the social and natural environment, reinforcing the likelihood that the ibex-headed man was intended to be understood as a real human being rather than a rendering of his trance-induced vision of himself. It is also possible that the ibex-headed personage represented a human figure performing roles that had already by this time been assigned to a notional divinity who was himself commingled in identity and attributes with the ibex (Barnett 1966; Porada 1995). The two concepts are not in fact mutually exclusive. Individuals in organized cults did acquire the privilege of assuming the role of a divinity in the performance of ritual functions—as cult stand-ins.

IDENTITIES OF THE SHAMAN

It may be that the ibex-headed man of late prehistory prefigured the priest-king of protoliterate times. Since, as we have noted, the shaman drops out of the imagery of Iran and Iraq after late prehistory, we can speculate that his roles may indeed have been subsumed by leaders who increasingly took on more institutionalized positions of power in cultic as well as secular affairs.

Edith Porada has specifically identified the late prehistoric ibex-headed man as a shaman (Porada 1995: 30–33). Exactly what the shaman meant in this context still needs to be addressed, however. The term *shamanism* derives from the accounts of 18th-century Russian Orthodox missionaries to Siberia, who recorded their experiences with a number of the tribes that inhabited the region (Hamayon 2001). Among the Siberian tribesmen, certain elements of shamanic ritual practice were common: the use of a costume, dance, song, and chant. Their shamans performed numerous services in their communities through these ritual practices: exorcising evil spirits, communicating with the spirit world, foretelling the future, and healing the sick.

Research, both within the popular press and among scholars of prehistory and ethnography, has often linked shamanism with ritual behavior based on trance. Trance theory was originally applied to prehistory through the work of Lewis-Williams and Clottes and Lewis-Williams (summarized in Clottes and Lewis-Williams 1998). Others have challenged many of their premises and conclusions (Harner 1973; Hamayon 1993; Noel 1997; Bahn 2001). According to some researchers, the use of rhythmic dance or psychedelic drugs led ancient shamans of various regions of the world into a state of trance, in which they were able to perform mystical feats to demonstrate their power and heal members of

the community (Thunderhorse 1990; Baldick 2000; Harner 2003). The frequent images of dance, portrayed on many of our seals, may suggest a type of trance state induced by dance. There is, however, no archaeological evidence from our late prehistoric Near Eastern context for the use of psychedelic drugs.

In areas where it can be studied ethnographically, trance often involves imagining the self as having the attributes of an animal or as inhabiting the body of an animal. The shamans of prehistory in Iran and Iraq probably did imagine themselves as entering into the body of the ibex. It seems most likely that they donned ibex masks in order to capture the charisma of this animal and to enhance the trance state by which they could acquire essential qualities of the animal world.

Masking in a ritual context enables the wearer of the mask to morph into a new and different identity (Tonkin 1979: 241; Pollock 1995: 582). Often, this transformation is attained not through the full concealment of the individual wearing the mask but by additions to the human form (Gell 1975: 301). Ritual masking is documented for a variety of Old World cultures from the cult of Artemis in ancient Greece (Dawkins 1929) to the fish-garbed healers of 1st-millennium BCE Mesopotamia (Black and Green 1992: 82–83). The most extensive evidence of masking in antiquity comes from Egypt (Wolinksi 1987; 1996). A painted canvas mask of the popular Egyptian deity Bes was excavated in a house at Kahun of the 2nd millennium BCE (Pinch 1994: 131–132). Here we see an element in the world of women's rituals around childbirth. An Egyptian figurine depicting a woman wearing such a Bes mask and also handling snakes brings us back to the shamans of Iran and Iraq. For in ancient Egypt, the snake was an attribute of Bes and an important component in Bes's efforts to enhance fertility and protect against the many dangers of childbirth. Surely the shamans of prehistory were healers who, among other tasks, also performed in rituals to protect childbirth and encourage fertility. The origins of religion have been linked to early methods of healing through magical ritual activity (McClenon 2002).

SEALS, AMULETS, TALISMANS

The evidence from Tepe Gawra and Susa proves that some shaman seals were used in administrative contexts, impressed onto container sealings (cat. nos. 38, 44, 88, 113, 114, 115). We do not know the nature of the commodities associated with these shaman seals. Thus, we are limited for the present in our ability to consider the ranges of administrative use for these particular thematic types of seals. Many questions arise. Were shaman seals used only by shamans? Or did others have access to this imagery as well? Would the imagery in any case have been restricted to a very small number of individuals within a community? Were shaman seals used as seals specifically and exclusively in relation to locking and labeling of commodities and implements of the shaman's craft (such as herbs for healing and paraphernalia for rituals)? The answer to this last question is probably "no." Analyses of the Gawra material suggest, at any rate, a context of redistributive economy glimpsed through the sealings (Rothman 1994a; 2002). This implies that at least some shaman seals may have been used in that economic sphere. The

shamans may well have occupied prestigious positions of wealth in their communities, so that their ritual roles and their other roles were not mutually exclusive.

In addition to the aspect of these shaman seals as practical social tools—as seals making impressed images—the artifacts may well have served as amulets or talismans in some instances. An amulet is a protective object worn or used to guard against potential dangers. A talisman is an object worn or used to enhance and to promote good things for the bearer (Pinch 1994: 105). Perhaps some of the shaman seals were worn by individuals who were not themselves shamans but who wished to use the force of the imagery for either amuletic or talismanic agency.

MAGIC

The linguistic and categorical distinctions among magic, medical science, and religion have their academic origins in the work of Sir James Frazer, author of *The Golden Bough*, originally published in 1911–1915 (Frazer 1990). Frazer divided the worlds of myth and ritual that he encountered into three domains, each marking a different rung on a perceived evolutionary ladder that led to Western civilization and Christianity. Frazer saw magic as the polar opposite of religion. Magic, he proposed, demanded effects from supernatural forces through spells and incantations. Religion instead involved supplication to a higher order. Frazer has been criticized on many counts, but his legacy has powerfully affected the ways we continue to contemplate the intersections of magical practices, healing arts, and religious experience.

For the late prehistoric Near East, the shaman's magic can best be considered without attempting to construct it in opposition to religion. The case for allowing these boundaries to blur is made well for ancient Egypt (Pinch 1994) and should be in place for our area of inquiry as well. Another salutary model is that developed by Stanley Tambiah. Focusing on a definition of magic based on its salient characteristics, Tambiah suggests that magic can be identified through the confluence of words and actions within the context of performance. He calls magic the "performative utterance" (Tambiah 1990). His work provides a useful point of departure for us in a realm where the visualizations of the dancing ibex-masked shaman is our window on the systems of belief and human agency in a world of nature operating 6,000 years ago.

7

Modes of Religious Experience in Late Prehistory

Karen Johnson

CONSIDERING RELIGION IN PRELITERATE ANTIQUITY

Is there any way to investigate the existence and nature of religious (as opposed to magical) experience and practice in late prehistory?

Our word *religion* derives from the Latin form *religionem*, of uncertain etymology. The Roman orator Cicero (106–43 BCE) connected it to the Latin *relegēre*, meaning "to reread, to read over again." Other ancient commentators connected *religionem* to the word *religāre*, meaning "to bind"—as in to bind one to a code or a system of rules of practice and belief (*Oxford English Dictionary* 1987).

Under the burden of such etymological reflections, it may seem implausible to contemplate "religion" for the late prehistoric Near East, particularly in the absence of written documents explicating what the system of beliefs might have entailed. It may seem preferable to leave this subtlety alone, acknowledging important elements that suggest some form of communal beliefs and practices that we cannot hope to analyze in terms of customary generic notions of "religion" in the Western tradition. Those few elements we might acknowledge before moving on to other things are:

(a) that shamanistic performance surely did occur based on the significant number of shaman seals in the repertoire;

(b) that the shaman representations strongly suggest performances for healing magic, for warding off dangers, and for courting the good auspices of beneficent spirits (chapter 6 this volume, for a and b);

(c) that the role of the shaman may have been a key factor in an emerging social-political hierarchy; and

(d) that burial assemblages reinforce the idea of emergent hierarchies and also indicate some well-developed systems of belief, offering practices, and other rituals associated with the life cycle.

Modern Western theorists on religion have, in fact, offered an opening for us by exploring the concept of *divergent modes* of religious experience and practice—from Max Weber's concept of world religions versus traditional religions to Goody's concept of literate versus nonliterate religions. There has been a strong tendency to register the tonalities of religious experience (to define two modes of religious experience) with reference to writing or its absence from the scene. This conceptual framework probably reflects ultimately on the authoritative hold on Western thought exerted by the ancient Roman commentators theorizing on the nature of *religionem* as they themselves experienced it.

Harvey Whitehouse (2000) has recently advanced a theory of divergent modes of religiosity that takes a number of key features from several of these

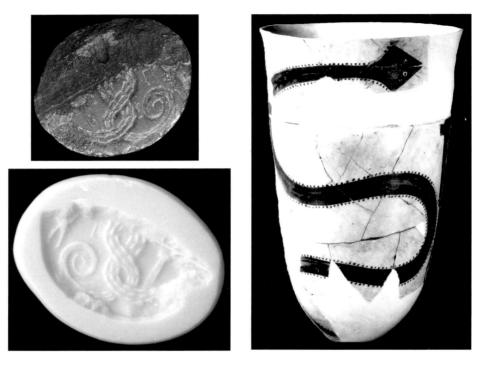

Fig. 7.1. Cat. no. 72. Fig. 7.2. Cat. no. 111.

previously constructed oppositional framings. He also sees two different phenomena of religious practice at work. But he understands them as divergent phenomena—not as necessarily totally discrete phenomena.

DOCTRINAL V. IMAGISTIC MODES

Whitehouse presents the two divergent phenomena as an imagistic and a doctrinal mode of religiosity.

In the *imagistic mode* religious ideas and actions unite small, cohesive groups through occasional and ad hoc ritual performance of a highly emotional nature. The agency of a local shaman intervening with the spirit world to assist the needs of an individual or group could be one instance in which religious notions are expressed. The articulated meaning of such religious ideas remains, however, elusive. Instead, the meaning comes to be highly personalized and individualized through each participant's experience in the performance of high-arousal rituals.

In the *doctrinal mode*, by contrast, religious ideas and actions are routinized, uniform, and shared across a large, centralized community of participants. The concept of doctrinal modes of religion presupposes the ability to codify a body of beliefs in written form, enabling coherence and adherence beyond the framework of small localized community activity. This religious practice takes place on a frequent and regularized basis but offers an experience of low arousal.

Based on what we know of the late prehistoric context, religious practice and belief display strong ties to the imagistic mode. One very interesting bit of

evidence in this regard is the stamp seal from Tepe Giyan showing two snakes devouring a quadruped (fig. 7.1). This large seal was clearly scored in antiquity as if by a sharp blow from a metal blade. The seal then broke along this deliberately created fault line. This implies a rite by which the seal was ultimately used not as an administrative tool for sealing but as a device in the performance of an exorcising act around a person-specific need. This would have been a high-arousal intervention working off the force of the snake image in some way (fig. 7.2). Compare the scoring of the snake beaker from Susa, apparently used for similar ritual purposes (Hole 1992: 34).

At the same time, however, our context arguably displays features that come under the definition of doctrinal practice. Points of crossing between the imagistic and the doctrinal include the fact that there was an expansive community of shared practice that was actually very large, as gleaned through shared representational commitments (chapters 1 and 2 this volume). We will elaborate on other definitive indications of this crossing into the doctrinal below.

Invitation to contemplate the late prehistoric setting as a nodal point in the crossing of imagistic with doctrinal modes comes indirectly in the final chapter of Whitehouse's *Arguments and Icons* (2000). Here he proposes that, although much previous research points to writing technologies and literacy as key elements in the independent invention of doctrinal modes of religiosity, a shift toward increasingly routinized forms of religious practice may have been catalyzed by other situations and phenomena as well. He urges inquiry into areas where we might be able to chart the crossing of imagistic and doctrinal modes not predicated on the notion of writing as the necessary precondition.

THE PROCESSES OF MEMORY

Whitehouse's theory differs from preceding theories of religion based on a polarity of modes. He argues that the divergent modes of religiosity as defined above actually involve the engagement of different systems of memory and cognition in the processing of the religious experience. This, in turn, has a profound effect on the way religious knowledge is transmitted over time and across space.

He postulates that participants in imagistic modes of religious experience tend to encode much of their revelatory religious knowledge in "episodic memory." This involves production of explicit mental representations resulting from an experience that is unique in time, context, and personal implication/meaning.

Participants in doctrinal modes of religious experience tend, rather, to encode much of their revelatory religious knowledge in "semantic memory," according to Whitehouse. This means that their explicit mental representations of religion result from an experience that is generic and procedural in nature rather than intensely personal in derivation.

SHIFTING THE PARADIGM

Here we move with Whitehouse to challenge prevailing hypotheses that privilege literacy and writing technologies as the primary precondition for the emergence

of doctrinal religious practice (see also Johnson 2004). We will do so by out-lining some key features of preliterate southwest Iranian culture in the late 5th through the early 4th millennium that strongly suggest conformance with many of the conditions generally associated with religious practice that should (by conventional definition) only occur in a literate environment. The implications of this analysis suggest ways we may begin to alter our understanding of the im-portance of symbolic visual expression as a cognitive cultural tool.

Decades of research place state formation in this area within the proto-literate period, beginning around 3700 BCE (Wright et al. 1975; Wright 1977). This suggestion is based on increases in the levels of administrative and political hierarchies, evidence of more complex settlement organization and artifactual systems of record keeping (well-established use of marked clay envelopes with complex tokens), population growth based on settlement characteristics and agricultural patterns, and increases in craft production and exchange (Wright and Johnson 1975). Yet the emergence of pictographic script, independent of ac-counting signs and tokens, does not occur until very late in the 4th millennium (Nissen 1986). Prevailing theories about writing, memory, and religious practice would suggest, then, that the doctrinal mode of religiosity could emerge only at the very close of the 4th millennium at the earliest.

The evidence tells a different story. It suggests that writing (in the ac-cepted sense of that word) was neither the necessary condition for the invention of doctrinal practices nor the precipitating factor leading to its development. Rather, writing was the precipitating factor leading to the robust *elaboration* of doctrinal religious practices, which seem to have first emerged even before the protoliterate period, in late prehistory, at the time of complex chiefdoms. During this late prehistoric period, one can argue, high-status groups exerted and main-tained social control through mechanisms redolent with signs of religious ideol-ogy. This ideology became increasingly routinized and increasingly widespread across expanding communities of influence. The conditions for the generation of specifically doctrinal religious practices must have been met using social tools other than written language—but tools that exerted similar cognitive effects. These tools, these mechanisms for the expression and purveying of a burgeon-ing doctrinal religion, were the systems of symbolic imagery in play during the seminal period of late prehistory that we interrogate in *This Fertile Land*.

THE ARCHAEOLOGY OF RELIGION

Archaeologists and theorists of religion and cognition do not necessarily con-verse with each other or use the same nuances of language in their work. There are challenges aplenty for the archaeologist even to identify remains that ought to qualify as evidence of "religion" in a basic overarching sense—let alone at-tempting to distinguish between imagistic and doctrinal religion.

Renfrew (1994) has proposed a useful outline for identifying archaeo-logical indicators of the occurrence of ritual practice. He includes: identification of specific locations dedicated to the practice (such as unusual features in the landscape, particular buildings like churches or temples, small shrines within a home, or burials); the presence of specialized equipment, such as votives, lamps,

musical instruments, clothing; indications for a significant investment of wealth and resources, such as the use of luxury materials; iconographical representations of deities, meaningful gestures, important symbols, or sacred animals; and, on occasion, the presence or tradition of religious text.

Each of these components of religious activity has material aspects that can be discerned archaeologically. Many of these indicators can be used for the investigation of late prehistory. Such archaeologically retrieved indicators can be integrated with Scott Atran's work (2002) in order to capture more fully some of the cognitive aspects of religion among ancient populations we cannot observe ethnographically.

Atran's operating guideline for identifying evidence of religion is that religion is a community's costly and hard-to-fake emotional and material commitment to supernatural, counterintuitive, and quasi-propositional worlds. These strategies for identifying "religious" practice are not immediately reconcilable with theories of religious experience operating in more cognitively based arenas. There may be a way to bring archaeological analysis closer to cognitive theory.

TOWARD AN ARCHAEOLOGY OF RELIGION AND COGNITION

Boyer (1994; 2001) has proposed that there is a fundamental commonality underlying all religious concepts, even though such ideas display a fantastic diversity across time and space. Theories in cognitive science, supported by numerous studies in developmental psychology, provide the basis for his argument (Wellman and Gelman 1998). Boyer describes how the human mind organizes a vast array of information about the world according to ontological categories (basic templates) that allow humans to make inferences about and have expectations for the things we encounter.

Having an endless number of templates would, however, prove inefficient and cognitively burdensome. For this reason, it is thought, there are only a handful of ontological categories humans tend to use as a framework: substance, artifact, plant, animal, human/person (Atran 2002). Each category has a set of features or properties a human mind expects to have satisfied in order to meet the criteria for a particular template. That said, the sets of features or properties are limited to the three domains of knowledge. These domains are called by various names in the literature, but here we will refer to them as: intuitive physics, intuitive biology, and intuitive psychology.

In sum, as humans we come to expect from an early age that the things around us will have features that conform (a) to recognized physical traits and activities (gravity, solidity, movement), (b) to recognized biological traits and activities (growth, reproduction, death), and (c) to recognized psychological traits and activities (beliefs, intentions, desires). Elements within the ontological categories of substance, artifact, plant, animal, human/person can of course intersect with all three domains of knowledge.

In the context of this theorization of human perception of the world, we return to Boyer's observation about religious concepts. He proposes that a "religious" idea will have features that simultaneously conform to and violate our expectations based on the domains of intuitive knowledge embracing the ontological

categories of human perception. An example of this (taken deliberately from a realm of non-religion-specific popular culture still current today) would be the idea of a ghost. A ghost conforms to certain features about humans in that it may speak, take on some semblance of human shape, and have intentions. At the same time, however, a ghost is also incorporeal and thus goes against the expectation we have of human physicality. It is a good example of a phenomenon, an idea, that simultaneously conforms to and violates human expectations. It is a counterintuitive phenomenon. Readers familiar with a range of discrete organized religions will be able to supply other examples of counterintuitive elements embedded in these belief systems.

Boyer also notes that compelling religious concepts are those ideas that are minimally counterintuitive. That is to say, the effectiveness of a counterintuitive phenomenon lies in its ability to violate our expectations—but only enough to engage our responses. Multiple violations of intuitive understanding (e.g., a rock that not only flies but also predicts the future and is seen everywhere at all times) impose too many constraints on the memory and on the mind's capacity to transmit and process an idea effectively.

REPRESENTATION AND RELIGION

The assertion that religious representations simultaneously conform to and minimally violate intuitive knowledge may be realized, to a certain extent, in the visual realm. Thus, the presence of visual images such as anthropomorphic characters, human-animal hybrids, animated landscapes, or creatures with human attributes and intentions might facilitate and strengthen the identification of religious iconography. We must, however, exercise caution here for two reasons.

First, the presence of such visual images, in and of itself, is not necessarily indicative of religious activity. Archaeologists must seek additional material remains, such as those suggested by Renfrew's indicators for ritual activity, in order to achieve a convergence of evidence for religious belief and practice.

Second (and this is the converse of the first caveat), not all visual representations with a religious valence are even minimally counterintuitive. For example, images of snakes or scorpions may occur in clearly qualifying religious contexts, as attributes of gods, for instance. Yet such images do not intrinsically violate intuitive knowledge. They may serve the religious utility of counterintuitive presence not by their intrinsic presentation but rather by the contexts in which they are deployed, the scale of their rendering, or other strategic means that do not violate the form of the animal but do transgress its normative social performance.

How one understands the nature of the religious imagery of a particular tradition will necessarily influence how one characterizes that tradition's beliefs and practices along imagistic and/or doctrinal trajectories. It might be helpful to distinguish between imagery that is produced by subjective experience and imagery that is objectively depicted; doing so might help to forge a stronger connection between the accounts of religion advanced by Boyer and Whitehouse.

In his description of imagery associated with Melanesian ritual, Whitehouse observed a record that was completely mundane (based on real life) from

the observer's perspective: dew, hair, wild boars. Whitehouse even referred to these vestiges at one point as representations of "everyday objects" (Whitehouse 2000: 118). Furthermore, he states explicitly that religious notions and meanings for participants in a predominantly imagistic tradition are "internally generated" and "may converge on certain themes and central ideas" but present neither uniformity nor exegesis (2001). So if imagistic ideas are multivocal, multivalent, and glimpsed in revelatory experience within an individual's mind, it would appear impossible to identify any particular counterintuitive idea or set of ideas, much less a visual depiction of such ideas, shared within the tradition.

Despite this problem, the archaeological search for counterintuitive concepts in imagistic practices is not insurmountable, especially if the religious representation is considered from the viewpoint of the participant. What if counterintuitive ideas in imagistic practices exist primarily, if not exclusively, through actual subjective experience? As Whitehouse argues, rituals in the imagistic mode are loaded with sensory pageantry. They are highly emotional and can be traumatic, ecstatic, and even life threatening; their experience has profound physical and cognitive effects.

Let us propose here that such ritual environments actualize ontological violations, in effect creating religious representations out of the participants themselves. To illustrate, suppose a ritual is so richly charged with sensory input, and so metaphorically evocative of the features of venomous snakes, that the participants in the process have the revelatory experience of actually believing they have experienced "death" and miraculous "rebirth" through a truly life-threatening rite of terror involving the snake.

Contrast this with a predominantly doctrinal mode that operates without such rituals. In such a case, religious representations of ontological violations are not actualized through the participants themselves. Rather, *they are incorporated into stories codified in verbal or textual rhetoric.* No longer belonging to the realm of first-person experience, such counterintuitive concepts more readily lend themselves to third-party visual depictions that cue into oral and/or textual traditions.

Based on this line of thought, we may propose the following chart, which predicts kinds of visual depictions relating to imagistic versus doctrinal practice:

Imagistic	Doctrinal
Representational art will tend to be mostly, if not exclusively, mundane.	Representational art will also be mostly mundane.
Abstract designs may be present.	Abstract designs may also be present.
There will be an ambiguity in the religious significance of representational art and abstract designs. Meaning cannot be gleaned simply by viewing the depictions.	There will be a greater specificity in the religious significance of representational art and abstract designs. The depictions themselves will cue into verbal and/or textual rhetoric.
If counterintuitive representations occur, they will be the product of the participants' ritual actions, or at least they will be identified with individual actors.	There will likely be an increase in the frequency of counterintuitive representations (although there need not be many). Religious ideas are no longer defined primarily by first-person experiences, and thus they lend themselves more readily to codified portrayal.

This chart has been conceived from an archaeologist's viewpoint. From this perspective, any representations regarded as potentially religious in nature must be evaluated against corroborating physical evidence for a ritual context.

LATE PREHISTORY TO THE PROTOLITERATE TURN

With these considerations in mind, we can proceed to a set of suggestions explicitly geared to the arena of *This Fertile Land*. It is possible to demonstrate that beginning in the late 5th millennium there was an apparent movement in religious beliefs and activity toward a more explicitly doctrinal mode, nearly 1,500 years before the first material examples of any kind of written documents. This notion is substantiated by the emergence of large, centralized ritual precincts and the proliferation of religious imagery, both mundane and counterintuitive. With both types of imagery, the depictions and symbols seem dominated by codified schemes. The sociopolitical climate of stratified chiefdoms provides the momentum for such a transformation; when a system of writing does materialize, it facilitates further elaboration of already emergent doctrinal practices.

The thrust of the following case will display itself variously depending on what one considers a "system of writing." For the ancient Near East, Schmandt-Besserat has advocated the theory that clay tokens used in counting activities served as the springboard for pictographic script once the cognitive leap from concrete to abstract counting had been made, for this "gave rise to a new system of data storage and communication" (1992: 191). We have already reviewed some aspects of her data as well as the controversial nature of her theory among specialists in Sumerology (chapter 4 this volume) and will not repeat that here. Whatever the details of specialized interrogation, Schmandt-Besserat's work brings into play important factors about symbolic systems and mnemonic tools in late prehistory.

The particular sociopolitical climate of late prehistory, with its attendant institutions and tools, may have exerted the same cognitive stimuli toward doctrinal modes of religion that are generally posited as the result of writing systems. In other words, the variety of visual mnemonic and record-keeping tools operational in late prehistory—coupled with the closely allied armature of artistic production in seals and painted pottery—fulfilled cognitive conditions for the emergence of doctrinal modes of religiosity well before writing.

TRACING SOCIETAL DEVELOPMENTS TO A DOCTRINAL TURN

The physical geography of western Iran supplies a dramatic backdrop for the cultural innovations and changes taking place there over thousands of years. Mountains delimit plains and highlands that were the focal locations for sedentary settlements and agricultural activity commingled with pastoral nomadism. Two sites in close proximity on the Susiana plain, Chogha Mish and Susa, display interlocking occupation patterns that capture the effects of shifting sociopolitical dynamics through the late prehistoric period into the protoliterate period and thus to the invention of writing. These two sites are part of a much larger world,

as our exhibition makes clear. Indeed, it is crucial to remember that the impulses we see in the Susiana plain exist within a partly shared system that extends to the areas of Tepe Giyan in northern Iran and Tepe Gawra in northeastern Iraq.

Chogha Mish was first occupied around the start of the 7th millennium. Based on the presence of specific types of ceramic ware, the initial settlement was modest but continued to expand throughout the early and middle Susiana periods (Delougaz and Kantor 1996: 279–284) into what was probably a complex chiefdom. Three features of spatial organization are helpful indicators for such social formations: settlement hierarchy with centers becoming larger than surrounding communities, residential segregation, and mortuary segregation (Wright 1994: 68). The extensive architecture at Chogha Mish during the middle Susiana period suggests a substantial and continuous settlement covering nearly 15 hectares, larger than the surrounding communities of the plain (Delougaz and Kantor 1996: 184). Additionally, reports of the architectural remains in trenches suggest that some domestic areas were larger and well planned, with features for specialized functions, such as kilns, so that it is possible to infer residential segregation to some degree (161). As for mortuary segregation at Chogha Mish, the evidence is scant, although two sources of data may provide a glimpse into burial practices. Four skeletons—one child and three adults—were recovered from apparently archaic Susiana contexts in an area known as the Gully Cut. No grave goods were present, but the skeletons appear to have been sealed by layers of clay. The area itself is interpreted as an open space for general activities and the disposal of debris, since there are no layers indicating occupation or abandonment (167). Contrast these graves to one from the middle Susiana period, which was found just outside a building of substantial mudbrick blocks on the higher slopes of the settlement (157–158). The skeleton is decayed and contains a disarticulated skull with a pronounced artificial cranial deformation (Ortner 1996). Such deformations are known elsewhere in this region, and Delougaz and Kantor note that earlier Susiana and Mesopotamian figurines with flattened and elongated heads may be an attempt to portray such morphology (158, n. 4). Very little can be inferred about the community at large from just these two burial types. In the absence of additional data, it is worth entertaining the idea that the burials may indicate changes in practice over time within a single community and perhaps reflect further vertical articulations within the society at a later period.

Taking these data together with evidence for settlement hierarchy and segregation, we may reasonably ascribe the term *complex chiefdom* to Chogha Mish by the middle Susiana period. A complex chiefdom is differentiated from a simple chiefdom by the presence of several ranked individuals from several community subgroups, rather than just a single subgroup, competing with one another for control (Wright 1994: 68). In essence, such ranked individuals are competing for larger group cohesion, which would likely require a verbal rhetorical framework for gaining and maintaining control. They might co-opt shared religious experience as an effective and expedient means for addressing larger group cohesion. This may be what we see occurring at Chogha Mish. Changes in the corpus of figurines found at the site may offer corroboration.

All of the human figurines date to the archaic and early Susiana periods, while all of the animal figurines (quadrupeds, birds, a snake) date to later periods.

Fig. 7.3. Clay ibex figurine from Chogha Gavaneh, found in same locus as cat. no. 1. Drawing courtesy of Kamyar Abdi.

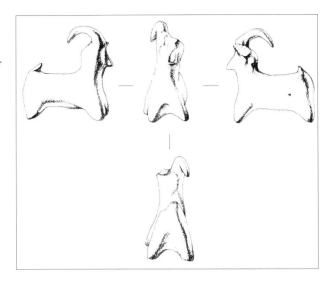

(We see such animal figurines at other Chalcolithic sites as well—including Susa and Chogha Gavaneh; fig. 7.3.) The excavators explore the possibility that the temporally specific abandonment here of human figurines in favor of a repertoire of animal types at Chogha Mish could be an accident of recovery. But they maintain that the sample sizes from trenches should be representative. Thus, they posit that the switch from human to animal figurines strongly suggests a shift in the concerns of the artisans as well as cultural change at large (258–260).

If we regard these figurines as cult objects (as such items are generally interpreted when found in later contexts), then we might consider the shift from human forms to animal forms as a change in explicit religious belief. We might consider this material as evidence of a shift in focus away from individualized experience embodied in human figurines to a focus on imagery that ranked individuals could more easily claim authority over—namely, animals. This was happening before the period of late prehistory that we focus on in *This Fertile Land*.

Even setting the figurines aside, the archaeology of prehistoric Chogha Mish at least provides evidence for a sociopolitical climate that was conducive to increasingly explicit, communally shared religious ideas.

Frequent skirmishes are characteristic of areas home to complex chiefdoms, as communities vie for regional control and assert authority. This was certainly the scenario on the Susiana plain in the late 5th millennium. In the late Susiana period Chogha Mish contracts, while explosive growth occurs at nearby Susa. This expansion was accompanied by the construction of a monumental mudbrick platform on the high-place ("acropolis") of the city. The remains of the platform and the buildings that occupied it are fragmentary, but they do allow tentative reconstruction of the complex. The platform itself rose in two tiers, with each stage displaying recessed corners, in effect apparently creating a cruciform design. Atop the platform was a complex of buildings, perhaps including temples, storage rooms, a residential building, and a charnel house (Steve and Gasche 1973; Hole 1992). Adjacent to the platform was a cemetery that has yielded hundreds of graves (possibly as many as 2,000) with similar assemblages, usually consisting of three ceramic vessels. Many of the burials were fractional, suggesting a delayed interment of the bones after the flesh had decomposed

(Canal 1978), and many appear to have occurred simultaneously (Hole 1992). Several interpretations surround the circumstances for such a massive burial event, but for now it is sufficient to note the monumental scale, the centralized location, and the regularized system of ritual presentation displayed.

The recurrent assemblage of ceramic vessels in the burials comprises three types—a tall beaker, an open bowl, and a small jar. Apparently long bones were deposited in the tall beakers and skulls in the open bowls (Hole 1983: 316). In total, nearly 4,000 vessels were recovered displaying a diversity of symbolic representation within a repeated and circumscribed repertoire. Susa was clearly the center setting the standard for this production, but its programmed imagery was shared among other sites on the Susiana plain. Notable motifs include circular and rectilinear geometric and abstract designs, nested and plain crosses, spades, and various animals, with the most frequent being the ibex, the wild sheep (mouflon), and large birds flying in tight formation. Only four of the bowls display anthropomorphic figures (Hole 1983; 1984). Susan Pollock (1983) conducted a stylistic analysis of Susiana ceramics in an attempt to show that a redundancy in stylistic embellishment may indicate an increase in the vertical articulations within a society, with the elite reinforcing their status through the use of symbolic messages. Indeed many examples of pots from the Susa cemetery share almost identical systems of representation. (Compare here figs. 1.10, 5.29, and 5.33; figs. 5.16 and 5.34.)

At the same time, the motifs appear to key into religious ideologies and activities. This is demonstrated in large part by their repetitive presence in burials. It is also demonstrated (a) through their display in a centralized ritual precinct and (b) through the redundancy of many of the representational formulae on seals. Many of the animal motifs appearing on pots and seals from Susa are the same as those from the animal figurines at Chogha Mish. This is not to say that the meaning of such symbols was exactly the same for each community but rather to show that the animal motifs occur in much more explicitly ritual contexts at Susa, thus strengthening the interpretation that they may be associated with a rhetoric of control that includes religious notions. In addition, cruciform designs appearing on ceramics and seals and echoed in the architectural details of the ceremonial platform appear to integrate religious ideas with political and economic institutions (Wright 1994). (See chapter 5, figs. 5.3–5.5 this volume.)

Another important factor here is the emergence on seals of the imagery of the "master of animals" (Amiet 1972; LeBrun 1971; Hole 1983). This is the figure of the shaman discussed elsewhere (chapter 6 this volume). Most scholars working with this material would hardly deny any religious significance here. But heretofore there has been little attempt to produce an analysis that actually develops the potentials of this material to address the questions posed in theoretical discourse on the nature of religious belief and practice.

The counterintuitive aspect of the shaman figure is very striking in this regard. When included among the diverse iconography of ritually associated depictions at prehistoric Susa, it interjects a counterintuitive element into a program of otherwise "mundane" (reality-based) images. The corpus of images is moving into a domain of the doctrinal mode.

The beginning of the protoliterate period proved eventful across southwestern Iran and Mesopotamia. It was a time during which state-level societies

84

first began to emerge, and with that came increases in population, settlement and administrative hierarchies, agricultural and craft production, and trade across larger regional areas. The material culture at Susa and Chogha Mish, including that of religious practice and belief, reflects all of these changes. At Susa, conflict is apparent in the destruction at the great platform; the complex was restored, but a later destruction phase also included the settlement (Canal 1978). Despite this, occupation at Susa is sustained throughout the protoliterate period. Roughly contemporaneous is a renewal of growth at Chogha Mish. Excavations have revealed extensive architectural remains across the site, with some areas indicating several building phases through the protoliterate period (Delougaz and Kantor 1996: 27–35). The characteristics of the houses suggest a dense urban population, probably enclosed within city walls. A monumental complex on the High Mound consisted of a polygonal platform (probably intended as the foundation for a temple) along with surrounding buildings and ritual features. The excavators recovered numerous colored clay cones that were likely used to decorate the exteriors of such public buildings. Parallels for such embellishment are found in the protoliterate remains of Uruk in southern Mesopotamia.

Symbolic and figural representation was greatly elaborated during the protoliterate period. Pittman notes,

> . . . one primary purpose of the increased invention and production of visual symbols was managing social interaction, for through them it was possible to replace actual human action with its representations. Actual and ritual action, used in the past for social management, it may hypothetically but consistently be suggested, was replaced or augmented to some degree by depictions of ritual actions and of relationships. That new function of social communication required both the elaboration of existing images and the creation of a substantial number of new ones, which acquired meaning through convention and homology that encompassed both human relationships and mythological and cosmological precepts. (Pittman 1992: 49)

Many of the seals known from protoliterate times display elements, both alone and in conjunction with new ones, previously seen in the religious imagery of late prehistory. Animals such as snakes, lions, birds, ibex, and scorpions are now engraved on cylinder seals rather than stamp seals. Paratactic arrangements of human figures enter in, with some impressions preserved on sealings showing the figures carrying items. When compared to similar motifs from the same period at Uruk in southern Mesopotamia, these files of people can reasonably be interpreted as porters and gift bearers in ritual ceremonies (Delougaz and Kantor 1996: 144). Indeed, two seal impressions from Chogha Mish illustrate a procession of humans and animals to a temple: one shows a member of the procession carrying a vessel standing at the gate posts of the temple; the other shows two humans, each carrying a staff, accompanied by a lion standing on its hind legs next to a temple. Even these elaborate representations of ritual are foreshadowed in stamp seals preserved as seal impressions on jar sealings from Susa. Six different container sealings bear impressions of one stamp seal depicting a large

Fig. 7.5. Drawing of a cylinder seal impression on a jar sealing from proto-literate Susa. Adapted by Karen Johnson from Pittman 1992: fig. 28.

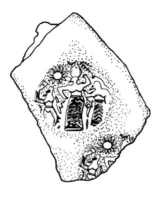

Fig. 7.4. Cat. no. 113.

dancing human figure (with arms akimbo) wearing an elaborate domed (and horned?) headdress and accompanied by two smaller figures (Aruz 1992: 43). The smaller figures hold vessels—one certainly shaped like the tall beakers from the Susa cemetery (Hole 1983) (fig. 7.4).

A new development not known from late prehistory is seen on a later (protoliterate) cylinder seal impressed on a jar sealing from Susa (Pittman 1992: 52, fig. 28) (fig. 7.5). Here the scene presents a narrative of human battle before a temple. The form of the temple links back to notions of collusion between secular power and religious institutions: the architecture incorporates horns that recall the exaggerated ibex horns depicted so assertively on late prehistoric ceramics and seals. The bow-wielding figure here is the priest-king, who exerts a certainly combined religious and secular power. No longer a masked shaman dancing to his mastery over animals, this early priest-king nevertheless emerges from the aura of that earlier tradition.

As we have seen, the administrative use of shaman stamp seals as tools to mark commodities was well established in late prehistory. The protoliterate jar sealings bearing impressions of cylinder seals with elaborate representations of war and regularized worship rituals both perpetuate and elaborate upon this mechanism by which religious authority blended with earthly domains of commodity control.

SUMMARIZING THE PROPOSITION

We can summarize the case study concerning the emergence of the doctrinal mode in the following way. The rise and organization of complex chiefdoms at Chogha Mish and Susa during the 5th millennium significantly affected religious belief and practice. Increasingly doctrinal religious notions became an important component of secular ideologies as a means for ruling individuals to gain and sustain power and control. Religious belief, which previously had been internally generated and transmitted through infrequent ritual, became increasingly explicit and homogeneous through artistic display. The resulting images portrayed religious representations with a capacity for stronger narrative valence, not only in the compositions involving event-specific situations such as battle scenes at the temple but also through the deployment of the cylinder seal that could roll out animal representations so that even they acquired the look of processional figures in a ritual performance. The centralization of ritual activity at the platform complexes and the communication of religious ideas tied to political dogma carried out in routinized economic activities contributed to both a more frequent transmission of religious belief and a greater demand for

semantic encoding. The religious activity generated by such sociopolitical surroundings was profoundly affected during the 4th millennium, when the realm of art became a more explicit means for managing and representing social interactions.

The doctrinal mode, with its cognitive features materializing out of sociopolitical dynamics, first emerged in southwestern Iran during the late prehistory of the 5th millennium and strengthened in form throughout the 4th millennium. Religious belief would eventually be codified through the invention of writing, then developed through its own discursive and narrative capacities, but these processes represented robust elaborations of a doctrinal trajectory that had been set in motion much earlier. The systems of signs and symbols in place in late prehistory document a widespread systematic application of coherent patterns of understanding of the order of things in an increasingly hierarchical and storied environment. The uniformity of motifs combined in variegated but systematic compositional formulae across a range of workshop products suggests the existence of ceremonial practices carried out according to established performative codes with clearly associated symbolic visual aids. This in turn hints at codified systems of belief in the service of an increasingly stratified society, with recognized symbolic imperatives of communication in play.

We have argued for the development of incipient doctrinal modes of religiosity well back in the late prehistoric setting of the ancient Near East, focusing on southwestern Iran. This was an era significantly before the invention of writing. But it was an era when other systems of sign notation and information storage for administrative purposes were operating side by side with symbolic tools of expression in the form of programmatic displays of signs and symbols with high metaphorical content. All this must be considered in the larger context of explorations of symbolic expression presented in *This Fertile Land*.

The incipient doctrinal modes of religiosity we have charted here in late prehistory offer a new paradigm for consideration. Our investigation opens up the visual record of late prehistory for further integration into the theoretical frameworks of a creative, interdisciplinary enterprise on religion and cognition.

That said, a caveat is in order here. Even in fully developed form, the doctrinal mode of religion never completely overtook all other forms of religious practice and magical practice in a manner reminiscent of Jared Diamond's notion of "kleptocracies" (1997: 277–278). Instead, multiple forms of both imagistic-religious and magical belief and ritual intervention continued to coexist in ancient Mesopotamia and Iran (as well as in ancient Egypt) alongside doctrinal modes even in fully developed historical times (e.g., Van Buren 1937–1939; Black and Green 1992: 124–128; Pinch 1994; Callieri 2001).

8
Fertility: Of Snakes, Displayed Females, Scorpions, Tortoises, Frogs

Margaret Cool Root

FERTILITY IN THE MALE DOMAIN

Many of the signs and symbols we have discussed in *This Fertile Land* allude to notions of fertility.[1] The idea of fertility in this context has related to the abundance of a well-tended natural realm, where earth, water, and sky work together with the agency of humankind to produce prosperity, goods for trade, and goods to be stored against a lean time.

Thus, a snake/arrow/spade-of-Marduk connection bridges ideas lodged in three overlapping realms: the natural world of animals and humans, the world of tools invented by humankind, and the notion of male divine agency in those associated worlds. The snake obviously represents the natural world. So, too, the phallic arrow is a sign that connotes maleness in a natural world that encompasses humans as well as many animals. The spade, in contrast, is a human-made tool that physically resembles snake and phallus. It also relates metaphorically to the snake and the phallus. In these ways the spade becomes both an attribute of and a symbol for the great male divinity called Marduk in historical periods of Mesopotamian civilization.

This set of relationships is empirically deduced and does not depend on Freudian or other modern articulations. Indeed, it is important to avoid construing meaning in the particular area of our focus by referring to cultures where very different valences operate for such creatures as the snake. These valences are not universally shared (Mundkur 1983; Anderson 1989). Even within the ancient Near East, ruptures in the longstanding tradition cited here occur at specific cultural moments for complex but demonstrable reasons (e.g., Meyers 1983: 349; Root 2002: 183–184).

There is no doubt that a critical aspect of snake imagery as we see it in late prehistory relates to a male capacity for fertility and sexual physicality couched in agrarian metaphors: the male as digger, penetrator, excavator of the earth. Aspects of the snake as purveyor of wisdom (aspects well documented in historical times) are difficult to approach for prehistory. But the association of the snake with the shaman certainly looks in that direction.

FERTILITY IN THE FEMALE DOMAIN

Another cluster of symbols from late prehistory occupies an alternative and complementary zone. This is a female domain of earthiness—essentially the

[1] Research over the years by Jessica Moore, Molly Klais, Lisa Cakmak, and Jessica Lutz has contributed substantially to this chapter.

88

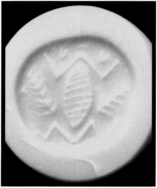

Fig. 8.1. Cat. no. 90.

host domain for the male counterpart. It is (metaphorically) the land to be marked off, dug and plowed, sown, watered, and harvested. The gendering of these two domains does not suggest rigid boundaries of thought on sexuality or social role in late prehistory. Quite the contrary, much in the record suggests an openness, an exuberance, a frankness in the fluidities of gendered symbolic thought. This permeability is also clear in later periods, when we have texts to enhance our understanding.

One seal in the Adams collection of ex-Herzfeld seals opens up our contemplation of a female symbolic domain (fig. 8.1). It offers a way of thinking about fluidity between human and animal in the female realm, just as the snake/arrow/spade enabled us to consider a similar fluidity in the male realm. This seal from Tepe Giyan (cat. no. 90) presents a waffle-patterned, lozenge-shaped central element at the heart of the circular field, framed by two slightly detached W formations at top and bottom. A tiny head in the form of a detached line appears above the pinnacle of the upper W formation. The whole creates a schematic human form shown "displayed"—its two pairs of limbs spread-eagled. The structure of the composition allows us to consider the figure in either of two ways: (1) prone, face up, and seen from above or (2) upright in full frontal mode and seen straight on. The ambiguity here is probably deliberate.

The displayed female presents her body for one or more of three defining dramatic moments relating to female fertility: (1) the invitational display of physical attributes as a preamble to sex, (2) the sex act itself, or (3) the birthing process. These possibilities are not mutually exclusive. This image is an early example of a symbol that, in one form or another, has enjoyed widespread resonance in many cultures worldwide (Fraser 1966; Anderson 1989: 73).

Sexual Display

From historical times in the Near East, there is plentiful evidence of nude females revealing themselves while standing in full frontal postures. Such figures explicitly broadcast sexual allure. They usually mark contexts of mythological and divine association that relate to larger ideas about fertility and sexuality (e.g., Collon 1987: 167 and fig. 776; Black and Green 1992: 144).

The strength of this later evidence requires that we consider our displayed female as a forerunner—as a symbol of sexual availability, perhaps within some framework of early mythical thought.

Sexual Union

The depiction of actual sexual encounter in late prehistory does not typically show the female prone on her back (or even lying down). Two examples of humans coupling in *This Fertile Land* both depict the figures standing, back-to-front (figs. 8.2 and 8.3). Other examples show seated figures (e.g., Tobler 1950: pl. CLXIII.87–.88). Sexual encounter is depicted in a variety of positions and on a variety of media and types of artifacts in succeeding eras. Somehow, the aura exuded by our displayed female seal (cat. no. 90) does not, however, conform to these traditions enough to urge that the image was intended specifically and directly to stand for, to symbolize, the sex act itself.

Sexual encounter as a representational theme in later times tended to have divine associations with the creation of the world (Black and Green 1992:

Fig. 8.2. Cat. no. 98 and drawing of cat. no. 98 by A. Wilburn.

 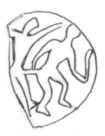

Fig. 8.3. Cat. no. 101A.

53–54) and with sacred marriage rites for the new year, in aid of institutionalized religion (Van Buren 1937–1939). Our late prehistoric seals already indicate budding notions of metaphor in this area. And the presence of the snake hovering above or alongside scenes of coupling (cat. no. 98; Tobler 1950: CLXIII.87) at minimum suggests the beneficent complicity of this creature in human performances of sexual activity as well as in the animal world (chapter 5 this volume).

Whether or not we are, however, entitled to see in the sexual coupling seals evidence of an incipient doctrinal mode of religiosity, incorporating codified rituals (chapter 7 this volume), remains elusive. It is the scorpion, not the snake, who presides over these scenes of sexual coupling in succeeding eras. This shift in the associative symbolic repertoire needs to be taken into account in any tentative commentary on this issue (see below).

Birthing

Early representations of the displayed female in the Near East clearly show birthing figures. From the Neolithic village of Çatal Hüyük in Turkey two displayed females appear in relief on walls of domestic shrines (Mellaart 1967: figs. 38 and 40). Round, swelling bellies indicate pregnancy. Arms and legs splay out and then turn upward in the same kind of electric energy emitted by the Tepe Giyan image. In this Neolithic setting, the female figures are giving birth to animals in scenes that convey special meaning. Presumably, they were intended to safeguard childbirth within the domestic shrines they decorate.

A statuette excavated from a house at the Neolithic site of Hacilar also shows a female figure in a display position. The similarity to renderings from Çatal Hüyük suggests that this also shows a woman in childbirth (Mellaart 1970: 481). Although she grasps her breasts with her hands, her legs are spread in the W formation seen on our seal from Tepe Giyan. On the statuette, the spread legs reveal carefully rendered female genitalia.

Later Mesopotamian cylinder seals include representations of birthing in various postures. On one, a very schematic female with rounded lozenge-shaped belly reveals her offspring emerging from between her splayed legs (Erlenmeyer and Erlenmeyer 1958: pl. XXXVII.49). The detached linear arms and legs in W formation echo the style of the seal from Tepe Giyan.

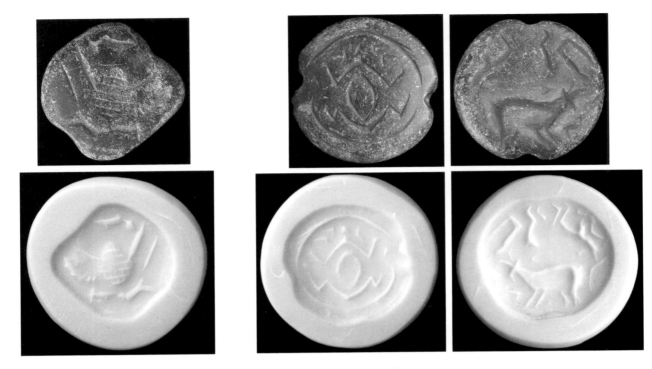

Fig. 8.4. Cat. no. 91.　　　　Fig. 8.5. Cat. no. 95 a and b.

Three Liminal Moments

The potent display posture seen clearly at Çatal Hüyük for childbirth may well be a backdrop for what we encounter in late prehistory. Our seal from Tepe Giyan thus resonates best with two of the three proposed possibilities of meaning implied by the posture. It suggests an emblem of sexual display (with a strong, later tradition to compare it to). It also suggests the female poised for or in the throes of birthing (with a strong Neolithic tradition to compare it to as well as evidence of continuity into historical periods).

Within this framing of liminal life experience glimpsed through the female domain of assertive allure and procreation lurks what is not depicted: sexual encounter. The sex act itself is certainly implied by the allure moment of the "before" and the resultant birth moment of the "after." In that sense it is a representational "absent presence" that attaches extra salience to what *is* visually present.

One may argue about how much was understood in late prehistory about the relation between sexual intercourse on the one hand and pregnancy and childbirth on the other hand. What we know of the agrarian and animal-husbandry practices of the age urges us to accept certain precepts. It would be perverse to propose a world in which humans had been domesticating and genetically manipulating plants and livestock for thousands of years without grasping elemental principles of procreation (Hole, Flannery, and Neely 1969; Zeder 1991; Zeder and Hesse 2000). It would be bizarre to contemplate a society dependent upon the maintenance of large herds of animals that somehow had not grasped the links among sexually motivated "display," sexual intercourse, and birthing.

The art itself suggests, furthermore, that lively metaphorical intertwinings of sexual act as physical urge, as mechanism of fertility, and as yielder of the

Fig. 8.6. Cat. no. 93.

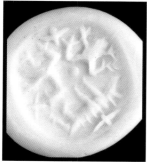

Fig. 8.7. Cat. no. 97.

procreative potential of plants, animals, and humans were firmly rooted in the late preliterate mindset. When poetic testimony does become available, these associations are already elaborately fixed in textual forms that themselves show evidence of long legacies of oral tradition behind them.

EXPANDING THE CORPUS OF DISPLAYED FEMALES

In addition to the one seal from Tepe Giyan we have discussed so far (fig. 8.1: cat. no. 90), other seals from late prehistory belong in the same image category of the displayed female. Also from the ex-Herzfeld collection in the Kelsey Museum are four more such seals. Two of these are extremely close to our first one in qualities of the female form (figs. 8.4 and 8.5). On the other two, the female forms are a little less schematic—the body being more integrated with the splayed append-ages (figs. 8.6 and 8.7). Similarly, an ex-Herzfeld seal from Tepe Giyan now in the British Museum is closely connected; its displayed figure belongs formally with this second cluster (fig. 8.8).

Since we can now actually examine these five ex-Herzfeld seals at the Kelsey, it is interesting to note that all five are carved of the dark gray or black rock often generically described as "steatite" in the literature and are of approxi-mately the same weight. All the seal shapes are either hemispherical or slightly conical or flattened, rounded shapes. None has an angular back like the protru-berance on a button-type seal. Without being utterly standardized, they share a physical conduciveness to holding and turning in the palm of the hand.

All five of these seals now in the Kelsey Museum show a great deal of wear on their carved surfaces. They stand out as distinctive in this respect. Thus, it is remarkable that not a single ancient impression of this type of prehistoric stamp seal has yet come to our attention. A search for comparanda for the dis-played female imagery so far adds four more seals to our group: one excavated (post-Herzfeld) at Tepe Giyan (Contenau and Ghirshman 1935: pl. 38.30; Bu-chanan 1967: 275), one excavated from a grave at Hakalan (Wickede 1990: fig. 39.1; Haerinck 1996), and two unexcavated examples (Amiet 1972: pl. 188 and Keel-Leu 1991: pl. 12).

The five seals in the Kelsey, the one ex-Herzfeld seal in the British Mu-seum, and these other four comparanda add up to ten seals depicting the dis-played female. Even with this fairly significant array of evidence of the motif, no comparable image is preserved through an ancient impression demonstrating its use as an administrative tool to seal a container or a door. Ten seals to zero ancient impressions is verging on a statistically significant ratio for an entire glyptic image category.

Fig. 8.8. Cat. no. 101B a (right) and b (left).

The presence of much abrasion on the carved surface (for the seals we have been able to examine closely) combined with the absence of any evidence of the motif in sealing contexts compels consideration. The displayed female seals may have been used exclusively in ritual practice. They may have been used as talismans to court good outcomes in birthing and the attendant needs of females and newborns—or as amulets to ward off the dangers lurking in those realms. These practices relate to magic and to imagistic religion (chapters 6 and 7 this volume).

In such contexts, they must have been deployed energetically to produce the kind of wear we see. The rock these seals are made of is quite soft and can be subject to visible abrasion through vigorous rubbing against many kinds of surfaces (including one seal against another) and even aggressive scratching with a fingernail. We must imagine these seals as performative tools in personal rites and procedures associated with females and their bodily/spiritual needs. From later times in the region, texts describe rituals involving the binding of seals on the body in birthing rituals (Goff 1963: 18; Marcus 1994: 9).

A later small copper figurine excavated at Tepe Hissar, Iran, perpetuates the tradition of displayed females as talismanic or amuletic items beyond the divide between preliterate and literate periods. It presents a schematized female, arms and legs stretched straight out to the sides, with a head formed of a simple triangle (Schmidt 1937: 191). The object and its find spot suggest personal use rather than votive intent as an offering to the gods.

Our theory about the displayed female seals is based on an argument *ex silentio* (an argument dependent on the absence of evidence to the contrary). This is very risky. It could be called into question simply by the discovery of one single bit of evidence showing that displayed female images were indeed used for sealing purposes in late prehistory. Nevertheless, the positive evidence we do have emboldens us for the present to make the tentative claim. If evidence of sealings with the displayed female does emerge, then we can interrogate it in the hope of discerning something about the use context that leaves our theory at least partially intact.

We must remember that there are many conditions under which a seal might be used to make impressions in clay. These reasons include administrative procedures in the usual sense. They may also have included procedures very specific to the domain of sexuality and fertility we are investigating here. There may have been doors to close off birthing rooms or chambers for sequestering during menstruation. Such areas might have needed to be sealed just as a door to a storeroom needed to be sealed. These needs and practices are well documented for ancient Egypt (Pinch 1994). We may someday find material evidence that seals were impressed in clay directly on the body as part of a ritual.

HUMAN-ANIMAL ELISIONS IN SEXUALITY AND FERTILITY

Scorpions

The most schematic renderings of displayed females on the late prehistoric seals are provocatively similar to the look of the scorpion. Indeed, one seal in the Kelsey Museum looks like a hybrid between a displayed female and a scorpion (fig. 8.9).

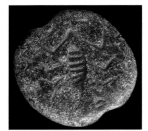
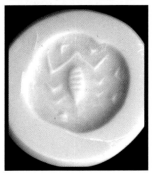

Fig. 8.9. Cat. no. 92.

The creature has a striated body reminiscent of what we see on two of our ex-Herzfeld displayed female seals (cat. nos. 90 and 91) as well as on two of our comparanda (Amiet 1972: pl. 188; Keel-Leu 1991: pl. 12). But the shape of the body now diminishes toward the lower end. The upper W formation remains—but in the absence of the complementary lower W, this evokes the pincers of a scorpion rather than the spread arms of the human female in display mode. Along the sides of the body appear two more legs, rendered as isolated notches in two neat rows.

Herzfeld actually sketched this creature with a scorpion's tail, although no tail is visible on the artifact (Herzfeld 1933: fig. 18). Even if this figure really had a scorpion tail, it would not be anatomically correct for the form in nature. It would need the pincers plus six legs (three on each side of the body). But the blurred boundary between the displayed female figure and a naturalistic scorpion is precisely what interests us here.

Scorpions in naturalistic form appear in Near Eastern art as early as the 5th millennium BCE, and they remain significant and prevalent throughout all antiquity in the region (Van Buren 1937–1939). In the ancient Near East the scorpion was a powerful symbol of both fertility and its corollary, prosperity. It was an attribute of and a symbol for the goddess Ishara, a goddess of human fertility and agricultural productivity. This identification with Ishara is secure. Three Babylonian boundary stones ("kudurrus") display symbols of the gods that actually include written captions. On each of these, the scorpion bears the label "Ishara" (Van Buren 1937–1939: 1; Seidl 1989: pls. 6.10 and 15.32).

As a goddess presiding over human fertility, Ishara was syncretized with Inana, the goddess of love, sexuality, and prowess in war (Roberts 1972: 37), and with the Sumerian grain goddess Nisaba (Roberts 1972: 47; Black and Green 1992: 143). Therefore, the intervention of Ishara was sought in human marriage, the mating of domesticated animals, and the fructifying of cultivated crops (Van Buren 1937–1939: 16). She seems to have functioned as a patroness of irrigation as well as other aspects of cultivation (Van Buren 1937–1939: 7). She also served as a guarantor of oaths and a protector of established communities. With all these interests, Ishara's presence—made manifest through the scorpion—was marked in representations as a symbol accompanying a wide variety of motifs, from scenes of sexual display, sexual intercourse, and birthing to scenes of contesting animals, banquets, and agricultural rituals. One cylinder seal known through its impression on a sealing from Ur of about 3200 BCE demonstrates the association between the sexual act and the scorpion in the period just after late prehistory: a couple engaged in intercourse, with a scorpion to one side (Legrain 1936: pl. 18.366). Van Buren interprets this imagery as a representation of the sacred wedding and the goddess Ishara's oversight of these ritual enactments (Van Buren 1937–1939: 16).

Often, too, the scorpion stands alone as an independent symbol for the goddess and her protective capacities over all she surveys. In late prehistory, scorpion imagery on stamp seals is already an established feature in the repertoire (cat. nos. 92, 94a, 96, 99a, 100), not only at Tepe Giyan and Tepe Gawra but also at Susa (Amiet 1972: no. 460). We cannot insist upon an association with a female divinity of established reputation and meaning at this early time. But, as

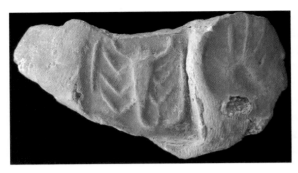 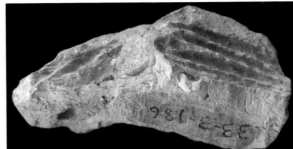

Fig. 8.10. Cat. no. 99.

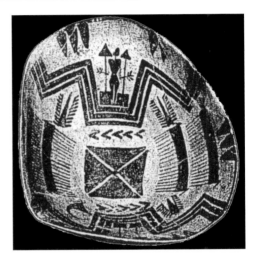

Fig. 8.11. Cat. no. 112.

we shall discuss below, it may be possible to speculate about a notional precursor of Ishara back in late prehistory.

Whatever the outcome of that speculation, it is noteworthy that we do find seals with the scorpion device used in clearly administrative contexts in late prehistory. The clay envelope from Farukhabad, impressed on the exterior with a scorpion stamp seal as well as with numerical markings, is especially eloquent on this point (cat. no. 100). The sealing from Tepe Gawra with deep rope marks on the back and a scorpion seal on the front surface could be indicative of a door sealing (fig. 8.10).

On a bowl from the Susa cemetery (fig. 8.11), a lone scorpion occupies one of the quadrants otherwise given over to flying vultures. This much-discussed artifact includes two segments that depict standing spade symbols on pedestals. On one side of the bowl, where the scorpion moves, the spades stand alone. On the other side, the space between the spades is occupied by a standing (apparently male) human figure with arms outstretched. The position of the scorpion in this provocatively asymmetrical composition suggests the creature's agency in the arrival (creation?) and elevation (deification?) of the human figure.

Several qualities of the scorpion in nature must have contributed to its associations with the goddess of human fertility. Scorpions do not mate until they are seven years old. The gestation period of the female scorpion is extremely protracted, lasting approximately thirteen months. Furthermore, she carries her offspring on her back. Thus, the scorpion resembles the human in certain behavioral aspects.

Ancient Near Eastern astrological texts identify the constellation Scorpio as Ishara (Van Buren 1937–1939: 1), and it is thought that this association goes back to remote times (Langdon 1914: 159). Scorpio is a dramatic constellation in the night sky, with its great pincers and elongated tail. This vision must also have forcefully compelled the imagination, leading to the proliferation of scorpion imagery from late prehistory down through later times.

The fact that the scorpion in nature is a creature with deadly powers was surely never far from consciousness in antiquity despite all the helpful roles ascribed to it. Like the snake, the scorpion needed to be conciliated by humans in the belief systems they constructed precisely because of its potential deadliness—especially to children. In terms of magical efficacy, the heavy benevolent roles laid on both the snake and the scorpion were a means of spinning webs of mythology around them so as to co-opt and neutralize their sinister aspects in the real natural world (Pinch 1994: 36–37).

Fluid States

The schematic displayed female seals are deliberately ambiguous in their evocation of scorpionlike qualities. Their form reflects a fluidity of identification between the human female and the scorpion. Some vestiges of that fluidity persist into later times. One cylinder seal from Susa shows a copulation scene in which the female is bent over at the waist, to be entered from behind. Her arms are bent out and up to frame her head—making her upper body look very much (and very deliberately) like a scorpion with extended pincers (Amiet 1972: pl. 175.2012).

The deliberate ambiguity between a significant class of the late prehistoric displayed females and the body of the scorpion indicates a perceived connection between human sexuality and the scorpion already at this time. Later, the two entities are usually separated so that the scorpion accompanies scenes of human-form figures.

Tortoises and Frogs

As a patroness of irrigation, the Mesopotamian goddess of fertility, Ishara, had links with the god Enki, of fresh waters (Van Buren 1937–1939: 27). The tortoise was an attribute of Enki (Van Buren 1936: 27). One of our late prehistoric seals seems as much like a tortoise as a scorpion (fig. 8.6). Its form is more solid, its head more pronounced. Others resemble frogs with outspread limbs (figs. 8.7 and 8.8). Their appendages are more physically integrated with their bodies. Their more corporeal aspects suggest the compact bodily qualities of frogs rather than the spindly qualities of the insect.

While the tortoise has its clear later history of association in doctrinal religion, the frog remains, throughout ancient Mesopotamian cultures, a figure of magical curative intervention in personal spheres (Van Buren 1936: 35–37). Both creatures operate in the realms of watery nature and thus associate with procreation and female matters. As with the scorpion, the frog's meanings and resonances around fertility are closely similar in Egypt (Maguire, Maguire, and Duncan-Flowers 1989: 10; Shaw and Nicholson 1995: 124).

An intriguing open bowl from the Susa cemetery shows a tortoise in the center of a composition, with sheep both above and below it and "quivers"

Fig. 8.12. Cat. no. 105.

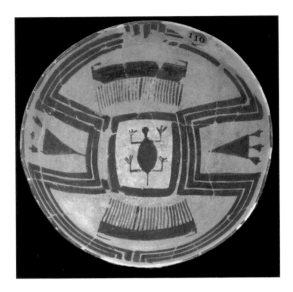

represented on either side (fig. 8.12). This is a most unusual variation on the decorative schemes of the open bowls from Susa. It is noteworthy that the two most remarkable variants on the norm in these bowls interject either the scorpion (cat. no. 112) or the tortoise. Furthermore, in both these cases the creature appears in a context in which inanimate emblems seem to bespeak important issues of emergent authority in religious-secular arenas. Both the spade and the quiver appear in decorative programs on the tall beakers from Susa.

We have already discussed the meaning of the spades on cat. no. 105 and elsewhere (e.g., cat. nos. 102 and 104). The quiver has been interpreted as a sign for the chief or his god (Pottier 1912: 38; Hole 1983: 319)—as a sign relating to the military domain of a powerful community figure. Similarly the tortoise may here be emerging as a symbol for a divine essence—in this case a divine essence that supports the irrigation of the fields. It is probably not a coincidence that somewhat later both the tortoise and the scorpion are strongly associated with the goddess Ishara.

Like the scorpion, the tortoise in the bowl is a symbolic agent, a facilitator of creation and fulfillment of the prosperous destiny mandated by the male community leader with the aid of higher orders of being (incipient deities).

Symbolic Frames

Open bowls from the Susa cemetery corpus frequently present the central element of the decorative program within a distinctive frame. Composed of parallel bands, the frame echoes the contours one may draw around the displayed female figure seen on our seals. It is open at top and bottom, arcing widely at both ends and moving inward toward a swelling middle zone. The arcs at top and bottom convey the same sense of sweeping, dynamic electricity conveyed by the complementary W formations of the displayed female. The middle zone suggests the belly core of the female bodily display. On the bowls, the middle zone hosts a limited range of significant emblems that anchor the entire visual field: usually a cross, but in this unusual case a tortoise instead.

Fig. 8.13. Cat. no. 90.

This framing motif may allude to the idea of irrigation running with orchestrated inevitability through and around the symbolic landscape of the entire vessel. It may simultaneously allude to the notion of the displayed female. Such polysemous allusion is in keeping with the world we have entered in *This Fertile Land*.

The framing of images, as one way in which visual meaning is produced, is part of the now classic discourse of art history (Schapiro 1969 [1994]: 1–32). Concepts of the optical and mental reception of frames, as dynamically and intrinsically expressive agents, are also part of the now classic discourse in studies of the psychology of visual perception (Arnheim 1982: 42–70). Furthermore, the ways in which pattern and substance interweave are now integral to the learned tradition of art history (Gombrich 1979). When Alois Riegl wrote his seminal study of ornament (Riegl 1985 [1893], 1992), the painted ceramics from Susa had not yet emerged from the ground. Since then, some forays into the expressive dynamic of form and narrative in ancient Near Eastern art have been attempted—most notably by H. A. Groenewegen-Frankfort (1978 [1951]). But a systematic study of the strategies of the extraordinary late prehistoric repertoire in art historical terms still remains unrealized.

FERTILITY, DIVINITY, AND MALE-FEMALE CONTIGUITY

On the displayed female seal with which we introduced this chapter (cat. no. 90), there are subsidiary elements in the design field that we have not yet acknowledged. A notch nestles in each of the two upward-opening V shapes of the W formation that indicates the female's outstretched arms. Two diagonal rows of notches flank the belly of the figure. On one side the notches are strung together by a fine line; on the other side they are set contiguously. In both cases, the result suggests sheaves of grain (fig. 8.13).

With its framing attributes of sheaves of grain, the image on the Tepe Giyan seal further conforms to images specifically called the "heraldic female" or "heraldic woman" in the ethnographic literature (Fraser 1966): a displayed female heraldically flanked by associated motifs that further inform her meaning.

The two notches near the head of our displayed female and the sheaves of grain flanking her body remind us in their positioning and narrative impact of the relation of the shaman to the subsidiary elements on another Tepe Giyan seal (cat. no. 30). There two dots (rather than two notches) nestle between the upraised arms of the shaman, and snakes (rather than sheaves of grain) pose along the sides of his body (fig. 8.14). Furthermore, the suggestive allusions to the scorpion through the posture of the female are similar in affect to the acquisition by the shaman of properties of the ibex. The dynamism of the human body in each case is charged by the agitation of arms and legs. The shaman, although barely more than a stick figure in corporeal values, dances with spellbinding vigor and abandon.

The shaman and the displayed female come together in one of the ex-Herzfeld seals from Tepe Giyan that is now in the British Museum (cat. no. 101B.a). Here two shamans flank a displayed female with notches and animals to either side

Fig. 8.14. Cat. no. 30.

98

Fig. 8.15. Cat. no. 101B.a.

on the outer margins (fig. 8.15). We may be witnessing glimmers of mythologized presentations in which powers of the male divinity of agricultural significance (an emergent Marduk) and those of the female divinity (an emergent Ishara) of similar realms may start to work together within a pantheon of interrelated essences.

Earlier we noted some possible connotations of the dots and notches (chapter 5). Whatever their precise meaning(s), they surely relate intimately to the composite meaning of each central figure. So, too, the snakes for the shaman and the sheaves of grain for the displayed female suggest that they have acquired the status of attributes—of symbols that defined for the beholder the identity of the figural image.

Attributes are a crucial mechanism in doctrinal religious contexts for the presentation, transmission, and perpetuation of codified meanings around divinity. In the ancient Near East the most vivid material examples of this come with the Babylonian boundary stones (kudurrus) of the 2nd millenium BCE. Encyclopedic inventories of attributes of and symbols for divinities range across these monuments: the spade of Marduk, the scorpion of Ishara, the tortoise of Enki, the snake, the solar emblems—so many of the symbols that we have glimpsed in late prehistory (fig. 8.16).

Looking once again, in closing, at our first displayed female seal, let us compare it to a cylinder seal from the early 2nd millennium. Here we see a presentation scene. Two worshippers approach the goddess Ishara. The first holds a plow, the second, a measuring pot for grain (Van Buren 1937–1939: 19). The sheaves of wheat sprouting forth from the shoulders of the goddess secure her identification. They are her attributes. In this they are no different from the sheaves of grain on our seal more than 2,000 years earlier. The scorpion lying beneath the measuring pot clinches the identification with Ishara on the Old Babylonian cylinder seal. This is a symbol for the goddess. It can stand for her. In late prehistory, a proto-Ishara may not yet have separated out the symbol from the anthropomorphic manifestation.

According to Jacobsen, "the ancient Mesopotamian saw numinous power as a revelation of indwelling spirit, as power at the center of something that caused it to be and thrive and flourish" (Jacobsen 1976: 6). This is Jacobsen's articulation of the concept of immanence. He understands this concept to have emerged during the protoliterate period or even earlier—in late prehistory (Jacobsen 1976: 9). Our explorations of signs and symbols in this early age reinforce Jacobsen's observation.

FERTILITY: WHAT IT MEANS

There is ample literature examining life and procreative agency in Paleolithic and Neolithic communities, considering representational traditions together with archaeological information on lifestyle, life cycle, and diet. Although late prehistory has not been subjected to the same intensity of interrogation in symbolic terms, archaeological and ethnographic data confirm the applicability of the same enlightened commentary on such matters. Fertility as a concept means something different to people in industrially developed countries today than it did in remote ancient times.

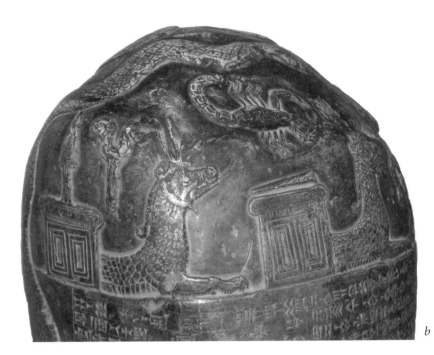

Fig. 8.16. (a) Cast of the kudurru of King Marduk-nadin-ahhe of Babylon (1099–1082 BCE). Kelsey Museum 2004.3.1. Original: British Museum WA 90841. (b) Detail.

Fertility in *This Fertile Land* does not mean to suggest an obsession in late prehistory with having many children per se—either for economic or religious reasons. We must heed the lessons of scholarship on earlier ages. Notions that the pregnant or birthing woman was deified as a symbol of the desirability of constant pregnancy have been discredited for Paleolithic and Neolithic periods. Representations of swollen, pregnant figures in these environments encapsulated ideas of abundance, well-functioning life cycles, and more. They were not, however, statements of an ideal of the female human physical state or admonishments to bear as many children as possible (Voigt 2000; Cohen 2003).

For late prehistory, many factors made the production of large families impractical. Optimally, a small group of offspring were produced who would actually survive the challenges of birth and infancy—along with the mother. Human fertility was important, as was every attempt to safeguard the life of the birthing mother and the newborn infant—but not rampant "fertility," in the sense of more is best. So, too, the monitored, successful fertility and the health of the animals tended in herds among the communities of late prehistory were critical to survival and to prosperity. Thus, fertility as we use the word here refers to notions of abundance in flourishing realms of a well-ordered world: its earth, sky, and waters; its humans, animals, and plants.

PART IV

Historiography, Archaeology, and the Art Market

9
Problems in Interpreting Late Prehistory

Margaret Cool Root

EUROCENTRIC MINDSETS

There are several burdens placed on our ability to work with the late prehistoric Near East. Elements of historiography certainly come into play. The interpretive history of how historians have dealt with the remote and preliterate past reveals a great deal, in other words, about our own ability to deal with that past. A persistently eurocentric mindset, which still prevails in many quarters, maps the world according to a conceptual center lodged in Western European traditions.

In the arena of the history of religion, we have seen that ancient Rome profoundly influenced how modern Western scholars have approached the task of categorizing the many varieties of religion in the world. Until recently this has often led to rigidities in thinking that have privileged the written and the underlying concepts of *relegēre* (to reread) in collusion with *religāre* (to bind) over other cognitive mechanisms for the codification, maintenance, and even monitoring of religious knowledge and belief (Johnson 2004; chapter 7 this volume).

In the arena of magic this is also true. Our very word *magic* derives from the Old Persian word *magus* (pl. *magi*), meaning a member of the ancient Persian priesthood of the fully historical era of the Achaemenid Persian empire (ca. 550–330 BCE). It is paradoxical indeed that our word *magic* derives from a culture that was self-proclaimed to have had an "Ordinance of Good Regulation," as King Darius the Great refers to it in the inscription on his tomb façade. This referential text is itself laced with guidelines on the practice of proper behavior in serving the wishes of the great god Ahuramazda (Kent 1953: 138–140).

The association of magic with Old Persian *magi* has roots in the way ancient Western commentators on the Persians considered Persia. Ancient Persian religion (like Persian culture in general) was sometimes poorly understood or deliberately misrepresented by the ancient Greek and Roman commentators for various reasons. These reasons ranged from overt political hostility to problems of interpreting the available evidence based on cultural misconceptions and miscommunications (Root in press). Among the latter was an evidentiary problem that modern commentators also face: the Persians even of historical times had an intensely oral tradition of transmission. Furthermore, their religious practices were very different from those of the West and were vulnerable to misunderstanding. They revered elements of nature such as fire, water, and earth. They incorporated symbols of fire, sun, and moon in their representations of worship ritual. They did not produce cult statues of their supreme deity, as the Greeks and Romans did for their entire pantheon of gods. And their renderings of this

supreme deity on relief sculptures and seals depicted a figure of ambiguous essence: a human form only half-bodied, emergent from a winged disk and floating in the sky. To top it off, their priests used the hallucinogenic *haoma* plant in the practice of their rites.

The religion of the historical Persians must have seemed to the Greeks and then the Romans like a practice of sorcery, astrology, and shamanistic magical performance out of the remote past. Certainly not a true form of *religionem*, as the Romans would put it. And thus the Persian *magi* of historical times become for us the paradigmatic magicians.

The difficulties the ancient West had classifying the practices of the Persian priesthood as anything but "magic" resemble the difficulties modern Western theory continues to have in grappling with the bleeding boundaries of religious practice and magical efficacy in late prehistory. Such boundaries defy rigid categorizations based upon very specific and selective traditions. Our ability to deal with late prehistory on its own terms will depend in part on our ability to move beyond certain entrenched paradigms of Western thought. The studies in theories of religiosity that are most congenial to the mixed experiential domain of late prehistoric Iran and Iraq emerge out of disciplines that are less constrained by this classical legacy: cultural anthropology (e.g., Rappaport 1999) and, quite significantly, discourse on cognition, as Johnson has shown.

ARCHAEOLOGICAL PRACTICE

This Fertile Land interprets the late prehistoric archaeological fruits of Iranian and Iraqi soil. The artifacts on display also have modern histories. These histories have molded scholarly and public reception of the objects in various ways; they have intertwined with political and personal destinies of the early 20th century of our own era—about 6,000 years after the cultural urgencies that initially prompted their creation.

The original context of an artifact must be physically destroyed in its excavating—even when the excavation conforms to the highest scientific standards. Its locus among other artifacts and in relation to diagnostic indices of date, use, and nuances of cultural meaning is lost except through the meticulous production of field notes. Such field records ideally will systematically record data that in some cases will wait for generations to find scientific applicability—as new technologies and approaches to learning open new doors. Once an artifact is removed from the soil without precise documentation, a crucial part of it is lost forever. When this happens with large bodies of evidence, the loss is exponential, for the potential scientific value in examining statistically informative quantities of evidence all from the same cultural context has been seriously compromised if not entirely eliminated.

LOST IN THE SUSA CEMETERY

The quintessential "large body of evidence" is the corpus of thousands of painted pots from the late prehistoric cemetery at Susa. Frank Hole has rightly said,

The vessels from the cemetery, as well as seals from Susa and other sites, exhibit a large corpus of motifs and combinations of design elements that provide rich possibilities for the study of personal emblems, specific iconographic motifs, associations of motifs with one another, stylistic differences and changes, and comparisons outside Susiana. (1983: 319)

Retrieving Representational Interactivity

This stipulated set of potential projects is of great anthropological and art historical interest. In essence it states the challenge we have laid out visually, as a catalyst for further work, in *This Fertile Land*—the importance of seeing the painted pottery and glyptic representational traditions as part of an interactive cultural system. Yet it is impossible to consider the painted pots from a whole range of vantage points because we are unable to reconstitute specific grave assemblages. The individual grave lots apparently were not recorded. Thus, we cannot know which specific pots went with which others to make up grave sets. A question twists in the wind: what, if any, correlations did exist between imagery deployed across the vessels in the typical three-pot sets?

To be sure, there are ways of querying the sea of variables represented in the corpus to see whether any patterns emerge relating to ceramic sets. We can develop tools for statistical analysis of the design systems across the vessel types, factoring in gross variations in work quality and looking at the whole excavated corpus. Interesting as such an exercise would be, its outcomes (of abstract theoretical interest only) might not be considered worth the expenditure of labor and commitment. The situation would be different if we could run statistical analyses on this issue knowing from the start which pots had been interred together. Even starting from that position, there would be plenty of variables to query statistically. But in that case, the outcomes would have some empirical substance to counteract inevitable concerns over the credibility of a project layered, by definition, with so much subjective input in its design.

Adding Gender, Age, Nutrition, Status

Not surprisingly for the time, the skeletal remains from the early Susa cemetery excavations were not systematically and scientifically analyzed for sex, age, and health/nutrition information. Nor were these remains apparently kept for later generations to investigate. They certainly were not systematically labeled and recorded according to which bones were interred with which grave assemblages, which specific vessels, and so on. Such data might have informed analyses of the imagery systems on the pots (e.g., enabling us to ponder gender-specific schemes).

So too the fifty-five copper axes and eleven copper disks associated with some of the graves cannot be linked up with specific decorative programs on the pottery or with their quality level. The capacity to make connections between the copper offerings and specific skeletal material is, of course, out of the question (Hole 1983: 316). Jacques de Morgan speaks very briefly of male and female skeletons and of distinctions in grave goods; but his remarks are anecdotal and unverifiable (1912: 6–13).

Lost opportunities for skeletal analysis are hardly unique to Morgan's work at Susa. This is the case even in situations where the archaeology was

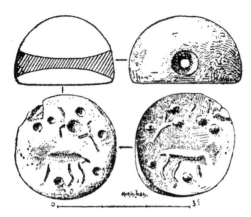

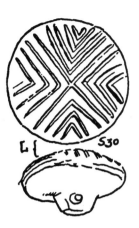

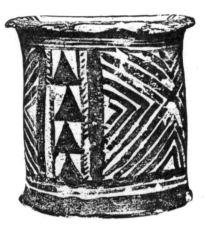

Fig. 9.1. Stamp seal apparently found in a vessel from the Susa cemetery. After Morgan 1912: fig. 25 bis.

Fig. 9.2. Stamp seal purportedly found covering a vessel from the Susa cemetery. After Herzfeld 1933: 87, fig. 14.

Fig. 9.3. Squat beaker from Susa, purportedly associated with seal in fig. 9.2. After Mecquenem 1912: pl. IX.1.

enlightened enough to imagine the significance of such issues and thus to make records of what objects went with which bones. Often in the early years of archaeology seemingly definitive commentary on the sexing of skeletons and the gendering of grave goods associated with them proceeded from the grave offerings to the skeletons rather than the other way. Unfortunately, gendered analyses of the offerings were sometimes based upon culturally biased (and incorrect) assumptions about what constitutes an appropriate item for a man as opposed to a woman. (Cosmetic pots are for girls; axes are for boys.) The results in such instances are suspect (Buchanan 1967: 539–540).

Seals in the Cemetery

Confusions on important points have crept into the literature and been compounded from the earliest publications of the finds.

It is well accepted that seals were extraordinarily rare in the grave assemblages of the Susa cemetery. Depending upon whom one reads, the excavators discovered either one seal or two in this context. Morgan (1912: 10, fig. 25 *bis*) published a sketch of the seal he presumed unique—a hemispherically shaped stamp decorated with a scorpion, quadruped, and dots—noting that it was found in the bottom of a vessel (fig. 9.1). Amiet (1972: 6; 1980: 20, fig. 114) reiterated the uniqueness of this seal to the entire cemetery. The particular associated pot was not, however, specified in any of these references. Hole (1983) echoed the remarkable fact that only one seal was excavated from the entire Susa cemetery—now without identifying the actual seal to which he alluded or mentioning its association with any vessel.

Alternative information was offered by Henri Frankfort (1924: 37), who noted that *two* stamp seals were found in the cemetery: one of them being the seal published in 1912 by Morgan ("with a rough animal representation"); the other being a seal with a "very vague cross-lined design." The latter seal seems likely to be identical to one sketched by Herzfeld and listed as from Susa (fig. 9.2). It is a very large button-type stamp seal displaying a cross with chevron-

filled quadrants (Herzfeld 1933: 87, fig. 14 [S30]). It is larger but otherwise very similar to two ex-Herzfeld seals from Tepe Giyan (cat. nos 11.e and 11.g).

Herzfeld stated that this seal was found used as the cover for a small cylindrical beaker in the cemetery. He cited this beaker as the one published in Mecquenem's study of the painted pottery (1912) as pl. X.1. This particular squat beaker is decorated with a prominent motif of a cross with nested chevron-filled quadrants filling a rectilinear frame (fig. 9.3).

The vagaries, compounded by the mysterious inconsistencies, of information on the relation of the seal(s) to the pot(s) are frustrating indeed. Further detective work may clarify the matter, but this is far from certain. And in any case part of the point is that for such a rich and fascinating body of evidence so much confusion exists on basic matters.

Seeking the Individual

How interesting it would be to feel confident in Herzfeld's authoritatively offered comment associating the chevron-filled cross seal to the beaker so similarly decorated. The chevron-filled cross motif is quite rare on the painted vessels. The statistical chances of the cross seal noted by Frankfort and Herzfeld ending up by sheer coincidence as the cover for this very particular pot are truly minuscule. If we had secure and unambiguous information, we might test hypotheses about a relationship between the imagery selected for the vessel in this burial and the seal included with it. This would provide us with a way to posit notions of the individual as represented through the Susa burials. The search for information on the signs and symbols of late prehistory as elements of individual identity, although difficult, is well worth some effort. Hole rightly offers it as a goal in the statement quoted at the beginning of this chapter. But the challenges—especially the challenges to our preconditioned mindsets—are myriad. It is one thing to imagine individual preference and ownership designation marked by some of the distinctive representational seals known to us through sealings from Susa and elsewhere: seals displaying shamans, for instance. It is another thing to imagine an individual emerging in relation to the highly conventionalized renderings of chevron-filled crosses.

We are programmed to privilege idiosyncratic representational imagery as emblematic of individual identity, choice, and cultural signification. We are programmed to see geometric pattern as symptomatic of the generic, non-individualized, and meaningless in any sense we would associate with personal identity. In *This Fertile Land* we have urged the potential significance of studying even very abbreviated geometric motifs as signs and symbols of potentially high cultural charge—even when we do not feel totally comfortable in defining precise and unambiguous meanings in all cases. There are also other ways in which geometric devices can exert force. They do not have to stand for other things in a semiotic sense in order to impart significance. Taken further, this conversation would lead us toward broad cross-cultural issues of the varying social and communicative roles of abstract design and "ornament" in distinct environments. This is an important topic, but not one we can treat adequately here. Suffice it to say that the material is available from the late prehistory corpus to add to such discourse in interesting ways. It is not as informative as it might have been because of flaws in retrieval at Susa (and Tepe Giyan). But it is still useful.

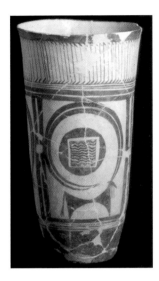

Fig. 9.4. Cat. no. 109.

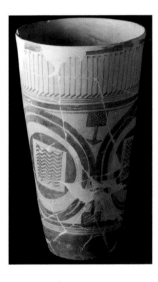

Fig. 9.5. Cat. no. 102.

Seals in Pots/Seals on Pots

Whatever the case regarding the linkage of actual seal(s) to actual vessel(s) in the Susa cemetery, the small number of seals found in these thousands of grave assemblages (one—or perhaps two, if we believe Frankfort and Herzfeld) seems astounding. Can we trust the excavation records on this point? Is it possible that a number of seals were skimmed off for the market at the time of excavation? Perhaps such skepticism is unwarranted, but it emerges out of our experience with issues to be addressed by Mallampati (chapter 10 this volume). If we do choose to be skeptical about the validity of the claim, we find some justification in the fact that seals have certainly been found with burials at other sites of the same period.

The matter is of great interest, since the exclusion of seals from the grave assemblages at Susa has led to speculation that seals at this time and in this place "were not associated with individuals" (Hole 1983: 321). It may be more apt, however, to consider that the secondary nature of most of the burials explains the lack of seals.

Elsewhere we have commented on the sense of emblematic placement of key motifs on the painted pottery from Susa—motifs that bear strong auras of contemporary stamp seal imagery writ large (figs. 9.4 and 9.5). Is it possible that these relationships indicate a deliberate production strategy for sets of these vessels? The ceramics specifically produced for the Susa cemetery were clearly intended for these ritualized secondary burials. We may be seeing decorative schemes on these pots that in some cases consciously folded in reference to seal devices in order to serve the identity needs of individuals (or individuals as members of differentiated social groups such as families or institutional affiliates). The idea would be that the seals of these individuals (originally kept with their dead bodies) were no longer available for reinterment (for whatever reason).

Perhaps it is not a coincidence that the only seal (or seals) stipulated as coming from the cemetery are said to have been retrieved from placement *in* or *with* pots. This would make it all the more appealing to consider the emblematic manifestation of seal imagery *on* pots.

10
Archaeology and Collecting:
Law, Ethics, Politics

Hima Mallampati

INTRODUCTION

Archaeological fertility, unlike agricultural fertility, is not a renewable resource. The only new antiquities that will grow in the place of those removed from the soil will be forgeries (Muscarella 2000).

Practices of uncontrolled antiquities collecting—ranging from unscientific excavation practices, to well-intentioned but context-destructive harvesting, to rampantly illicit site looting—all in varying degrees arise in relation to artifacts on display in our exhibition. Two of our cases also involve the unknowns left in the wake of the retrieval of unusually large bodies of site-specific evidence. These two cases are the early excavation strategies at the Susa cemetery under Morgan for the French mission (Carter 1992) and the harvesting situation Herzfeld pursued at Tepe Giyan (Root 2000).

On the other side of the ledger, we also bear witness here to an array of exemplary archaeological practices from the early 20th century down into the 1990s. These include the late 20th-century French and international investigations at Susa seeking to salvage information from the earlier years of work there through carefully targeted and analytical new excavation as well as painstaking reexamination of old records and old trenches. The exemplary side of the ledger also includes wholly new excavation and survey projects aimed at careful elucidation of the past.

Here we narrate some of the legal, ethical, and political intricacies of archaeological practice, primarily in Iran, in the early 20th century. We take this story up to the present day, with its troubling intersections inscribed across war, archaeology, looting, and the art market in the early 21st century. Our goal is twofold: (1) to elucidate Ernst Herzfeld and his contemporaries in relation to their ambiguous positions as archaeologists and collectors of late prehistoric art in Iran and (2) to explore the history of antiquities legislation in a somewhat larger context—beginning with Iran and Herzfeld's interesting role there and moving on to discuss its more recent past and its prospects for any kind of future in a global setting. Overall, then, we present the artifacts discussed in *This Fertile Land* against the backdrop of legal, ethical, and political histories, making particular use of primary documents.

We in the United States can probe this history using our own government archives. For, as we shall see, the United States was very invested in the outcomes of archaeological policy in Iran right from the beginning of the 20th century. The plentiful records held in the National Archives, College Park, MD, form the basis of investigation here. Other important U.S. resources for such work include the Ernst Herzfeld Papers in the Freer Gallery of Art and Arthur M. Sackler Gallery Archives of the Smithsonian Institution in Washington. Archives in relevant

European countries (particularly Germany and France) are increasingly subject to penetrating historiographical inquiry on the topic at hand (Gunter and Hauser 2005). And in Iran state archives are now accessible for scholarly work that is being produced for an international community (e.g., Abdi 2001).

ARCHAEOLOGY AND COLLECTING IN IRAN—EARLY YEARS

The vicissitudes of archaeological inquiry in Iran reach far back in time. From an Iranian perspective, efforts are being made to elucidate the tensions of mythology, history, and politics that accompanied thinking about and documenting the past in such a richly textured, ancient land (Mousavi 2002).

A watershed moment in the modern archaeology of Iran occurred in 1900. On August 11 of that year the French were granted an exclusive and perpetual right (an archaeological monopoly) to be the sole conductors of fieldwork in all of Iran (National Archives: copy of the official agreement [M715, Roll 37, 891.927/5]; unnamed 1916 document furnished by the Persian legation in Washington in 1923 [M715, Roll 37, 891.927/-]; Abdi 2001; Majd 2003). Under Article II of this agreement authorized by Mossafer-ad-Din, the reigning shah of Persia, the French were (a) required to compensate the Iranian state for full value of all gold and silver objects found during excavations; they were (b) granted ownership of one-half of all objects unearthed in excavations outside of Susa; and they (c) gained sole ownership of all objects excavated within Susa.

Under the auspices of this international agreement and with the aid of more than 1,200 local workers, the French archaeologist Jacques de Morgan oversaw fieldwork in the late prehistoric cemetery at Susa for several years in the first decade of the 20th century. The finds, including thousands of painted pots from the graves, were sent to the Musée du Louvre in Paris for exhibition and study (National Archives: W. Smith Murray to Secretary of State, Jan. 25, 1925 [M715, Roll 37, 891.927/4]; Hole 1992).

Between 1935 and 1938 numerous sets of the Susa I pottery were distributed by the Louvre to regional museums in France as well as to other institutions in Europe in a move to share the extraordinary wealth of the Susa cemetery through a program of permanent loans (M. C. Root, pers. comm. via Régistre d'objets mis en dépot, Département des Antiquités Orientales du Louvre). Among the beneficiaries of the program were also three U.S. museums: the Peabody Museum of Harvard (1935), the Metropolitan Museum of Art (1938), and the Buffalo Museum of Science (1938). The Buffalo Museum of Science acquired its set of three Susa pots through the energetic engagement in Paris of Mr. Chauncey Hamlin, president of the museum from 1920 to 1948 (E. Peña, pers. comm. 2003). We display two of them in *This Fertile Land* (cat. nos. 102, 103). They were officially accessioned by Buffalo in 1984.

ERNST E. HERZFELD

Among the luminaries of Iranian archaeology in the early 20th century, none shone brighter and with as many facets as Ernst Emil Herzfeld (1879–1948). This

giant in the scholarly community, who advocated for archaeological and cultural preservation, was also (perhaps paradoxically to us now) an avid collector of antiquities (Gunter and Root 1998; Root 2000; 2005).

Herzfeld's interests ranged from prehistoric to Islamic periods, as is apparent in the more than sixteen expeditions and excavations he undertook in the Middle East—in Iran as well as in neighboring lands (Ettinghausen 1951; Gunter and Hauser 2005). Born into an assimilated Jewish family in Germany, Herzfeld earned a degree in architecture and soon afterward focused his attention on Near Eastern art and archaeology, specializing in Iran. He enjoyed a high regard among Iranian royalty, bureaucrats, and scholars alike (Majd 2003: 72).

THE 1930 IRANIAN ANTIQUITIES LAW AND ARCHAEOLOGICAL EXCAVATIONS

Non-French foreign diplomats in Iran lamented France's monopoly over excavations in the country—as did Iranian, American, British, and German scholars, such as Ernst Herzfeld. A 1925 communication from W. Smith Murray to the U.S. Secretary of State declares,

> It is greatly to be regretted that this country [Iran] has not seen fit to adopt an open door policy, thus admitting the archaeologists of other countries such as Americans or British who, in view of the means at their disposal, would doubtlessly be able to make marvelous discoveries here. (National Archives: Jan. 25, 1925 [M715, Roll 37, 891.927/4])

Herzfeld's displeasure with the French archaeological monopoly is evident from a different state communication (National Archives: Murray memorandum of March 26, 1926 [M715, Roll 37, 891.927/24]). The State Department's interest in Iranian archaeology is well catalogued in numerous letters between the U.S. legation in Tehran and the State Department (National Archives: M715 Rolls 10, 37, and M1202 Rolls 22–24). Many sought to regulate Iranian archaeology by increasing Iranian control and administration over its antiquities. In addition, the Iranian National Relics Society strove in 1922 to restore the defunct Department of Antiquities in the Ministry of Education in an effort to create a national library and museum, register edifices as national monuments, and classify objects in the possession of state institutions. This Society was made up of Iranian officials and private citizens along with one foreigner: Ernst Herzfeld (National Archives: Hoffman Philip to Secretary of State, August 11, 1926 [M715, Roll 37, 891.927/28 with an attached copy of the Bylaws of the National Relics Society]; Abdi 2001: 56).

Herzfeld was the most trusted non-Iranian working toward antiquities legislation in Iran that would simultaneously break the French monopoly while also creating a system for division of finds between the host country (Iran) and foreign excavating institutions (National Archives: David Williamson to Secretary of State [M715, Roll 37, 891.927/45]). He was even employed by the Society in 1925, in which capacity he prepared a draft law concerning the regulation of archaeological work in Iran based on laws then in effect in Greece and Egypt.

After much political pressure from Iranian leaders and foreign embassies, the 1900 agreement granting French monopoly over excavation was annulled in 1927. The door was now open for non-French excavations in Iran.

Under this annulment agreement of October 18, 1927, the French government waived its exclusive right to conduct archaeological excavations in Iran with the understanding that a French citizen (André Godard) would become the Director General of [Iranian] Antiquities, the National Library, and the Museum for a fixed period of time (National Archives: attachment to Hoffman Philip's letter to Secretary of State, November 5, 1927 [M715, Roll 37, 891.927/36]). This post was one that many in the Iranian government had hoped Herzfeld would occupy in acknowledgment of his early and persistent advocacy of issues surrounding Iranian archaeology and cultural patrimony (National Archives: Sheldon Whitehouse to Howard Shaw of Department of State, October 1, 1926 [M715, Roll 37, 891.27/37]).

COLLECTING AND EXPORTATION OF ANTIQUITIES IN THE EARLY 20TH CENTURY

Herzfeld candidly notes that during his explorations of Iran, Iraq, and Afghanistan from February 1923 until October 1925, he collected "small objects . . . on every ancient site, mainly consisting in ceramics, besides metal and stone implements" (National Archives: Herzfeld, "Summary . . . ," attached to Murray memorandum of March 27, 1926 [M715, Roll 37, 891.927.24]). He amassed much of his collection of late prehistoric stamp seals both on site from Tepe Giyan in 1928 and through purchase from inhabitants of nearby Nihavand (Root 2000). He also bought seals from the art markets in Hamadan, Harsin, Tehran, and Constantinople (Root 2000: 19). His large collection of prehistoric painted pottery from Iran and elsewhere in the Near East was once said to rival the collections in the Louvre, the Tehran Archaeological Museum, the Hermitage, and the British Museum (Root 2005: 230).

In his collecting Herzfeld conformed to the typical practice of his day. Many distinguished archaeologists of the pioneering phase combined fieldwork with active collecting practices of one sort or another. On one end of the spectrum were serious and forward-looking excavators like the great Flinders Petrie (operating in Egypt) who also acquired private collections. On the other end were men like Arthur Upham Pope (operating in Iran) who were deeply entrenched in the antiquities trade for profit (Root 2005; National Archives: Charles C. Hart to Secretary of State, June 14, 1930 [M715, Roll 37, 891.927/55]; Charles C. Hart to Secretary of State, July 21, 1931 [M1202, Roll 22, 891.927/124]—both on Pope). Herzfeld fits much better with Petrie than with Pope.

On the heels of the annulment of the French monopoly, Herzfeld dug trial trenches at the prehistoric site of Tal-i Bakun in Fars (chapter 3 this volume). These archaeological investigations did not have the status of a full-fledged excavation under institutional auspices and were essentially permitted without being considered clandestine. In the same year (1928) he went to Tepe Giyan on a reconnaissance mission. He registered distress at the local looting of this very promising mound and characterized his collecting of hundreds of late prehistoric seals there

as a salvage mission (Herzfeld 1930: 65–66). His prompt publication of a good number of these seals was an important landmark in scholarly inquiry on the prehistory of Iran (Herzfeld 1933; Root 2000).

113

THE LEGISLATION OF 1930

While engaged in his archaeological investigations and collecting activity, Herzfeld was also continuing energetically to work with the National Relics Society in Iran. This organization called for antiquities regulations to protect the national heritage. Its efforts catalyzed the creation of a comprehensive antiquities law, which was viewed as a necessary precondition for granting excavation permits to foreign archaeologists in Iran.

Many foreign archaeologists feared engaging in fieldwork without proper legal channels to protect their interests abroad, particularly regarding the distribution and ownership of excavated finds. Important drafts of the antiquities law were prepared by Herzfeld, Godard (as Director of the Department of Antiquities), Arthur Upham Pope (the connoisseur and antiquities dealer), and Yahya Khan Gharagouzelou (the Iranian Minister of Education).

Whereas the Herzfeld-Godard version of the legislation was supported by American archaeologists due to the equitable division of finds guaranteed to excavators, Gharagouzelou's draft was supported by private landowners, who sought to protect their proprietary interests over artifacts discovered on their lands. The various drafts of this legislation are illuminating (National Archives: Charles C. Hart to Secretary of State, June 14, 1930 [M715, Roll 37, 891.927/55]).

This impasse was resolved when the Iranian government endorsed the Herzfeld-Godard version, with several concessions provided to appease the private landowners. The Law for the Protection of National Vestiges (hereafter the "1930 Iranian Antiquities Law") was ratified on November 3, 1930. An English translation of the law is available as an attachment to the Charles C. Hart letter to the Secretary of State (National Archives: November 25, 1930 [M1202, Roll 22, 891.927/76]; see also Charles C. Hart to Secretary of State, May 6, 1931 [M1202, Roll 22, 891.927/102]).

Article 1 of the legislation endowed the Iranian government with the right to protect and supervise "artistic remains, buildings and sites, whether movable or immovable, which have been created in Persia [Iran] up to the end of the Zandi Dynasty [until 1779]" (National Archives: Attachment to the Charles C. Hart letter to the Secretary of State, November 25, 1930 [M1202, Roll 22, 891.927/76]). Article 11 allowed the state to oversee archaeological work and gave it the ability to assign fieldwork to foreigners.

The hotly debated issue concerning the division of finds was addressed under Article 14, which entitled the Iranian government to pick out ten recently excavated antiquities for its collection, while the remainder were to be equally divided between the excavators and the state. Article 14 only applied to movable antiquities. Immovable objects, such as buildings or parts of buildings, were considered the sole property of the Iranian government.

The first division of archaeological finds under Article 14 occurred

under F. Wulsin of the University of Pennsylvania, representing the Kansas City Museum at the Bronze Age site of Tureng Tepe on the southeastern Caspian plain. Detailed discussions are preserved concerning the division of artifacts in this instance (National Archives: Charles C. Hart to Secretary of State, September 18, 1931 [M1202, Roll 22, 891.927/133]). Other crucial aspects of the law, which will be discussed below, included details surrounding the registration of antiquities, the preservation of historic sites and antiquities, and the conditions governing the sale and exportation of antiquities.

Passage of the Iranian Antiquities Law was a major step in the history of Old World archaeology. Interestingly, the urgencies of its passage had as much to do with diplomacy as with the perception of the need for stewardship of the past. A crucial concern in the passage of the Iranian Antiquities Law appears to have been the fostering of political relations between Iran and various other countries. An Exhibition of Iranian Art, set to open imminently in London, was a very specific catalyst leading to its passage. This was a cultural event that served as an emblem of the new diplomatic engagement (National Archives: Charles C. Hart to Secretary of State, October 4, 1930 [M1202, Roll 22, 891.927/61]). Thus, we see one way in which archaeological legislation was a form of international political capital.

Within a year after the legislation was ratified, five foreign excavations were under way in Iran: at Persepolis under Herzfeld's supervision for the Oriental Institute of the University of Chicago, at Tepe Hissar near Damghan under Dr. Erich Schmidt for the University of Pennsylvania and Philadelphia Museums, at the Bronze Age site of Tureng Tepe under Dr. F. Wulsin for the Kansas City Museum and the University of Pennsylvania Museum, and at both Susa and Nihavand/Tepe Giyan under the direction of the French mission (National Archives: Charles C. Hart to Secretary of State, September 18, 1931 [M1202, Roll 22, 891.927/133]; Charles C. Hart to Secretary of State, March 23, 1931 [M1202, Roll 22, 891.927/97]; Contenau and Ghirshman 1935). Institutions in the United States, bolstered by the expertise and clout of several eminent German archaeologists (most especially the great Herzfeld himself), were early off the mark to establish concessions in the new configuration of Iranian archaeology following the breakup of the French monopoly. Although depending partly on German talent, American institutions were now gaining a sure foothold in Iran.

On September 16, 1931, the Iranian government approved a list of historic locations, including Tappeh Jiyan [Tepe Giyan], Nihavand, and Susa, that were considered to deserve special protection under the legislation (National Archives: attachment to Charles C. Hart letter to Secretary of State, November 7, 1931 [M1202, Roll 22, 891.927/136]; attachments to Charles C. Hart letter to Secretary of State, March 4, 1932 [M1202, Roll 22, 891.927/141], and to Charles C. Hart to Secretary of State, August 3, 1932 [M1202, Roll 22, 891.927/150]).

Although well regarded by American archaeologists and the State Department as clearing the path for foreign excavations and as a means to acquire excavated objects by foreign institutions, the 1930 Iranian Antiquities Law, particularly Article 14, was criticized by many Iranians for the same reason. There was significant resentment at the idea of an equal division of artifacts between the excavators and the Iranian government, as the following editorial for the *Shafaq-i-Sorkh* makes clear:

What is meant by the division of antiquities? Are antiquities divisible objects? Any historical piece unearthed is without parallel. How can any given piece be taken in return for another piece? Antiquities are not beets, carrots or potatoes which could be treated as like products divisible between the farmer and the landowner when it is time to dig them out of the soil . . . we implore His Majesty [the shah] to give this matter personal attention and to stop the free outgo of our ancestral remnants and historic records, the like of which it will be impossible to find anywhere else throughout the world. . . . It is our belief and that of any sensitive patriotic Persian that it is a thousand times better for these objects to remain buried as they were for several thousand years than their being digged [*sic*] and divided like carrots and turnips only to afford decorations for foreign museums. (National Archives: English trans. from *Shafaq-i-Sorkh*, December 3, 1931, as attachment to Charles C. Hart letter to Secretary of State, December 30, 1931 [M1202, Roll 22, 891.927/140])

According to some, the price for allowing foreign excavations, namely an equal division of finds from sites, was too high a cost since it resulted in the loss of national treasures.

HERZFELD IN IRAN AFTER 1930

Herzfeld's best-known position was as the director of fieldwork at Persepolis for the Oriental Institute of the University of Chicago from 1931 to 1934. During this same period he served as supervisor to the official Chicago team excavating at prehistoric Bakun nearby. An evocative photograph shows him at Persepolis in 1933 contemplating a painted vessel from Bakun, with sculpture fragments from the capital of the Persian empire laid out on a table below (Breasted 1933: 389).

His work at Persepolis—this most prestigious site in all of Iran—was marred in the end by several factors and riddled with paradox. Infighting with the assistant field director and architect at Persepolis, Friedrich Krefter, seems to have been exacerbated by the differing positions of these two German nationals in relation to Nazi agendas. Equally politicized and personal disputes with other foreign archaeologists in Iran—most notably Arthur Upham Pope—were now isolating Herzfeld politically (Root 2005: 247–249).

Controversies with the Iranian government about how to interpret the provisions of the 1930 Iranian Antiquities Law regarding divisions of finds provided the pretext, in the end, for dissolving Herzfeld's longstanding relationship to the governance of Iranian archaeology. Problems arose in 1933 over the extraordinary discovery of the thousands of inscribed and sealed clay tablets of the Achaemenid Persian empire, the Persepolis Fortification tablets (Garrison and Root 2001: 23–28).

Herzfeld seems to have been caught in the middle on this issue. He felt that the tablets should either be taken to the U.S. for further study or provided to the Oriental Institute outright as remuneration for the project's efforts at

Persepolis. At the time, the Iranian government flatly refused both requests. The Oriental Institute then suspended work in an effort to strengthen its hand during negotiations for the division of artifacts. The Iranian government declared that the concession to the United States would be revoked if excavations did not resume. This saga is told in numerous documents (National Archives: William H. Hornibrook to Secretary of State, May 16, 1934 [M1202, Roll 23, 891.927 Persepolis/79]; James H. Breasted to Wallace Murray, June 30, 1934 [M1202, Roll 23, 891.927 Persepolis/82]; James H. Breasted to Iranian Prime Minister, July 20, 1934 [attachment to M1202, Roll 23, 891.927 Persepolis/91]; William Hornibrook to Secretary of State, August 21, 1934 [M1202, Roll 24, 891.927 Persepolis/167]; Wallace Murray Memorandum, August 16, 1934 [M1202, Roll 24, 891.927 Persepolis/115]; M1202, Rolls 23 and 24).

Herzfeld was dismissed from his position at Persepolis in 1934 by request of the Iranian government (William Hornibrook to Secretary of State, December 27, 1934 [M1202, Roll 24, 891.927 Persepolis/292]). The political climate in Germany precluded his return there. In a letter to Charles Breasted, secretary of the Oriental Institute and son of James H. Breasted, its director, Herzfeld writes that,

> in Germany so many letters are being opened that I would not have liked to write. Instead of growing more peaceful, the state of affairs is becoming extremely more critical. . . . The return to Germany will be very difficult. In the Education Ministerium, at the universities and museums so many hostile forces are at work—I do not like to speak about the matter—that one would rather not go back. It is too dangerous and there is no hope of finding mental tranquility for scientific work. A young veterinary [sic] 35 years of age has been made rector of the University of Berlin and wears the official insignia over the yellow shirt of his Nazi uniform. Under no circumstances write to me in Germany.

This letter was attached to another in 1935 (National Archives: Charles Breasted to Wallace Murray, April 20, 1935 [M1202, Roll 24, 891.927 Persepolis/362]).

Instead of returning to Germany, Herzfeld accepted an appointment as professor in the School of Humanistic Studies of the Institute for Advanced Study at Princeton, NJ, in 1936 (Ettinghausen 1951: 262). Prior to his death in 1948, he donated a large portion of his notebooks, sketches, journals, photographs, and plans to the Freer Gallery of Art, Smithsonian Institution, in hopes of their future use by archaeologists and art historians (Ettinghausen 1951: 265). He sold a selection of similar archival materials to the Metropolitan Museum of Art along with some artifacts from the Persepolis excavations (Root 1976). The sale of his antiquities had gone on over the course of many years (chapter 11 this volume). The sale of the bulk of his prehistoric stamp seals in 1947 was specifically intended to raise funds for his retirement.

ANTIQUITIES LEGISLATION AND ILLICIT EXPORTATION

Prior to the enactment of the 1930 Iranian Antiquities Law, the Iranian government required that antiquities be examined by agents of the Ministries of

Public Instruction and of Finance before an export duty was imposed (National Archives: W. Smith Murray to Secretary of State, June 10, 1925 [M715, Roll 37, 891.927/16]; W. Smith Murray to Secretary of State, October 10, 1925 [M715, Roll 37, 891.927/22]). This legislation enabled easy collection of export fees and prevented both stolen objects and artworks regarded as possessing significant national value from leaving the country (National Archives: W. Smith Murray to Secretary of State, October 10, 1925 [M715, Roll 37, 891.927/22]). The 1930 Iranian Antiquities Law and the Regulations for its execution did several things: (a) they tightened export and collecting restrictions with monetary penalties for smuggling artifacts; (b) they imposed criminal prosecution for unauthorized trading in antiquities; (c) they required specific export permits; and (d) they required antiquities trading permits (National Archives: attachment to Charles C. Hart to Secretary of State, November 25, 1930 [M1202, Roll 22, 891.927/76] for an English translation of 1930 Iranian Antiquities Law; attachment to Charles C. Hart to Secretary of State, May 6, 1931 [M1202, Roll 22, 891.927/102] for an English translation of the Regulations). Under the Regulations, exportation of antiquities required a permit detailing the method of acquisition, the quality, and the commercial value of the object in question (National Archives: attachment to Charles C. Hart to Secretary of State, May 6, 1931 [M1202, Roll 22, 891.927/102]).

Allegations concerning the illicit exportation of art rather than the improper acquisition of art tainted Herzfeld's reputation while in Iran. Purportedly, in 1929 he unsuccessfully attempted to export antiquities out of the country without the Iranian government's permission (National Archives: David Williamson to Secretary of State, June 10, 1929 [M715, Roll 37, 891.927/43]). In 1934 and 1935, he was again accused of trying to export antiquities out of Iran without proper authorization. The Acting Minister of Education for the Iranian government notified officials at the U.S. State Department that Herzfeld was suspected of evading customs officials by having antiquities exported through diplomatic baggage. One communication notes that "the [Iranian] Government believes that it has been a common practice of Dr. Herzfeld to export objects of art without first obtaining the consent of Persian [Iranian] officials" (National Archives: William H. Hornibrook to Secretary of State, December 27, 1934 [M1202, Roll 24, 891.927/292]). The scope of the alleged exportation scheme by Herzfeld is not, however, described in State Department records.

Various Iranian officials alleged that Herzfeld exported antiquities out of the country in the diplomatic baggage of the German legation and with the crown prince of Sweden (National Archives: William H. Hornibrook to Secretary of State, January 21, 1935 [M1202, Roll 24, 891.927 Persepolis/317]). Obviously, if diplomatic baggage was left unchecked, one must question how Iranian officials discovered these illicitly exported antiquities. But the Iranian government's contention was not entirely groundless since some individuals did apparently export antiquities in diplomatic baggage. One such incident involved the illegal exportation of a 16th-century Koran cover and a brocade textile through the U.S. diplomatic pouch (National Archives: W. Smith Murray to Secretary of State, June 10, 1925 [M715, Roll 37, 891.927/16).

In the particular case of Herzfeld, some suspected that he was accused of illegally exporting antiquities in a politically motivated campaign to discredit him and remove him from his position at Persepolis (National Archives:

118

William H. Hornibrook to Secretary of State, January 21, 1935 [M1202, Roll 24, 891.927 Persepolis/317]). An alternative view suggests that the primary impetus for Herzfeld's removal from the Persepolis project related more to his political denunciation of the shah's policies than to his alleged illicit exportation of antiquities (Majd 2003: 21). For his part, Herzfeld vehemently denied the smuggling accusations in a memorandum of January 30, 1935, sent to the State Department (National Archives: attachment to Charles Breasted to Wallace Murray, February 5, 1935 [M1202, Roll 24, 891.927 Persepolis/297]). Whether or not Herzfeld actually engaged in the smuggling of antiquities, no formal charges were ever brought against him.

ISSUES OF COLLECTING IN THE PRESENT DAY

Early archaeology centered just as much on acquiring artifacts as it did on collecting contextual information for future study (Chase, Chase, and Topsey 1988: 32). The discourse surrounding collecting antiquities has become more heated in the past few decades due to increased consumption, varied scientific practices, and heightened restrictions from source countries. Renfrew has put it this way: "when it comes to collectors of illicit antiquities, the only good collector is an ex-collector. The 'only giving it a good home' argument may apply for stray dogs, but with antiquities it abets the looting process" (2000: 77).

International cultural property is generally defined as ethnological or archaeological material thought to be over 250 years old that is of cultural and national significance. Disputes surrounding the collection of such international cultural property diverge into varying viewpoints, with passionate advocates on each side. One perspective emphasizes the positive rationales for collecting antiquities, while the other side counters with the negative aspects of how these antiquities are acquired.

Cultural internationalists argue that collecting antiquities bridges the divide between societies and fosters mutual understanding with the free circulation of objects, which they believe are the shared property of all mankind (Merryman and Elsen 1998: 71). Proponents of this stance assert that the acquisition of antiquities provides immeasurable educational benefits by bringing artifacts from private collections into the public realm (Cuno 2001: 92). Critics claim, however, that acquiring antiquities often involves disregarding export laws of source countries and also causes intensified looting of archaeological sites as well as theft from museums in an effort to meet the increased demand for these goods. Cultural nationalists posit that artifacts found within their countries' borders are directly connected to national history and identity, so other nations should respect and enforce collecting restrictions and export decisions made regarding such artifacts (Merryman and Elsen 1998: 71).

There is a strong drive to repatriate artifacts and monuments that, although legally acquired, are considered so central to the national identity and community of the source country that they should be returned (Herscher 1989: 120). Advocates of export and collecting restrictions argue that looting irreparably damages archaeological data by removing artifacts from their context. As Coggins has put it,

Once a site has been worked over by looters in order to remove a few salable objects, the fragile fabric of its history is largely destroyed. Changes in soil color, the traces of ancient floors and fires, the imprint of vanished textiles and foodstuffs, the relation between one object and another, and the position of a skeleton—all of these sources of information are ignored and obliterated by archaeological looters. (Coggins 1972: 263)

Any educational benefit that may accrue to those in wealthier nations, where antiquities eventually end up, occurs at the expense of poorer nations, which are deprived of their archaeological patrimony.

Many scholars refuse to study, interpret, and analyze objects that have an unknown provenance (origin and ownership history), are illicitly exported, or are possibly looted from an archaeological site. Rationales for this strategy include the following: (a) looted or unprovenanced items fail to provide a context in which they were discovered; (b) scholarly use of these objects may indirectly drive up the market for antiquities and increase looting; and (c) the authenticity of unprovenanced works is difficult to gauge in a market filled with forgeries (Chase, Chase, and Topsey 1988: 35).

In an effort to prevent looting and theft of antiquities, some scholars also refuse to authenticate or document unprovenanced antiquities when doing so would facilitate their sale (Renfrew 2000: 75; Brodie and Gill 2003: 39). Others, however, argue that not researching unprovenanced items does a great disservice since even unprovenanced antiquities are important enough to warrant study and integration into the scholarly record (Cuno 2001: 92–95).

Given these present-day collecting issues, one may question whether the ex-Herzfeld corpus of late prehistoric stamp seals ought to be recognized in scholarly discourse. The seals were not, after all, found during the course of an archaeological excavation. Rather, they were picked up on site by Herzfeld and purchased from inhabitants in Nihavand. Looting is often defined as the unrecorded, unpublished, and illicit removal of artifacts from sites in an effort to make a commercial profit (Renfrew 2000: 15). Was Herzfeld a looter? Are the seals from Tepe Giyan looted artifacts?

In 1928, when Herzfeld acquired the Tepe Giyan seals, there was no antiquities legislation regulating the acquisition of antiquities in Iran. Therefore, his activities, although questionable by modern codes of conduct, were not illegal. Given that Herzfeld recorded the provenance of his seals and made no attempt to obfuscate the manner in which he acquired them, it is problematic to label his activity at Tepe Giyan "looting."

The motivations for collecting antiquities today have not drastically altered from Herzfeld's age, although the scale of the phenomenon is much greater at present. The popularity of collecting antiquities today is evident in the volume of activity at Sotheby's and Christie's, both of which hold summer and winter sales of antiquities (Brodie and Gill 2003: 33). Rationales for purchasing artifacts include personal interest in acquiring unique, aesthetically pleasing objects for private possession, financial investment, rescuing antiquities from destruction, and a desire to better understand ancient cultures and different societies. Some also describe a personal thrill gained from the adventure and intrigue of the

collecting process, along with other motivations (Vitelli 1984: 144). Ancient seals in particular tend to attract collectors for their aesthetic appeal, modest pricing, ease of transportation, ease of preservation, and resultant lower insurance rates. Seals make up a major portion of the Near Eastern artifacts that are collected today. The average price for seals on the American antiquities market tends to hover around several hundred dollars, but a record $400,000 plus was paid for an 8th-century BCE cylinder seal said to have come from Iran (Charle 2003).

Collectors do, however, face many uncertainties when dealing with antiquities, including issues of their authenticity, their price, and—most troubling—their provenance. For most of the antiquities that come up for sale there is no information in the sales catalogue regarding when and from where the object was retrieved and no account of its ownership history. A study of London's Sotheby's and Christie's catalogues from World War II into the 21st century has indicated that most sales have no named seller or prior owner; 95–96% of the objects are accompanied by no information on provenance (Brodie and Gill 2003: 33; Chippindale et al. 2001). Without this information, there is no assurance that an artifact was not looted. With a large corpus of forgeries on the market, some are willing to pay increasingly high prices for "authentic" artifacts, thus further driving up the economics of collecting (Borodkin 1995: 384). The growth of Internet trading has resulted in a decreased ability to control and regulate the antiquities trade. Even now, with much coverage in the popular press on the glutting of the antiquities market with looted Iraqi antiquities following the U.S. invasion of 2003, many collectors seem undeterred by ethical quandaries.

CURRENT ANTIQUITIES LAWS AND TREATIES

International Treaties

International treaties concerning antiquities trading and collecting are only successful when a large number of signatory countries are willing to carry out their terms. The Hague Convention of 1954 for the Protection of Cultural Property in the Event of Armed Conflict ("Hague Convention") concerns the protection of archaeological sites, historic monuments, museums, and antiquities during wartime (Convention for Protection of Cultural Property in the Event of Armed Conflict, May 14, 1954, 249 U.N.T.S. 215, 240). The Hague Convention introduced a novel justification for protecting cultural property: antiquities were regarded as the "cultural heritage of all mankind" (Convention for the Protection of Cultural Property in the Event of Armed Conflict, May 14, 1954, pmbl, 249 U.N.T.S. 215, 240; Lehman 1997: 533). Parties to the Hague Convention promise to safeguard cultural property during hostilities by vouching not to use cultural property for military purposes and by stopping theft and vandalism of antiquities (Convention for the Protection of Cultural Property in the Event of Armed Conflict, 249 U.N.T.S. 215, 240, Article 4, §1 and §3).

Unlike the Hague Convention, the UNESCO Convention on the Means of Prohibiting and Preventing the Illicit Import, Export and Transfer of Ownership of Cultural Property of 1970 ("UNESCO Convention") was designed to protect cultural property during peace time by enabling signatory countries to

assert standing in foreign jurisdictions when recovering illegally exported antiquities (Convention on the Means of Prohibiting and Preventing the Illicit Import, Export and Transfer of Ownership of Cultural Property, Nov. 14, 1970, 823 U.N.T.S. 231). Currently, there are over one hundred signatory nations to the UNESCO Convention. Member nations agree to limit the movement of stolen and illegally imported cultural property in a number of ways, including providing more care for cultural property within their own jurisdictions, fostering interchange of cultural property for scientific, cultural, and educational purposes, and imposing import and export controls at the request of another member party. Some parties, such as the U.S., ratified only certain provisions of the UNESCO Convention and accepted the convention with reservations, such as maintaining the right to determine whether or not to impose another nation's export controls over imported artifacts.

Finally, the 1995 UNIDROIT Convention on Stolen or Illegally Export-ed Cultural Objects enables private parties, not just nations, to sue to recover artworks in foreign jurisdictions (The International Institute for the Unification of Private Law [UNIDROIT] Convention on Stolen or Illegally Exported Cul-tural Objects, June 23, 1995).

Although the U.S. is a party to the UNESCO Convention, it has yet to ratify either the Hague Convention or the UNIDROIT Convention. As the world's largest importer of and buying market for antiquities, the United States plays a crucial role in the prospects for improvements in standards. Clearly, it is not through international agreements that actions are being taken to protect the cultural patrimony of nations that are sources of antiquities.

U.S. Law

Although it has not ratified the Hague or UNIDROIT Conventions, the United States has implemented various laws to deal with antiquities trading. These legal instruments range from criminal to civil laws, federal to state laws, and tem-porary to permanent legislation. The U.S. Customs Code is especially useful in returning smuggled artifacts to source countries under the following categories of criminal charge: abetting (18 U.S.C. 2 [1988]); conspiracy (18 U.S.C. 371); im-portation through a false statement (18 U.S.C. 542); smuggling (18 U.S.C. 545); and making false statements to a federal agency (18 U.S.C. 1001). One of the earliest American laws was the American Antiquities Act of 1906, which penal-ized private individuals for excavating, destroying, or removing antiquities from federal lands (PL 59-209; 16 U.S.C. 431 [2000]).

Certain types of Pre-Columbian sculpture and murals are restricted from entering the country under the Regulation of Importation of Pre-Colum-bian Monumental or Architectural Sculpture or Murals Act of 1972 (PL 92-587; 19 U.S.C. 2092 [1988]). The Native American Graves Repatriation Act (25 U.S.C. §§3001–3013 [2000]) requires federally funded museums to inventory Native American burial artifacts, including skeletal remains, and return them to tribes upon request.

The Archaeological Resources Protection Act of 1979 (16 U.S.C. §§470ee–470mm [2000]) imposes monetary fines, imprisonment, and forfeiture of artifacts with regard to items transported interstate in violation of any state or local law.

The National Stolen Property Act of 1934 (18 U.S.C. 2311) imposes criminal penalties for importing known stolen property.

The Racketeering Influenced and Corrupt Organizations Act ("RICO") (18 U.S.C. 191 [1988 and Supp. V 1993]), as well as federal mail fraud, wire fraud, tax fraud, and conspiracy laws have all been used with mixed results in art-smuggling cases.

The amount of legislation may seem to offer ample safeguards. But prosecutors face multiple problems in implementing these statutes (Borodkin 1995: 394–397). Furthermore, U.S. legislation has generally sought only to limit either the importation of certain types of antiquities or the manner in which antiquities change hands on U.S. soil. The Convention on Cultural Property Implementation Act of 1983 ("CPIA"—19 U.S.C. §§2601–2613), which is the U.S. implementing legislation that covers merely a portion of the 1970 UNESCO Convention, enables the United States to restrict the importation of stolen antiquities documented in foreign museums and state-run institutions (19 U.S.C. §2607).

Obviously this provision does not aid governments whose artifacts were looted from archaeological sites or private individuals whose objects were stolen. Under this provision, the United States—rather than the foreign nation—is authorized to bring suit for the return of the artifact (Spiegler and Kaye 2001: 126). CPIA also enables the U.S. government to enter into unilateral emergency agreements with foreign countries to restrict the importation of artifacts for a term of up to eight years (19 U.S.C. §2603). And finally, CPIA facilitates entry into bilateral or multilateral agreements with foreign nations that have shown their cultural property to be in jeopardy.

The goal here is to limit the importation of specific artifacts during a renewable five-year term (19 U.S.C. §2602). As of June 2004, the United States has bilateral and emergency agreements in effect with Bolivia, Cambodia, Cyprus, El Salvador, Guatemala, Honduras, Italy, Mali, Nicaragua, and Peru. (The history of CPIA's implementation is reviewed in a study that is now rather dated: Hingston 1989.) Other countries frequently enter into bilateral agreements to enforce their export controls, as treaties between Belgium and Zaire and between the Netherlands and Indonesia illustrate (Herscher 1989: 118).

This legislation seeks primarily to deter looting and destruction of archaeological sites by restricting the importation of specific artifacts into the United States. To accomplish this, it calls for self-help mechanisms in source countries to protect their cultural property. Such mechanisms must exist before the U.S. enters into a bilateral agreement (McIntosh 2002: 243). As a result of such emergency and bilateral agreements with specific foreign nations, American dealers and collectors (both private and institutional) who purchase protected material from these places often need to document that the object in question was either legally exported from the foreign nation or imported into the U.S. before the agreement was entered into (McIntosh 2002: 244–245).

As regards the Middle East, blanket restrictions on the importation of Iranian and Iraqi antiquities implemented by U.S. political-economic sanctions are currently still in place. The impetus here was not to protect antiquities but to punish nations deemed unfriendly to U.S. interests. The looting of Iraqi artifacts following the 2003 U.S. invasion of Iraq has engendered much debate about the protection of cultural heritage; it has encouraged lawmakers to insist

on reforming CPIA in proposed House Bill 1047, which has passed through the House of Representatives and Senate and is awaiting the appointment of conferees at the time of this writing. One section of the bill enables the U.S. to ban trade in Iraqi objects, including antiquities, removed from Iraq after 1990. Under the current version of CPIA, the U.S. may impose import controls only if the foreign nation is a party to the UNESCO Convention and has submitted a formal written request to the president. At present neither Iran nor Iraq has submitted any formal requests under CPIA to the United States for protection of their cultural patrimony. If, however, House Bill 1047 is passed into law, Iraq would not need to make a formal request for emergency protection of its antiquities.

Foreign Laws

Countries rich in archaeological heritage generally deal with looting through various export controls. Bator (1982: 9–13) notes that illegal trade is comprised of four factors: export regulations, theft, importing illegally exported cultural property, and importing stolen cultural property.

Some nations place an embargo or total prohibition on exporting antiquities. The range of such restrictions varies: South American countries often use total prohibitions to preserve pre-Columbian and colonial objects; France and Italy prohibit the export of works having significant national importance; Canada and Great Britain require export permits for broad classes of objects; and Switzerland imposes limited restrictions on export of artworks (Merryman and Elsen 1998: 70). Such export restrictions on antiquities are not modern regulatory devices; one of the earliest efforts to restrict excavation and the export of antiquities was instituted under Pope Pius II in 1462 (Prott and O'Keefe 1984: 453).

Other countries nationalize antiquities found within their borders (Borodkin 1995: 391). Foreign legislation that classifies antiquities as state property enables those governments to act as owners seeking return of their stolen property in foreign courts. American courts are not, however, bound by another nation's characterization of the alleged removal as theft. American courts may also refuse to apply foreign law because it is too broadly defined or not put in practice in the foreign country. The case of Peru v. Johnson, for instance, rejected Peru's analysis of its law and concluded that Peru's laws did not adequately vest ownership of antiquities in the Peruvian state (*Peru v. Johnson* 720 F. Supp. 810 [C.D. Cal, 1989], *aff'd*, 993 F.2d 1013 [9th Cir. 1991]). A legal distinction also arises between ownership of the artifact and possession of the artifact so that in some countries private individuals may collect (i.e., possess) antiquities, but they are not legally regarded as the owners of the objects.

Still other countries seek preemption or the first right of the state or institutions to acquire privately owned works offered for export (Merryman and Elsen 1998: 70). Often, however, problems arise when individual artifacts on the market cannot be attributed to a specific site or even a particular country of origin, in which case several states may claim ownership. In Republic of Lebanon v. Sotheby's, Lebanon, Croatia, and Hungary all unsuccessfully argued that disputed Roman silver was derived from within their national borders (*Republic of Lebanon v. Sotheby's*, 561 N.Y.S.2d 566 [N.Y. App. Div. 1990]).

IRANIAN LAW TODAY

Current Iranian laws relating to cultural property impose strict standards for exporting antiquities and stringent constraints on antiquities dealing. Modern Iranian law regarding antiquities prohibits dealing and strives to crack down on systemic looting of archaeological sites. With the establishment of the Iranian Cultural Heritage Organization in 1985, all archaeological sites became registered, and larger sites began to be patrolled by security officers. In 1990, the Republic of Iran closed antiquities stores, arrested perpetrators, confiscated artifacts, and expelled some staff members from foreign embassies for their participation in the looting and collecting of antiquities (Abdi 2001: 72).

IRAQI ANTIQUITIES LEGISLATION

Antiquities laws in Iraq were first enacted by the Ottoman Empire in 1874, which placed all archaeological excavation in the region under the jurisdiction of the Ministry of Education. Archaeological finds under the 1874 legislation were divided equally among the excavators, the landowners, and the government. A subsequent 1884 law stated that the government owned all excavated antiquities; a 1906 law prohibited the export of all antiquities without a license (Majd 2003: 6). The 1884 and 1906 provisions were similar to antiquities laws in place in Europe (e.g., Italy, France, and Russia) in which all excavated antiquities became the property of the state (Majd 2003: 84).

The Iraqi Antiquities Law of 1924, which replaced the earlier Ottoman Law, was drafted by the famous Englishwoman Gertrude Bell (1868–1926), as Iraqi Director of Antiquities (Asher-Greve 2004: 173–176). Under this law, the Director of Antiquities of Iraq was entitled to first choice among the newly excavated objects for state possession; then the excavator was permitted to retain such "objects as [would] reward him adequately, aiming as far as possible at giving such person a representative share of the whole result of excavations made by him" (National Archives: P. Knabenshue to State Department, October 26, 1933 [T1180, Roll 14, 890g.927/64], citing the 1924 Iraqi Antiquities Law). Further, Article 23 enabled excavators to export these artifacts. Although in its day this legislation was seen as a major step toward protecting Iraqi antiquities, it later came to be viewed as too generous to excavating institutions from other countries. It was under the auspices of this legislation that the excavations at Tepe Gawra were conducted, with a large portion of the finds going to the University of Pennsylvania Museum.

Prior to the U.S.-led Gulf War of 1991, modern Iraqi law concerning antiquities had been modeled on a piece of 1936 legislation that significantly altered the thrust of the 1924 law. The 1936 Iraqi Antiquities Law vested all ownership rights to unexcavated objects with the Iraqi government, specified terms for conducting excavations in Iraq including the acceptable time period for publishing results of the excavation, and allowed foreign excavators to make casts of the discovered objects, permitted them to own half of the duplicate antiquities, and enabled them to own and export objects when the Iraqi government already possessed similar objects in its national museums (301 Antiquities

Law No. 59 of 1936, Chapter 1–5, available as an attachment to P. Knabenshue
to State Department, July 6, 1936 [T1180, Roll 14, 890g.927/35]). The 1936 Iraqi
Antiquities Law was amended in 1974 and in 1975 to prohibit private individu-
als from acquiring movable antiquities and to bar the exportation of antiquities
out of Iraq (Antiquities Law No. 59 of 1936, 4th ed., Chapter III, Article 16 [1]
and Article 26). In the aftermath of the 1991 Gulf War, antiquities appeared
in droves on the art market (Crossette 1996; Oyer 1999: 62–64; Gottlieb and
Meier 2003). In response, the government of Iraq amended its antiquities laws
in 2002, creating stricter penalties for infringements, with sanctions as severe
as capital punishment.

It is well known that looting of museums and archaeological sites has
been rampant in the wake of the U.S. invasion of Iraq in 2003. Iraqi antiquities
(especially seals) have flooded the international market. Thus, sagas of archaeol-
ogy, collecting, and legislation remain closely tied to political narratives.

11
Tepe Giyan Lives.
Herzfeld's Harvest—Jane Ford Adams's Buttons

Margaret Cool Root

HERZFELD'S SEALS

The histories of the objects in *This Fertile Land* intertwine with an impressive cast of characters in Near Eastern archaeology. For our narrative, it is Ernst Herzfeld who, although still somewhat elusive, looms largest. We have reviewed the complex backdrop against which Herzfeld operated throughout the early decades of the 20th century (chapter 10 this volume). That story revealed archivally gleaned details of Herzfeld's political, legislative, and (in the end) personal difficulties relating to antiquities in Iran. We followed him to the U.S., where he lived for more than ten years until his death in 1948. In closing, we pursue the post-Iran history of Herzfeld's collection of late prehistoric stamp seals.

Herzfeld harvested hundreds of late prehistoric stamp seals at Tepe Giyan and neighboring Nihavand village in 1928 (Herzfeld 1930). He acquired many others on the art market. To his credit, he published 159 of these seals in 1933, in an article that established as a field the synthetic study of prehistoric glyptic through broad comparisons of imagery from one site to another (and also introduced cross-cultural issues between, e.g., Minoan glyptic and the late prehistoric imagery from Iran and Iraq). Here he illustrated comparanda from various other collections, assiduously noting provenance for his own seals. He made no secret of the fact that some of the items were collected and purchased right at Tepe Giyan/Nihavand, while others were bought in lots from dealers in Hamadan, Constantinople (Istanbul), and elsewhere. In travel sketchbooks he also noted this information (cat. nos. 89 and 101). The partial collection inventory, preserved now in the Ernst Herzfeld Papers of the Freer Gallery of Art and Arthur M. Sackler Gallery Archives, includes notes on dealers' names and prices paid.

The artifacts from Tepe Giyan/Nihavand became, through Herzfeld's early work on them, a large, significant body of evidence used repeatedly for decades by other scholars. Herzfeld's sketches of the artifacts (usually including a profile as well as a rendering of the seal face) were republished throughout the entire subsequent 20th century. This despite the fact that Herzfeld (a) did not include dimensions or systematic descriptive commentary on material or condition and (b) presented only a few of the seals in photographs to supplement his sketches.

Like the ceramics from the Susa cemetery, the Tepe Giyan seals collected by Herzfeld are a large body of evidence demonstrably from one site in Iran. Like the Susa pots, they retain this core legitimacy for whatever research applications they are able to serve despite their diminishment through decontextualization. The sheer quantity of evidence they represent that is securely associated with a single northwest Iranian site combines with the fact that they formed the basis

for the discourse on all such material until the recent anthropological turn in seal studies (chapter 3 this volume). All told, then, the Herzfeld seals ought to be a major resource for further inquiry based upon new types of questions.

LOST AND FOUND

It is a curious commentary on prehistoric stamp seal studies that so many scholars used the Herzfeld seals so often without apparently bothering to investigate their whereabouts in order to fill in basic lacunae in their physical record. Even the record of the imagery carved on them is subject to query. While Herzfeld was a skilled draftsman, his renderings of the seals are sometimes idiosyncratic. They really are sketches, making no pretense at accuracy in the manner of a modern archaeological rendering.

No one who referred to groups of his seals as comparanda following the seminal 1933 publication seems to have known what became of the bulk of them or to have made a serious effort to find out. Briggs Buchanan, the eminent seal specialist, thought "most" of them had gone to the University of Pennsylvania Museum (Buchanan 1967: 265). And he was in a position to know such things (Root 2000: 15). In fact, Pennsylvania has no record of receiving any acquisitions from Herzfeld whatsoever. Buchanan's confusion may suggest that Herzfeld at one time considered trying to donate or sell part of the collection to Pennsylvania. Given its tradition in the field (especially at Tepe Gawra), Pennsylvania would indeed have been a fitting U.S. repository for the Tepe Giyan corpus. Clearly, however, if a deal was proposed, it fell through for some reason still unknown.

JANE FORD ADAMS AND THE PURCHASE OF HERZFELD'S SEALS

By the 1940s Herzfeld was well established in the United States at the Institute for Advanced Study. Scholars in this country assisted his relocation here, as one of many German intellectuals who fled their homeland during the Nazi regime and sought asylum under the auspices of the Committee in Aid of Displaced German Scholars. The great art historian Meyer Schapiro recommended him as "unquestionably the foremost living scholar in ancient and mediaeval Persian art" (New York Public Library, Manuscripts and Archives Division: Meyer Schapiro to Secretary of the Committee, November 13, 1935).

Already in 1944 he was beginning to divest himself of a lifetime's accumulation of books, papers, diaries, field notes and drawings, and artifacts. He sold a significant collection of books and archival material to the Metropolitan Museum of Art in that year (Root 1976). And in 1946 he donated an even larger body of his papers to the Freer Gallery of Art.

The disposition of his enormous collections of Near Eastern antiquities was another matter entirely. At this writing, the whereabouts of all his prehistoric pottery is not something we have investigated. The post-Iran history of the prime core of his late prehistoric stamp seal collection is, however, gradually becoming clear.

Fig. 11.1. Cat. no. 10 (seals a–r ordered left to right and top to bottom).

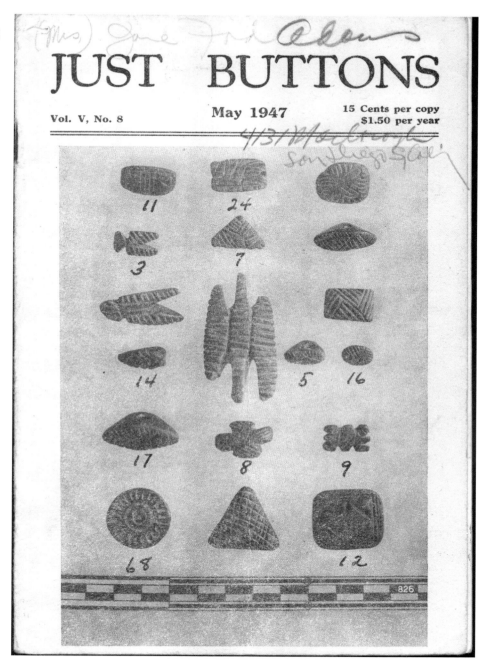

By a quirk of fate in 1991, the Kelsey Museum was offered (as a gift) a collection of 158 "ancient buttons" by one Dr. John Adams of San Diego, California. These buttons had been purchased in 1947 by Dr. Adams's wife, Jane Ford Adams (1900–1990), from the Gans Gallery in New York City. Mrs. Adams had responded to a sales catalogue published as an edition of a magazine called *Just Buttons*, a journal for button historians and collectors (fig. 11.1). The artifacts were billed there as "the earliest buttons ever known." Dr. Adams, himself a Michigan alumnus of 1920, wished to offer the collection to the Kelsey Museum in memory of his wife, who had been an alumna of the class of 1925.

The sales catalogue essay (Muehsam 1947) made much of the connection of the artifacts with Ernst Herzfeld and Tepe Giyan. It was immediately obvious to us at the Kelsey Museum that we were being offered a very significant portion (but surely not all) of Herzfeld's collection of late prehistoric stamp seals from Iran—marketed as ancient buttons.

THE BUTTON BUSINESS

When Mrs. Adams's "buttons" reached Ann Arbor, they were still sewn (with thick thread running through their perforation holes) onto the large display cards they had originally been presented on in the Gans Gallery. The first of these display cards held twelve stamp seals (our Kelsey Museum accession numbers 1991.3.1–12) (fig. 11.2). The card caption designates them as "Prehistoric Buttons" and characterizes them as "Excavated at Tepe Giyan, a west Persia site, by the German archaeological expedition under Ernst Herzfeld." It goes on to say that "Dr. Herzfeld believes that they were used as garment fasteners in the Neolithic Age, probably from about 4000 B.C."

There are several inaccuracies in this characterization—inaccuracies that Herzfeld himself would definitely have known:

(a) The items were not excavated in any proper sense;
(b) there was never a "German archaeological expedition" at Tepe Giyan;
(c) only a portion (albeit a large portion) of the lot had a Tepe Giyan provenance; and
(d) they date to the Chalcolithic, not the Neolithic, period.

Another element in the Gans Gallery marketing blurb is also factually incorrect, although it quite accurately represents a notion Herzfeld himself had fostered as a scholar. This is the idea that the seals actually started out as buttons (as garment fasteners). In his published work he vacillated on the subject (sometimes contradicting himself). He did, nevertheless, repeatedly suggest that seals actually developed as administrative tools for making positive impressions on clay from things that had originally been meant as carved stone buttons. His idea was that people at some point began using their buttons as seals—as marking devices. This is not the way it worked in antiquity, but the fact remains that Herzfeld left a legacy of this notion in the literature (Root 2005).

HERZFELD AND EDWARD GANS

It is thus with tremendous interest that we turn to the man who developed the button-marketing strategy for Herzfeld's seals. In 1944, Herzfeld struck up a friendship with Mr. Edward Gans (1887–1991), owner of the Gans Gallery. Like Herzfeld, Gans was a German Jew who was forced to leave Nazi Germany. Although a banker by trade in Germany, Gans began collecting classical antiquities and coins as a hobby, which later became his professional livelihood when he emigrated to the United States (Azarpay n.d.; Azarpay and Zerneke 2002).

Edward Gans has reminisced about his relationship with Herzfeld, mentioning the sale of his seals:

Fig. 11.2. Cat. no. 11 (seals a–l ordered left to right and top to bottom).

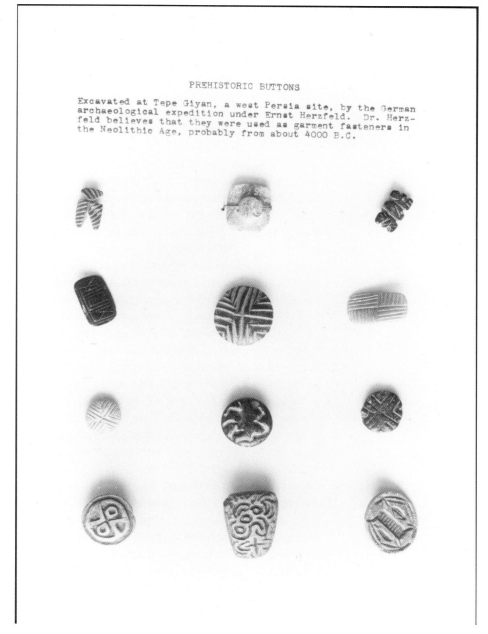

PREHISTORIC BUTTONS

Excavated at Tepe Giyan, a west Persia site, by the German archaeological expedition under Ernst Herzfeld. Dr. Herzfeld believes that they were used as garment fasteners in the Neolithic Age, probably from about 4000 B.C.

He [Herzfeld] had a fine collection of Classical coins, predominantly Parthian, which I sold for him at mail auction, publishing in the catalog a number of valuable comments by him. He also entrusted me with the sale of numerous antiquities in various fields especially "*Kleinkunst.*" These objects were mostly of Near Eastern origin which at that time had a limited market. So it was a challenge to find interested buyers. I remember a charming collection of bone spindle whorls from early Persia which went to the Cleveland Museum. Another collection consisted of about a hundred stamp seals made of stone, oddly engraved.

We frequently discussed them, and said that they were *very* early; probably made at a period when the conception of personal property was yet unknown. And hence the word "seal" was not appropriate. He preferred, perhaps half joking, to call them "buttons." Now I had to find a party who would be interested in acquiring a collection of "seals called buttons." I learned of the existence of a magazine published for American button collectors, called *Just Buttons,* and asked Dr. Gerd Muehsam, curator of the Cooper's Union in New York, to write an article about Herzfeld's "Buttons" based on Herzfeld's notes. After its publication the president of the American Button Club approached me and bought the collection, being aware of the problematical character of the items. She still has the collection and would never part with it. For me it was an interesting episode at that time. (Azarpay n.d.)

It is fascinating to get the inside track on this strategizing between Herzfeld and Gans. The memoir helps to elucidate Herzfeld's ambivalence about identifying his artifacts as seals, and it somewhat mitigates the cynical element in the marketing ploy. Gans's reminiscence is also important for the light it sheds on the purchaser—Jane Ford Adams. One can sense her intense interest in the artifacts, whether or not they were really used as garment fasteners. Looking at the seals now, it is easy to understand how an historian of the button would be attracted to the aesthetic dynamics of shapes and decorative treatment on these small items intended certainly for display on the person as well as for practical use as administrative tools. This is especially the case when one looks into historical button studies and begins to appreciate the ranges of social meaning and aesthetic/representational interest of buttons (e.g., Epstein and Safro 1991).

REARTICULATING AND REASSEMBLING THE EX-HERZFELD COLLECTION

Of the seals that came to the Kelsey Museum, we have been able to associate eighty-nine with Tepe Giyan and nineteen with seals taken from the ancient mound and sold to Herzfeld by villagers at nearby Nihavand. Along with these seals, fifty came to the Kelsey without a pedigree of association with Tepe Giyan/ Nihavand. In *This Fertile Land*, we have used very few of the seals not directly associated with Tepe Giyan/Nihavand. Those we have used are brought in to demonstrate very specific points.

What happened to the rest of Herzfeld's seals? The eighteen items illustrated in the group photograph on the cover of *Just Buttons* provided some initial clues. Fifteen of them were indeed in the Gans Gallery sales lot that went to Mrs. Adams. The other three (cat. nos. 10.g, 10.h, and 10.q) were not actually up for sale in New York. They, we have discovered, were acquired by the British Museum in 1936. Two additional ex-Herzfeld seals from Tepe Giyan known through his 1933 essay as well as his sketchbooks and inventory are illustrated in British Museum–related publications (Collon 1990: 12, fig. 1A [WA 128665] and 1997: figs. 1/2 [repeating WA 128665] and 1/3 [WA 128664]).

The full catalogue of the British Museum holdings of early stamp seals will not be published for some time, but we have been able to sort out the basic

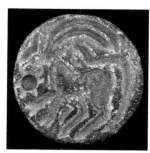

Fig. 11.3. Cat. no. 85.

information related to Herzfeld. Nine ex-Herzfeld stamp seals from prehistoric Tepe Giyan are on display in London at this writing. In addition to the seals pictured on the cover of *Just Buttons*, one more of these seals now on display in London is featured in *This Fertile Land* through Herzfeld's original sketch (cat. no. 89B).

Recently, through the good offices of Mariana Giovino working with Dominique Collon (of the British Museum), we have been able to assess the extent of their ex-Herzfeld holdings in storage. We had hoped to locate a fourth seal of great interest to us on the displayed sketchbook pages (cat. no. 101A, showing two humans coupling). This one is not, apparently, in the British Museum. Seals in storage at the British Museum that are featured in our exhibition through Herzfeld's sketchbooks are cat. nos. 89A and 101B.

The seals we have traced to the British Museum all correlate with notes by Herzfeld in his inventory, where he inserts a "BM" next to selected items. One exception is our cat. no. 85 (fig.11.3). This is annotated "BM" in the inventory but has come to Ann Arbor with the Adams (ex-Herzfeld) collection.

The seals that went to the British Museum include some of the especially interesting and compelling ones with a Tepe Giyan provenance—from the vantage point of dynamic figural representation, large size, and/or fine quality of carving and look of material. The Tepe Giyan seals that came to Ann Arbor also include many examples that fit into this category purely on the level of what we might call "connoisseur appeal." Between the British Museum and the Kelsey Museum we now have reassembled the heart of the Tepe Giyan/Nihavand seals Herzfeld published in 1933 (plus a large selection of the unprovenanced examples). More important than the aspect of connoisseur appeal is the fact that the large corpus of Tepe Giyan seals now in Ann Arbor enables us to begin to reconsider the provenanced corpus according to new agendas.

We can ask new questions that attempt to recapture some of their potential archaeological significance for cultural history despite the fact that the loci of the finds is irretrievably lost. Some of the types of issues we can address are broached in this book. Statistical analysis of subsets of geometric devices (chapter 4 this volume) is one example of the sort of methodology that can now be attempted—with the aim of breaking down the persistent devaluation of non-figural images as meaninglessly decorative forms.

Achieving a documentary record for all the seals, including dimensions, weights, materials analysis, wear analysis, and accuracy on the images, is a base line for future work. The Kelsey Museum is preparing a full documentary catalogue of the ex-Herzfeld stamp seals, which will present all this information for the Adams seals. This will include building up comparanda for all the seals in the collection with excavated material, especially from sites with sealings as well as seals and from sites where the quantities of seals retrieved may so far be extremely small although their evidentiary value is particularly high for other reasons.

JANE FORD ADAMS ONCE MORE

If any private collector was to end up as steward of the ex-Herzfeld collection, Jane Ford Adams seems to have been ideal. She kept them as buttons—the way button collectors do, sewn onto cards. She never intended to disperse the collection, for she appreciated the significance of the artifacts as a body of material that had an intellectual integrity as a unit.

134

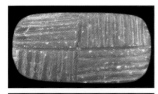

Fig. 11.4. Cat. no. 11.f.

*Fig. 11.5. Cat. no. 12
(a) frontispiece and title
page; (b) fig. 2/1 illustrating
cat. no. 11.f.*

Mrs. Adams, we find, was a serious scholar of the history of buttons. She published one of the seals in *This Fertile Land* (fig. 11.4) in a book about buttons (Albert and Adams 1951) (fig. 11.5). Here she makes the point that "buttons" might have been put to multiple uses. Their function as indicators of "rank or position" and as emblems "to ward off evil," combined with their function for "other odd purposes as well," seems to cover many of the valences of ancient seals as scholars of Near Eastern archaeology understand them today.

The fact that we can now reexamine a good portion of the ex-Herzfeld corpus compensates to some degree for the damage caused when private collecting of antiquities removes them from scholarly purview. Art dealers do not divulge the names of the individuals who purchase their sales lots. It is only through the good will of the purchaser that one can learn the fate of artifacts put up for sale. The return of so many of the ex-Herzfeld seals to the scholarly domain allows them to help us address questions about the signs and symbols of early Iran and Iraq. It allows us to place Herzfeld's initial pioneering investigations into a context illuminated more recently by Elizabeth Henrickson (1952–2002) and others who have worked to interpret the nature and social meaning of seals in late prehistory through controlled archaeological practice.

1. *Coup de Bouton.* A cartoon from 1777 in which a fashionable gentleman dazzles a lady with the brilliance of his large steel buttons.

a

THE
BUTTON SAMPLER

BY
LILLIAN SMITH ALBERT
AND
JANE FORD ADAMS

M. BARROWS AND COMPANY, INC., PUBLISHERS
NEW YORK

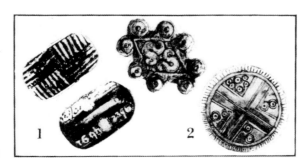

b

PART V

Apparatus

Appendix on Materials Analysis

Kathleen Davis
Suzanne Davis

The seals collected by Herzfeld at Tepe Giyan and Nihavand, Iran, in 1928 offer a variegated visual aspect to the naked eye (see back cover). For professionals such as art historians, trained to focus on visual clues, the color of a rock might seem to be the best way to identify its principal components. But for a geologist color is one of many diagnostic tools used to identify a specific mineral, and it is in fact the least reliable indicator because trace impurities can alter mineral color drastically. For example, in an identical aluminum oxide crystal structure, trace amounts of chromium produce the characteristic red color of ruby, while trace amounts of iron and titanium produce the blue of sapphire. The inclusion of rock color in the object catalogue of this book therefore does not suggest anything diagnostic. It is merely descriptive of the look of each artifact in its present condition, pending detailed mineral analysis of each artifact.

Our ongoing analysis of the mineral compositions of the ex-Herzfeld seals in the Adams collection uses primarily Raman Spectroscopy, with some additional analysis provided by Scanning Electron Microscopy (SEM). Both Raman and SEM are nondestructive. In the past fifteen years, advances in Raman technology have made this technique increasingly practical and appropriate for nondestructive analysis of artifacts. A few museum research laboratories now employ Raman Spectroscopy as a nondestructive analytical technique, including the British Museum.[1] We hope, with our work on the ex-Herzfeld collection, to stimulate comparable analytic projects at institutions with significant provenanced holdings of late prehistoric stamp seals from Iran and Iraq. When the British Museum turns to the scholarly publication of its early stamp seals, it will be particularly interesting ultimately to pool information on this material, since the British Museum now holds numerous ex-Herzfeld stamp seals from Tepe Giyan (including our publication catalogue numbers 10.g, 10.h, 10.q, 89A, 89B, and 101B).

Preliminary studies of the ex-Herzfeld seals reveal that artisans producing seals in the Tepe Giyan region worked with a variety of rocks yielded by the complex geological anatomy of the Zagros Mountains. The metamorphic rocks available in this area are part of the dramatic history of a great fold-and-thrust geologic belt formed from the massive collisions of tectonic plates.

[1] The Department of Scientific Research in the British Museum has worked with a variety of techniques for the mineralogical analysis of ancient Near Eastern cylinder seals of later periods. They have recently moved from using X-ray diffraction powder cameras (XRD), a "destructive" technique requiring the removal of very small samples from the artifacts (Sax 2001), to a program in Raman Spectroscopy (http://www.thebritishmuseum.ac.uk/science/techniques/sr-tech-raman.html and M. Sax pers. comm.).

The majority of the Herzfeld seals from Tepe Giyan are formed from low to mid-grade metamorphic rocks. Within this majority, one of the predominant categories is typified by a black to gray rock with varying accessory minerals. Based on the geological setting, and the presence of chlorite and other hydrated minerals, these rocks are probably greenschist facies. Greenschist facies rocks are often green to dark gray or black in color, largely because of the presence of chlorite, which is an iron-rich mineral. The greenschist facies is in fact characterized by the presence of chlorite and other related minerals. One such mineral is muscovite, which has been identified in multiple seals from the ex-Herzfeld collection. Greenschist facies zones are commonly found in fold-and-thrust belts.

Another identifiable category of low to mid-grade metamorphic rock found in this group of seals is typified by a hydrated, magnesium-rich composition. These seals are predominantly attapulgite and/or talc, two closely related minerals. Although very similar in composition, these seals are variable in appearance. In some cases the seals are uniformly gray in color, while in others the seals are variegated in color, with hues ranging from white to pink to lilac. A number of seals in this category have an altered appearance due to the presence of a secondary mineral coating on the surface.

Publications of collections of late prehistoric stamp seals from the Near East have relied heretofore on generalized notions to express material. Characteristically the materials of most such seals have been presented categorically and generically as "serpentine" or "steatite." The fact that our analyses are showing a preponderance of seals from Tepe Giyan to have been composed chiefly of greenschist facies rocks is already an important corrective to the tendency to offer generic designations that have not been tested.

The "serpentine" designation is problematic. A geologically more appropriate designation would be serpentinite, a rock composed primarily of serpentine minerals, which are a family of sheet silicates rich in magnesium, and a member of the greenschist facies. But in addition to that terminological issue, the commonly used serpentine designation also highlights other questions. Serpentine/serpentinite has a Mohs hardness of 3–5; this would have presented more of a challenge to early seal carvers than some other materials. Softer rocks, represented, for example, by the gray to pink attapulgite and/or talc seals, have a Mohs hardness of around 1–2 and thus would be easy to carve with any harder material. The chlorite-rich group of seals can be expected to have a Mohs hardness of 3–5. While more time-consuming and technically challenging to carve, these rocks could still be carved with a variety of harder materials available in the region, such as quartz (Mohs hardness 7). It will be interesting to learn if there are any correlations between the carving technique and material of specific seals. One might interrogate the data to learn, for instance, whether certain of our very sketchily rendered images were carved into a chiefly attapulgite/talc composition specifically because this material could be used by "amateurs" scratching out designs for themselves without benefit of technical training. With our continuing work on this unique collection of late prehistoric stamp seals, we hope to identify and explore interesting questions such as this. We also hope to further characterize the mineral compositions of the rocks from which the seals are formed and to describe these compositions in terms that are useful for art historian and geologist alike.

Catalogue of Artifacts, Didactics, and Images in the Exhibition

Margaret Cool Root

Notes

1. We have omitted a date line in this catalogue because we are dealing with material uniformly embraced between about 4000 (or somewhat earlier) and 3700 BCE. To attempt to be more specific than that in this format would be to suggest a misleading capacity for definitive dating of the production time for specific artifacts from site to site.

2. All the seals are perforated, so we have also omitted this as an entry line.

3. Scholarly terminology for late prehistoric stamp seal shapes varies widely (Rashad 1990: 17–26). Here we have attempted to use a terminology that is descriptive and as unambiguous as possible. Thus, for instance, we use "hemispherical" adjectivally to describe a range of roughly hemispherically shaped seals in place of the scholarly term "hemispheroid." We use the term "button-type stamp seal" in place of the commonly used "button seal" specifically to clarify a potential confusion. To wit: "Button seals" have been so called in the scholarly literature because of their formal resemblance to modern buttons with perforated protrusions at the back. But this term runs the risk with nonspecialist readers of suggesting a functional relation to modern buttons as garment fasteners.

4. Mineralogical analysis of the rock compositions of the ex-Herzfeld seals is still in progress. Comprehensive results will be published in the forthcoming scholarly monograph on the collection. Here we describe the material in visual terms only. We use the word *rock* rather than *stone* because mineralogically this is more precise. *Rock* describes the fact that the material of the seals in almost every case is made up of metamorphic mineral composites (see "Appendix on Materials Analysis"). *Stone* and its oft-used correlate *seal stone* in the literature misleadingly suggest a mineralogical homogeneity that is inappropriate for most of the seals in the ex-Herzfeld collection from Tepe Giyan.

5. Condition reports for this particular presentation focus on major damage leading to loss of a portion of an artifact. They do not attempt to characterize all surface phenomena such as scratches.

6. One primary bibliographic citation of record is given for each artifact, where this exists. Where one of the ex-Herzfeld seals is previously unpublished but is documented in the Herzfeld sketchbooks or preserved portions of his collections inventory, we give this information instead. For published ex-Herzfeld seals we cite Herzfeld 1933 rather than the unpublished archival resources.

7. We list the artifacts and images displayed in the exhibition by reference to their presentation in the exhibition itself. In keeping with the theme of the exhibition and the approach in this publication, the titling of each entry relates to its representational content.

8. For ease in cross-referencing within this publication, we have assigned item numbers to the individual entries. These numbers are not, however, used in the actual exhibition.

Corridor Case 1

THIS FERTILE LAND: ARCHAEOLOGY AND THE VISUAL RECORD OF HUMAN EXPERIENCE

1. An Ibex

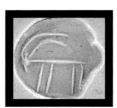

Cast of a button-type stamp seal with flat circular face
Original seal (pictured here): Naturally formed translucent gray glass
Diam. seal face: 1.51 cm; H. seal: 0.29 cm
Chips along edge and back; numerous microscopic cracks
From 1998 Iranian Center for Archaeological Research excavations at Chogha Gavaneh, Iran
Operation W 263, Level VIII, Stratum 42
Abdi 2002: 186–187, 249; Abdi forthcoming
Museum disposition pending
Cast: Courtesy of Kamyar Abdi and the Iranian Center for Archaeological Research

2. Cross with Chevron-Filled Quadrants

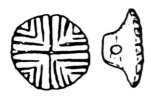

Drawing of a button-type stamp seal with convex circular face
Seal: Gray rock
Max. Diam. seal face: 2.7 cm; H. seal: c. 1.3 cm
Intact
From 1968 University of Michigan and Archaeological Services of Iran excavations at Farukhabad, Iran
X 698, layer B 42
Wright 1981: 54 and fig. 29d
National Museum of Iran, Tehran
Drawing: Courtesy of the University of Michigan Museum of Anthropology

3. Ibexes, Birds, and Crosses

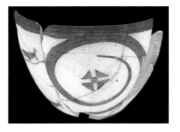

Fragmentary small painted clay bowl
Thin-walled, fine-textured whitish ware with dark gray glaze
H. 8.0 cm
Broken and mended
From 1968 University of Michigan and Archaeological Services of Iran excavations at Farukhabad, Iran
X 449, layer A 23 Farukh phase
Wright 1981: fig. 22f and pl. 8, E
University of Michigan Museum of Anthropology 60248

4. Water Birds and Vultures

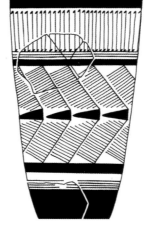

Two fragments of a painted clay beaker
Dense buff ware with brownish black glaze
H. upper fragment: 6.5 cm; H. lower fragment: 3.9 cm
Fragments not contiguous; not restored
From 1971 University of Michigan and Archaeological Services of Iran excavations at Sharafabad, Iran
University of Michigan Museum of Anthropology 61222 a–b
Previously unpublished
Postulated reconstruction of beaker: H. c. 23.0 cm
Rendered by Seth R. Button

Corridor Case 2
SEALS: MEANINGS AND SOCIAL FUNCTIONS

5. Man Leading Animals; Snake

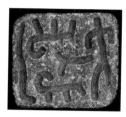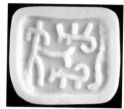

Rectangular plaque stamp seal with flat face
Black rock
L. seal face: 3.3 cm; W. seal face: 3.1 cm; H. seal: 0.7 cm
Minor chips and abrasions
From Herzfeld's 1928 explorations at Tepe Giyan/
 Nihavand, Iran
Herzfeld 1933: 94 (fig. 19: Nih—no number)
Kelsey Museum of Archaeology 1991.3.137
Gift of Dr. John Adams from the estate of Mrs. Jane Ford
 Adams

6. Boar, Snake, and Notches

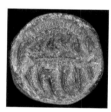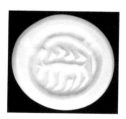

Hemispherical stamp seal with flat circular face
Dark gray rock
Diam. seal face: 2.8 cm; H. seal: 1.4 cm
Minor chips and abrasions
From Herzfeld's 1928 explorations at Tepe Giyan, Iran
Herzfeld 1933: 99 (fig. 22: TG 2351)
Kelsey Museum of Archaeology 1991.3.153
Gift of Dr. John Adams from the estate of Mrs. Jane Ford
 Adams

7. Two Fragments of a Communication Envelope:
(a) Circular Counting Marks

(b) Interior Token Indentation

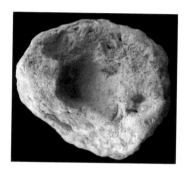

Silty, tan clay
Max. Dim.: c. 5.4 cm; Wall Th.: c. 1.5 cm; Diam. interior:
 c. 2.0 cm; Dim. interior tetrahedral token: c. 0.85 cm
 on a side (based on indentation)
Broken into four pieces; surface very degraded
From 1968 University of Michigan and Archaeological
 Services of Iran excavations at Farukhabad, Iran
X 556, layer B 34, probably intrusive from earlier level
Wright 1981: 156, fig. 75d, and pl. 16e
University of Michigan Museum of Anthropology X 556
Drawing by Andrew Wilburn

8. Model of an Ancient Sealing Impressed with Two
Stamp Seals
Seal images: modern-made impressions of Kelsey
 Museum of Archaeology 1991.3.137 and 1991.3.153
Back: modern-made impressions of rope and contiguous
 surfaces

9. Model of a Marked and Sealed Communication
Envelope—Broken Open
Exterior: Facsimiles of circular counter marks and
 modern impressions of two seals: Kelsey Museum of
 Archaeology 1991.3.137 and 1991.3.153
Interior: Facsimiles of late prehistoric tokens

142

Corridor Case 3

**ERNST HERZFELD, JANE FORD ADAMS,
AND THE BUTTON MARKET**

**10. The Cover of *Just Buttons* 5.8 (May 1947):
Serving as the Gans Gallery Sales Brochure**

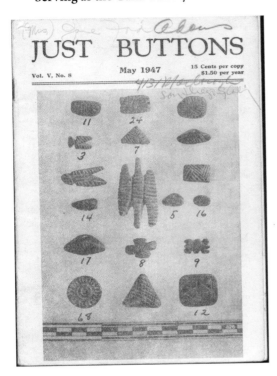

Prepared by Dr. Gerd Muehsam of the Cooper Union for
 Mr. Edward Gans
From the estate of Mrs. Jane Ford Adams
Kelsey Museum of Archaeology Archives

left to right and top to bottom:

**10.a From Herzfeld's 1928 explorations at Tepe
 Giyan, Iran**
Herzfeld 1933: 85 (fig. 13: TG 2394)
Kelsey Museum of Archaeology 1991.3.20
Gift of Dr. John Adams from the estate of Mrs.
 Jane Ford Adams

**10.b From Herzfeld's 1928 explorations at Tepe
 Giyan/Nihavand, Iran**
Herzfeld 1933: 85 (fig. 13: Nih—no number)
Kelsey Museum of Archaeology 1991.3.28
Gift of Dr. John Adams from the estate of Mrs. Jane
 Ford Adams

**10.c From Herzfeld's 1928 explorations at Tepe
 Giyan/Nihavand, Iran**

Herzfeld 1933: 85 (fig. 13: Nih—no number)
Kelsey Museum of Archaeology 1991.3.29
Gift of Dr. John Adams from the estate of Mrs. Jane
 Ford Adams

**10.d From Herzfeld's 1928 explorations at Tepe
 Giyan, Iran**
Herzfeld 1933: 85 (fig. 13: TG—no number)
Kelsey Museum of Archaeology 1991.3.1
Gift of Dr. John Adams from the estate of Mrs. Jane
 Ford Adams
See cat. no. 11.a

**10.e From Herzfeld's 1928 explorations at Tepe
 Giyan, Iran**
Herzfeld 1933: 85 (fig. 13: TG 2655)
Kelsey Museum of Archaeology 1991.3.18
Gift of Dr. John Adams from the estate of Mrs. Jane
 Ford Adams

**10.f From Herzfeld's 1928 explorations at Tepe
 Giyan, Iran**
Herzfeld 1933: 85 (fig. 13: TG 2397)
Kelsey Museum of Archaeology 1991.3.25
Gift of Dr. John Adams from the estate of Mrs. Jane
 Ford Adams

**10.g From Herzfeld's 1928 explorations at Tepe
 Giyan, Iran**
Herzfeld 1933: 85 (fig. 13: TG 2402)
British Museum, 1936 acquisition: WA 128673

**10.h From Herzfeld's 1928 explorations at Tepe
 Giyan, Iran**
Herzfeld 1933: 85 (fig. 13: TG 2686)
British Museum, 1936 acquisition: WA 128672

**10.i From Herzfeld's 1928 explorations at Tepe
 Giyan, Iran**
Herzfeld 1933: 85 (fig. 13: TG 2395)
Kelsey Museum of Archaeology 1991.3.39
Gift of Dr. John Adams from the estate of Mrs. Jane
 Ford Adams

**10.j From Herzfeld's 1928 explorations at Tepe
 Giyan, Iran**
Herzfeld 1933: 85 (fig. 13: TG 2656)
Kelsey Museum of Archaeology 1991.3.22
Gift of Dr. John Adams from the estate of Mrs. Jane
 Ford Adams

**10.k From Herzfeld's 1928 explorations at Tepe
 Giyan, Iran**

Herzfeld 1933: 85 (fig. 13: TG 2391)
Kelsey Museum of Archaeology 1991.3.26
Gift of Dr. John Adams from the estate of Mrs. Jane
Ford Adams

10.l From Herzfeld's 1928 explorations at Tepe Giyan, Iran
Herzfeld 1933: 85 (fig. 13: TG 2408)
Kelsey Museum of Archaeology 1991.3.23
Gift of Dr. John Adams from the estate of Mrs. Jane
Ford Adams

10.m From Herzfeld's 1928 explorations at Tepe Giyan, Iran
Herzfeld 1933: 85 (fig. 13: TG 2654)
Kelsey Museum of Archaeology 1991.3.24
Gift of Dr. John Adams from the estate of Mrs. Jane
Ford Adams

10.n From Herzfeld's 1928 explorations at Tepe Giyan/Nihavand, Iran
Herzfeld 1933: 85 (fig. 13: Nih—no number)
Kelsey Museum of Archaeology 1991.3.19
Gift of Dr. John Adams from the estate of Mrs. Jane
Ford Adams
See cat. no. 20

10.o From Herzfeld's 1928 explorations at Tepe Giyan, Iran
Herzfeld 1933: 85 (fig. 13: TG—no number)
Kelsey Museum of Archaeology 1991.3.3
Gift of Dr. John Adams from the estate of Mrs. Jane
Ford Adams
See cat. no. 11.c

10.p From Herzfeld's 1928 explorations at Tepe Giyan/Nihavand, Iran
Herzfeld 1933: 90 (fig. 17: Nih—no number)
Kelsey Museum of Archaeology 1991.3.65
Gift of Dr. John Adams from the estate of Mrs. Jane
Ford Adams
See cat. no. 66

10.q From Herzfeld's 1928 explorations at Tepe Giyan, Iran
Herzfeld 1933: 85 (fig. 13: TG 2392)
British Museum, 1936 acquisition: WA 128674

10.r From Herzfeld's 1928 explorations at Tepe Giyan, Iran
Herzfeld 1933: 85 (fig. 13: TG 2393)
Kelsey Museum of Archaeology 1991.3.138

Gift of Dr. John Adams from the estate of Mrs. Jane
Ford Adams
See cat. no. 54

11. First of the Original Display Cards from the Gans Gallery Sale (1947)

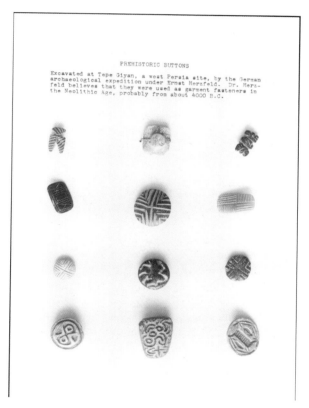

Stamp seals harvested and/or purchased by Dr. Ernst E.
Herzfeld (1920s)
Kelsey Museum of Archaeology 1991.3.1–1991.3.12

left to right and top to bottom:
11.a Parallel Line Pattern
Notch-shaped stamp seal with a triangular base
element and a gabled back, with convex seal
face
Gray rock
L. seal face: 1.7 cm; Max. W. seal face: 1.1 cm;
H. seal: 0.7 cm
Gouge on seal face
From Herzfeld's 1928 explorations at Tepe Giyan,
Iran
Herzfeld 1933: 85 (fig. 13: TG—no number)
Kelsey Museum of Archaeology 1991.3.1
Gift of Dr. John Adams from the estate of Mrs. Jane
Ford Adams

11.b Cross with Filled Quadrants of Parallel Lines
Button-type stamp seal with convex, rounded
 rectangular face
Reddish gray rock, with surface mineral accretion
L. seal face: 2.2 cm; W. seal face: 1.9 cm;
 H. seal: 1.2 cm
Chip off one corner
From Herzfeld's collection (1920s–1934), no
 provenance
Previously unpublished
Kelsey Museum of Archaeology 1991.3.2
Gift of Dr. John Adams from the estate of Mrs. Jane
 Ford Adams

11.c Scattered Linear Pattern
Tripartite irregularly shaped stamp seal with flat face
Black rock
L. seal face: 1.8 cm; Max. W. seal face: 1.1 cm;
 H. seal: 0.6 cm
Small chip off seal face
From Herzfeld's 1928 explorations at Tepe Giyan,
 Iran
Herzfeld 1933: 85 (fig. 13: TG—no number)
Kelsey Museum of Archaeology 1991.3.3
Gift of Dr. John Adams from the estate of Mrs. Jane
 Ford Adams

11.d Symmetrical Pattern of Crosses and Lines
Rectangular button-type stamp seal with flat face
Dark gray rock
L. seal face: 2.2 cm; W. seal face: 1.5 cm;
 H. seal: 0.5 cm
Chips along edges and seal face
From Herzfeld's 1928 explorations at Tepe Giyan,
 Iran
Herzfeld 1933: 85 (fig. 13: TG 2396)
Kelsey Museum of Archaeology 1991.3.4
Gift of Dr. John Adams from the estate of Mrs. Jane
 Ford Adams

**11.e Cross with Filled Quadrants of Nested
 Notches**
Button-type stamp seal with circular convex face
Black rock
Diam. seal face: 2.6 cm; H. seal: 0.9 cm
Small chips along edges
From Herzfeld's 1928 explorations at Tepe Giyan,
 Iran
Herzfeld 1933: 87 (fig. 14: TG 2383)
Kelsey Museum of Archaeology 1991.3.5
Gift of Dr. John Adams from the estate of Mrs. Jane
 Ford Adams

**11.f Cross with Filled Quadrants of Parallel-Line
 Patterns**
Rounded rectangular button seal with flat face
Gray-green stone (a homogeneous muscovite)
L. seal face: 2.6 cm; W. seal face: 1.4 cm;
 H. seal: 0.5 cm
Small chip on seal face
From Herzfeld's collection (1920s), purchased in
 Constantinople
Herzfeld 1933: 85 (fig. 13: Cospl.)
Kelsey Museum of Archaeology 1991.3.6
Gift of Dr. John Adams from the estate of Mrs. Jane
 Ford Adams

11.g Cross with Chevron-Filled Quadrants
Button-type rounded rectangular stamp seal with
 convex circular face
Pink rock with greenish white mineral accretion
Diam. seal face: 1.5 cm; H. seal: 0.6 cm
Condition excellent
From Herzfeld's 1928 explorations at Tepe Giyan,
 Iran
Herzfeld 1933: 87 (fig. 14: TG 2398)
Kelsey Museum of Archaeology 1991.3.7
Gift of Dr. John Adams from the estate of Mrs. Jane
 Ford Adams

11.h Boar with Snake
Button-type stamp seal with convex circular face
Black rock
Diam. seal face: 2.2 cm; H. seal: 1.0 cm
Condition excellent
From Herzfeld's 1928 explorations at Tepe Giyan,
 Iran
Herzfeld 1933: 87 (fig. 14: TG—no number)
Kelsey Museum of Archaeology 1991.3.8
Gift of Dr. John Adams from the estate of Mrs. Jane
 Ford Adams

**11.i Outlined Cross (Incompletely Rendered) with
 Chevron-Filled Quadrants**
Button-type stamp seal with convex circular face
Black rock
Diam. seal face: 2.0 cm; H. seal: 0.6 cm
Chips along edges and seal face
From Herzfeld's 1928 explorations at Tepe Giyan,
 Iran
Herzfeld 1933: 87 (fig. 14: TG 2386)
Kelsey Museum of Archaeology 1991.3.9
Gift of Dr. John Adams from the estate of Mrs. Jane
 Ford Adams

11.j Cross Formation; Quadrants Filled with Opposing Framed Dots and Triangles; Concentric Circles around Perimeter

Button-type stamp seal with raised, flat circular face
Gray rock with buff-colored mineral accretion
Diam. seal face: 2.3 cm; H. seal: 1.2 cm
Chip along edge
From Herzfeld's 1928 explorations at Tepe Giyan, Iran
Herzfeld 1933: 87 (fig. 14: TG 2656)
Kelsey Museum of Archaeology 1991.3.10
Gift of Dr. John Adams from the estate of Mrs. Jane Ford Adams

11.k Dots and Circles, Dashes, a Cross, and Curvilinear Elements

Trapezoidal button-type stamp seal with rounded, convex trapezoidal face
Brownish gray rock
L. seal face: 3.1 cm; Max. W. seal face: 2.3 cm; H. seal: 1.0 cm
Chip at one corner
From Herzfeld's collection (1920s), purchased at Hamadan
Herzfeld 1933: 85 (fig. 13: Ham.)
Kelsey Museum of Archaeology 1991.3.11
Gift of Dr. John Adams from the estate of Mrs. Jane Ford Adams

11.l Four Ibex Heads Joined to One Central Body; Two Seedlike Elements

Gable-backed button-type stamp seal with flat circular face
Gray rock with greenish white mineral accretion
Diam. seal face: 2.8 cm; H. seal: 0.8 cm
Chips along edges and back
From Herzfeld's collection (1920s–1934), no provenance
Previously unpublished
Kelsey Museum of Archaeology 1991.3.12
Gift of Dr. John Adams from the estate of Mrs. Jane Ford Adams

12. *The Button Sampler*, **by Lillian Smith Albert and Jane Ford Adams (New York: M. Barrows and Company, Inc. 1951)**

University of Michigan Fine Arts Library

Fig. 2/1:
Cross with Filled Quadrants of Parallel-Line Patterns

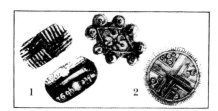

Rounded rectangular button-type stamp seal with flat face
Kelsey Museum of Archaeology 1991.3.6
Gift of Dr. John Adams from the estate of Mrs. Jane Ford Adams
See cat. no. 11.f

13. Examples of Modern Buttons Collected by Jennifer Boan (UM BA 2004)
From "The Button Lady" (Evelyn Gibbons, Proprietor)
5135 Plymouth Road, Ann Arbor

14. Diagram: Facsimile of an Ancient Door Sealing

Shown as if impressed with Kelsey Museum seals
 1991.3.7 and 1991.3.8
Adapted from Marcus 1996: fig. 6.2, by Peg Lourie using
 seal impression renderings by Lorene Sterner

15. Diagram: Facsimile of an Ancient Leather Bag Sealing

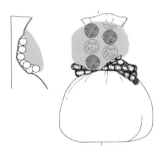

Shown as if impressed with Kelsey Museum seals
 1991.3.7 and 1991.3.8
Adapted from Marcus 1996: fig. 5.2 a–b, by Peg Lourie
 using seal impression renderings by Lorene Sterner

16. Diagram: Facsimile of an Ancient Reed Basket Sealing

Shown as if impressed with Kelsey Museum seals
 1991.3.7 and 1991.3.8
Adapted from Marcus 1996: fig. 5.3, by Peg Lourie using
 seal impression renderings by Lorene Sterner

Corridor Case 4

MATERIALS, FORMS, CARVING TECHNIQUES

17. Basket-Weave Pattern

Barrel-shaped cylindrical bead seal perforated
 longitudinally through the cylinder
Brownish gray rock
L. seal: 2.5 cm; Max. Diam. seal: 1.1 cm
Minor chips
From Herzfeld's 1928 explorations at Tepe Giyan, Iran
Herzfeld 1933: 84 (fig. 12: TG 240i)
Kelsey Museum of Archaeology 1991.3.13
Gift of Dr. John Adams from the estate of Mrs. Jane Ford
 Adams

18. Parallel-Line Pattern

Notch-shaped gable-backed stamp seal with convex two-
 pronged face
Grayish brown rock
L. each prong of seal face: 2.0 cm; Max. W. across
 combined prongs: 1.2 cm; H. seal: 0.8 cm
Minor chips along edges
From Herzfeld's 1928 explorations at Tepe Giyan, Iran
Herzfeld 1933: 85 (fig. 13: TG 2403)
Kelsey Museum of Archaeology 1991.3.15
Gift of Dr. John Adams from the estate of Mrs. Jane Ford
 Adams

19. Basket-Weave Pattern

Rectangular gable-backed stamp seal with convex face
Gray rock
L. seal face: 1.6 cm; W. seal face: 1.1 cm; H. seal: 1.1 cm

Minor chips along two edges
From Herzfeld's 1928 explorations at Tepe Giyan, Iran
Herzfeld 1933: 85 (fig. 13: TG 2398)
Kelsey Museum of Archaeology 1991.3.17
Gift of Dr. John Adams from the estate of Mrs. Jane Ford
 Adams

20. Oblique Parallel-Line Pattern

Cruciform plaque stamp seal with flat face
Gray rock
L. seal face: 2.2 cm; W. seal face: 1.5 cm; H. seal: 1.1 cm
Minor chips on seal face
From Herzfeld's 1928 explorations at Tepe Giyan/
 Nihavand, Iran
Herzfeld 1933: 85 (fig. 13: Nih—no number)
Kelsey Museum of Archaeology 1991.3.19
Gift of Dr. John Adams from the estate of Mrs. Jane Ford
 Adams

21. Complex Bifurcated Linear Pattern

Pointed hemispherical stamp seal with convex face
White rock
Diam. seal face: 1.3 cm; H. seal: 0.7 cm
Some abrasion
From Herzfeld's 1928 explorations at Tepe Giyan, Iran
Herzfeld 1933: 85 (fig. 13: TG [IV 15 s.n])
Kelsey Museum of Archaeology 1991.3.27
Gift of Dr. John Adams from the estate of Mrs. Jane Ford
 Adams

22. Bifurcated Linear Pattern

Square-faced flattened hemispherical stamp seal with flat face
White rock with pink hues
L. seal face: 1.5 cm; W. seal face: 1.3 cm; H. seal: 0.8 cm
Some abrasion at perforation holes
From Herzfeld's 1928 explorations at Tepe Giyan, Iran
Herzfeld 1933: 88 (fig. 15: TG 2404)
Kelsey Museum of Archaeology 1991.3.51
Gift of Dr. John Adams from the estate of Mrs. Jane Ford
 Adams

23. Radial Linear Pattern

Flattened hemispherical stamp seal with flat, rounded
 rectangular face
Black and white mottled rock
L. seal face: 2.1 cm; W. seal face: 1.8 cm; H. seal: 0.8 cm
Chip off seal face; abrasion at perforation holes
From Herzfeld's 1928 explorations at Tepe Giyan/
 Nihavand, Iran
Herzfeld 1933: 88 (fig. 15: Nih—no number)
Kelsey Museum of Archaeology 1991.3.55
Gift of Dr. John Adams from the estate of Mrs. Jane Ford
 Adams

24. Drilled Dots in Curvilinear Nests

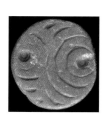 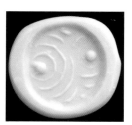

Hemispherical stamp seal with flat circular face
Black rock
Diam. seal face: 3.1 cm; H. seal: 1.2 cm
Chip on seal face
From Herzfeld's 1928 explorations at Tepe Giyan, Iran
Herzfeld 1933: 90 (fig. 17: TG 234i)
Kelsey Museum of Archaeology 1991.3.69
Gift of Dr. John Adams from the estate of Mrs. Jane Ford
 Adams

25.

Side a): Animal, Snakes, Rectangular Element

Side b): Bifurcated Linear Pattern of Nested Chevrons

Two-sided rectangular plaque seal carved with shallow
 incisions
Black rock
L. seal face: 3.3 cm; W. seal face: 2.5 cm; H. seal: 0.8 cm
Deep abrasion at perforation holes
From Herzfeld's 1928 explorations at Tepe Giyan, Iran
Herzfeld 1933: 102 (fig. 25: TG 2374)
Kelsey Museum of Archaeology 1991.3.97
Gift of Dr. John Adams from the estate of Mrs. Jane Ford
 Adams

26. Drilled Snakes and Linear Patterns

Hemispherical stamp seal with flat circular face; multiple
 attempts at perforation
Brownish gray rock
Diam. seal face: 3.5 cm; H. seal: 1.8 cm
Some chips along edges
From Herzfeld's 1928 explorations at Tepe Giyan/
 Nihavand, Iran

Previously unpublished (Herzfeld Sketchbook XXVIII,
 neg. 6405 upper left, Ernst Herzfeld Papers)
Kelsey Museum of Archaeology 1991.3.113
Gift of Dr. John Adams from the estate of Mrs. Jane Ford
 Adams

27. Three Snakes in Parallel Meander Pattern

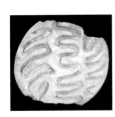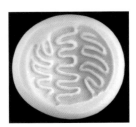

Circular button-type stamp seal with convex face
Gray rock with white mineral accretion
Diam. seal face: 3.1 cm; H. seal: 1.2 cm
Massive chips along edges
From Herzfeld's 1928 explorations at Tepe Giyan/
 Nihavand, Iran
Herzfeld 1933: 87 (fig. 14: Nih—no number)
Kelsey Museum of Archaeology 1991.3.129
Gift of Dr. John Adams from the estate of Mrs. Jane Ford
 Adams

28. Bifurcated Pattern of Snakes, Notches, and Lines

Hemispherical gable-backed stamp seal with flat, circular
 face
Red rock
Diam. seal face: 3.0 cm; H. seal: 1.1 cm
Broken along perforation, with only half the seal
 preserved
From Herzfeld's 1928 explorations at Tepe Giyan, Iran
Herzfeld 1933: 90 (fig. 17 = TG 2354 as per Herzfeld
 Sketchbook XXVII, neg. 6439, Herzfeld Papers)
Kelsey Museum of Archaeology 1991.3.132
Gift of Dr. John Adams from the estate of Mrs. Jane Ford
 Adams

29. Bifurcated Pattern of Notches and Lines

Stepped-back rectangular stamp seal with flat,
 rectangular face
Gray rock
L. seal face: 3.6 cm; W. seal face: 3.3 cm; H. seal: 1.8 cm
Chip at one corner
From Herzfeld's 1928 explorations at Tepe Giyan, Iran
Herzfeld 1933: 92 (fig. 18: TG 2685)
Kelsey Museum of Archaeology 1991.3.141
Gift of Dr. John Adams from the estate of Mrs. Jane Ford
 Adams

Gallery Cross—Case 1

SIGNS OF THE SHAMAN

30. Shaman Flanked by Snakes, Notches, and Dots

Flattened hemispherical stamp seal with flat circular face
Greenish gray rock
Diam. seal face: 3.4 cm; H. seal: 1.4 cm
Abrasion at perforation holes
From Herzfeld's 1928 explorations at Tepe Giyan, Iran
Herzfeld 1933: 101 (fig. 24: TG 2333)
Kelsey Museum of Archaeology 1991.3.91
Gift of Dr. John Adams from the estate of Mrs. Jane Ford
 Adams

31. Shaman and Snakes

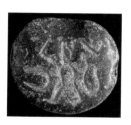

Hemispherical stamp seal with flat circular face
Black rock
Diam. seal face: 4.0 cm; H. seal: 1.8 cm
Large chip off top of seal face
From Herzfeld's 1928 explorations at Tepe Giyan, Iran
Herzfeld 1933: 101 (fig. 24: 2349)
Kelsey Museum of Archaeology 1991.3.92
Gift of Dr. John Adams from the estate of Mrs. Jane Ford
 Adams

32. Shaman with Snakes, Bird, and Notches

Hemispherical stamp seal with flat circular face
Brownish gray rock
Diam. seal face: 2.7 cm; H. seal: 1.2 cm
Chips along edges; abrasion at perforation holes
From Herzfeld's 1928 explorations at Tepe Giyan, Iran
Herzfeld 1933; 101 (fig. 24: TG 2335)
Kelsey Museum of Archaeology 1991.3.94
Gift of Dr. John Adams from the estate of Mrs. Jane Ford
 Adams

33.
Side a): Shaman with Snakes (?)

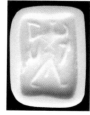

150

Side b): Meandering Snake with Three Dots at Top, Notches at Side

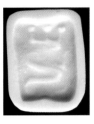

Long edges: Linear Patterns

Rectangular plaque stamp seal with flat faces
Black rock
L. seal face: 2.6 cm; W. seal face: 1.8 cm; H. seal: 0.8 cm
Minor abrasion on seal face and at perforation holes
From Herzfeld's 1928 explorations at Tepe Giyan, Iran
Herzfeld 1933: 102 (fig. TG 2377)
Kelsey Museum of Archaeology 1991.3.100
Gift of Dr. John Adams from the estate of Mrs. Jane Ford
 Adams

34.
Side a): Shaman with Snakes, Animals, and Notches

Side b): Ibex, Snakes, Notch, and Arrow

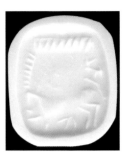

Rounded rectangular plaque stamp seal with flat faces
Black rock
L. seal face: 4.5 cm; W. seal face: 3.6 cm; H. seal: 1.2 cm
Minor chips; some abrasion at perforation holes
From Herzfeld's 1928 explorations at Tepe Giyan, Iran
Herzfeld 1933: 102 (fig. 25: TG 2506)
Kelsey Museum of Archaeology 1991.3.101
Gift of Dr. John Adams from the estate of Mrs. Jane Ford
 Adams

35. Shaman (as Cruciform Figure), with Dots, Schematic Quadrupeds (?), and Nested Notches

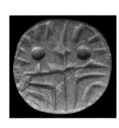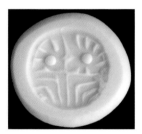

Flattened hemispherical stamp seal with flat circular face
Brownish gray rock
Diam. seal face: 3.4 cm; H. seal: 1.2 cm
Chip off one side of seal face
From Herzfeld's 1928 explorations at Tepe Giyan/
 Nihavand, Iran
Herzfeld 1933: 88 (fig. 15: Nih—no number)
Kelsey Museum of Archaeology 1991.3.102
Gift of Dr. John Adams from the estate of Mrs. Jane Ford
 Adams

36.
Side a): Shaman with Snakes and Notches

Side b): Two Animals "Tête-Bêche" (Head-to-Tail)

Rectangular plaque stamp seal with flat faces
Dark gray rock
L. seal face: 3.1 cm; W. seal face: 1.9 cm; H. seal: 0.9 cm
Minor chips along edges
From Herzfeld's 1928 explorations at Tepe Giyan, Iran
Herzfeld 1933: 102 (fig. 25: TG 2375)
Kelsey Museum of Archaeology 1991.3.104
Gift of Dr. John Adams from the estate of Mrs. Jane Ford
 Adams

37. Prancing Shaman with Ibex and Crosses

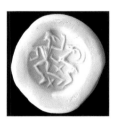

Low gable-backed stamp seal with convex, irregularly
 circular face
Black rock
L. seal face: 2.0 cm; W. seal face: 1.7 cm; H. seal: 0.5 cm
Condition excellent
From 1927–31 University of Pennsylvania and Dropsie
 College excavations at Tepe Gawra, Iraq
Level XIII. 3k

Tobler 1950: no. 95
Loaned by the University of Pennsylvania Museum of
 Archaeology and Anthropology: 37.16.357

38. Container Sealing
Front: Shaman Wielding a Boomerang (?)—
** Impression of Rectangular Stamp Seal**

Back: Reed and Rope Marks

Clay
Sealing: Max. Pres. L. 8.5 cm; Max. Pres. W. 4.5 cm;
 Max. pres. H. 3.2 cm
Seal face: Max. Pres. L. 3.0 cm; Max Pres. W. 3.5 cm
Impressed surfaces clearly legible
From 1927–31 University of Pennsylvania and Dropsie
 College excavations at Tepe Gawra, Iraq
Level XI.10m
Tobler 1950: no. 81
Loaned by the University of Pennsylvania Museum of
 Archaeology and Anthropology: 38.13.18

Gallery Cross—Case 2
NOTCHES AND DOTS/CROSSES AND QUADRANTS

39. Central Dot Ringed by Ten Dots

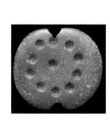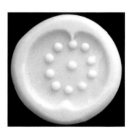

Flattened hemispherical stamp seal with flat circular face
Black rock
Diam. seal face: 2.9 cm; H. seal: 1.0 cm
Severe chipping and abrasion at perforation holes
From Herzfeld's 1928 explorations at Tepe Giyan, Iran
Previously unpublished (TG 2358, as per Herzfeld
 Sketchbook XXVII, neg. 6439, Herzfeld Papers)
Kelsey Museum of Archaeology 1991.3.109
Gift of Dr. John Adams from the estate of Mrs. Jane Ford
 Adams

40. Central Dot Ringed by Five Dots, with Seven Tailed Dots on Perimeter

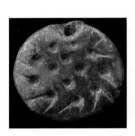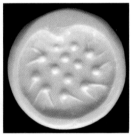

Hemispherical stamp seal with flat circular face
Brownish black rock
Diam. seal face: 4.6 cm; H. seal: 2.0 cm
Severe abrasion at perforation holes
From Herzfeld's 1928 explorations at Tepe Giyan, Iran
Previously unpublished (TG 6439, as per Herzfeld
 Sketchbook XXVII, neg. 6439, Herzfeld Papers)
Kelsey Museum of Archaeology 1991.3.110
Gift of Dr. John Adams from the estate of Mrs. Jane Ford
 Adams

41. Connected Coil of Ten Dots, with Five Dots on Perimeter

Flattened hemispherical stamp seal with flat circular face
Dark gray rock
Diam. seal face: 1.4 cm; H. seal: 0.8 cm
Severe abrasion at one perforation hole
From Herzfeld's 1928 explorations at Tepe Giyan, Iran

Previously unpublished (see Herzfeld Sketchbook
 XXVII, neg. 6440/41: TG 2371, Herzfeld Papers)
Kelsey Museum of Archaeology 1991.3.114
Gift of Dr. John Adams from the estate of Mrs. Jane Ford
 Adams

42. Rows of Nested Notches Bifurcated by a Line

Hemispherical stamp seal with flat circular face
Dark gray rock
Diam. seal face: 3.0 cm; H. seal: 1.1 cm
Small chips
From Herzfeld's 1928 explorations at Tepe Giyan, Iran
Herzfeld 1933: 92 (fig. 18: TG 25i0)
Kelsey Museum of Archaeology 1991.3.73
Gift of Dr. John Adams from the estate of Mrs. Jane Ford
 Adams

43. Kneeling Shaman Flanked by a Snake and a Tree; Dot and Cross Framing His Head

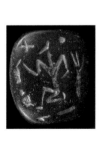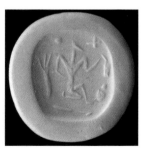

Irregular rectangular gable-backed stamp seal
Black rock
L. seal face: 2.8 cm; W. seal face: 2.2 cm; H. seal: 1.2 cm
Intact
From 1927–31 University of Pennsylvania and Dropsie
 College excavations at Tepe Gawra, Iraq
Level XI-A. 6J
Tobler 1950: no. 84
Loaned by the University of Pennsylvania Museum of
 Archaeology and Anthropology: 37.16.76

44. Container Sealing
**Front: Impression of Circular-Faced Stamp Seal
Showing Shaman and Notches**

 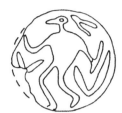

Back: Rope Marks

Clay
Sealing: Max. Pres. L. 5.5 cm; Max. Pres. W. 4.0 cm; Max.
 Pres. H. 2.3 cm
Seal face: Diam. 3.0 cm
Impressed surfaces clearly legible
From 1927–31 University of Pennsylvania and Dropsie
 College excavations at Tepe Gawra, Iraq
Level XII. 5Q
Tobler 1950: no. 78
Loaned by the University of Pennsylvania Museum of
 Archaeology and Anthropology: 36.6.309

45. Fragment of a Communication Envelope:
Circular Counting Marks; Stamp Seal Impression

Silty, tan clay
Max. Dim. envelope: c. 5.4 cm; Wall Th.: c. 1.5 cm; Diam.

interior cavity: c. 2.0 cm; Dim. interior tetrahedral
 token: c. 0.85 cm on a side (based on preserved
 indentation)
Broken into four pieces; surface very degraded
From 1968 University of Michigan and Archaeological
 Services of Iran excavations at Farukhabad, Iran
X 556, layer B 34, probably intrusive from earlier level
Wright 1981: 156, fig. 75d, and pl. 16e
University of Michigan Museum of Anthropology X 556
Drawing by Andrew Wilburn

46. Cross with Single Notches in Quadrants

Hemispherical stamp seal with flat circular face
Reddish black rock
Diam. seal face: 2.0 cm; H. seal: 0.9 cm
Chips along edges
From Herzfeld's 1928 explorations at Tepe Giyan, Iran
Herzfeld 1933: 88 (fig. 15: TG 2385)
Kelsey Museum of Archaeology 1991.3.47
Gift of Dr. John Adams from the estate of Mrs. Jane Ford
 Adams

47. Squared Cross with Single Dots in Quadrants;
Parallel Lines Radiating from the Square

Hemispherical stamp seal with flat circular face
Gray and white mottled rock
Diam. seal face: 3.1 cm; H. seal: 1.4 cm
Large chip off one corner
From Herzfeld's 1928 explorations at Tepe Giyan, Iran
Herzfeld 1933: 88 (fig. 15: TG 236i)
Kelsey Museum of Archaeology 1991.3.54
Gift of Dr. John Adams from the estate of Mrs. Jane Ford
 Adams

48. Cross with Quadrants Filled with (a) Nested Notches and (b) Lined Triangles

Hemispherical stamp seal with flat circular face
Gray rock
Diam. seal face: 2.8 cm; H. seal: 1.3 cm
Small chip on seal face; abrasion at perforation holes
From Herzfeld's 1928 explorations at Tepe Giyan, Iran
Herzfeld 1933: 89 (fig.16: TG 2360)
Kelsey Museum of Archaeology 1991.3.56
Gift of Dr. John Adams from the estate of Mrs. Jane Ford Adams

49. Cross with Quadrants Filled with Lined Triangles

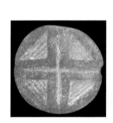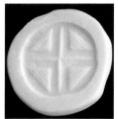

Hemispherical stamp seal with flat circular face
Gray rock
Diam. seal face: 3.1 cm; H. seal: 1.0 cm
Abrasion at perforation holes
From Herzfeld's 1928 explorations at Tepe Giyan, Iran
Herzfeld 1933: 89 (fig. 16: TG 2359)
Kelsey Museum of Archaeology 1991.3.57
Gift of Dr. John Adams from the estate of Mrs. Jane Ford Adams

50. Cross Squared by Lines

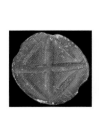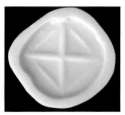

Hemispherical stamp seal with flat circular face
Black rock
Diam. seal face: 2.6 cm; H. seal: 1.0 cm
Multiple chips along edges
From Herzfeld's 1928 explorations at Tepe Giyan, Iran
Herzfeld 1933: 89 (fig. 16: TG 2345)
Kelsey Museum of Archaeology 1991.3.58
Gift of Dr. John Adams from the estate of Mrs. Jane Ford Adams

51. Cross Filled with Solid Triangles

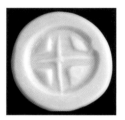

Hemispherical stamp seal with flat circular face
Dark gray rock
Diam. seal face: 2.3 cm; H. seal: 1.0 cm
Minor chipping
From Herzfeld's 1928 explorations at Tepe Giyan, Iran
Herzfeld 1933: 89 (fig. 16: TG 2684)
Kelsey Museum of Archaeology 1991.3.59
Gift of Dr. John Adams from the estate of Mrs. Jane Ford Adams

52. Cross Filled with Solid Triangles

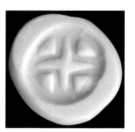

Hemispherical stamp seal with flat circular face
Dark gray rock
Diam. seal face: 3.0 cm; H. seal: 1.3 cm
Chips along edges
From Herzfeld's 1928 explorations at Tepe Giyan, Iran
Herzfeld 1933: 89 (fig. 16: TG 2357)
Kelsey Museum of Archaeology 1991.3.60
Gift of Dr. John Adams from the estate of Mrs. Jane Ford Adams

53. Solid Cross Nested within Outlined Cross

Hemispherical stamp seal with flat circular face
Red rock
Small chip on seal face
Diam. seal face: 1.2 cm; H. seal: 0.6 cm
From Herzfeld's 1928 explorations at Tepe Giyan, Iran
Herzfeld 1933: 89 (fig. 16: TG 2405)
Kelsey Museum of Archaeology 1991.3.62
Gift of Dr. John Adams from the estate of Mrs. Jane Ford
 Adams

54. Cross Squared by Lines and Framed by Multilined Square

Button-type stamp seal with rounded rectangular convex
 seal face
Gray rock
L. seal face: 2.6 cm; W. seal face: 2.3 cm; H. seal: 1.1 cm
Massive abrasion at perforation on back
From Herzfeld's 1928 explorations at Tepe Giyan, Iran
Herzfeld 1933: 85 (fig. 13: TG 2393)
Kelsey Museum of Archaeology 1991.3.138
Gift of Dr. John Adams from the estate of Mrs. Jane Ford
 Adams

55.
Side a): Dancing Shaman

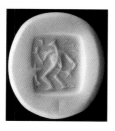

Side b): Cross with Chevron-Filled Quadrants

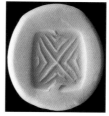

Rectangular plaque stamp seal with slightly convex
 rectangular faces
Black rock
L. seal face: 1.7 cm; W. seal face: 1.2 cm; H. seal: 0.5 cm
Abrasion at perforation holes along Side b
From 1927–31 University of Pennsylvania and Dropsie
 College excavations at Tepe Gawra, Iraq
Level XI-A. 4Q
Tobler 1950: no. 80
Loaned by the University of Pennsylvania Museum of
 Archaeology and Anthropology: 35.10.171

Gallery Cross—Case 3
WATER, EARTH, SKY

56. Stacked Zigzags

Pointed hemispherical stamp seal with flat circular face
Gray rock
Diam. seal face: 3.0 cm; H. seal: 1.3 cm
Minor chips and abrasions
From Herzfeld's 1928 explorations at Tepe Giyan, Iran
Herzfeld 1933: 92 (fig. 18: TG 1679)
Kelsey Museum of Archaeology 1991.3.72
Gift of Dr. John Adams from the estate of Mrs. Jane Ford
 Adams

57.
Side a): Crossed-Line (Waffle) Pattern

Side b): Linear Marks

Irregular hemispherical stamp seal with one flat, roughly
 circular face (a) and one irregular convex face (b)
Dark gray rock
Max. L. seal face: 3.0 cm; Max. W. seal face: 2.1 cm; H.
 seal: 1.4 cm
Large chip off Side a; abrasion at perforation holes
From Herzfeld's 1928 explorations at Tepe Giyan, Iran
Herzfeld 1933: 95 (fig. 20: TG 2379)
Kelsey Museum of Archaeology 1991.3.87
Gift of Dr. John Adams from the estate of Mrs. Jane Ford
 Adams

58.
Side a) and Side b): Stacked Zigzags/Snakes

Irregular rectangular plaque stamp seal with flat,
 irregular rectangular faces
Greenish black rock
L. seal face: 2.3 cm; W. seal face: 1.9 cm; H. seal: 0.9 cm
Chip at one perforation hole
From Herzfeld's 1928 explorations at Tepe Giyan, Iran
Herzfeld 1933: 102 (fig. 25: TG 2344)
Kelsey Museum of Archaeology 1991.3.98
Gift of Dr. John Adams from the estate of Mrs. Jane Ford
 Adams

59. Irregular Crossed-Line (Waffle) Pattern

Hemispherical stamp seal with flat circular face
Dark gray rock
Diam. seal face: 2.2 cm; H. seal: 1.0 cm
Condition excellent
From Herzfeld's 1928 explorations at Tepe Giyan, Iran
Herzfeld 1933: 88 (fig. 15: TG 2364)
Kelsey Museum of Archaeology 1991.3.131
Gift of Dr. John Adams from the estate of Mrs. Jane Ford
 Adams

**60. Crossed-Line (Waffle) Pattern, with Added Dots
 and Linear Marks**

Button-type stamp seal with convex circular face
Black rock
Diam. seal face: 3.2 cm; H. seal: 1.4 cm
Minor chips
From Herzfeld's 1928 explorations at Tepe Giyan, Iran
Herzfeld 1933: 87 (fig. 14: TG—no number)
Kelsey Museum of Archaeology 1991.3.139
Gift of Dr. John Adams from the estate of Mrs. Jane Ford
 Adams

61. Container Sealing
Front: Fragmentary Impression of a Circular Stamp Seal Showing Ibex, Birds, Fish, and Notch

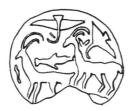

Back and Side: Reed Marks and Fingerprints

Clay
Sealing: Max. Pres. L. 4.5 cm; Max. Pres. W. 6.0 cm; Max. Pres. H. 5.0 cm
Seal: Orig. Diam. seal face: c. 3.0 cm
Large chip at lower portion of sealing; cracked diagonally into two almost equal parts
From 1927–31 University of Pennsylvania and Dropsie College excavations at Tepe Gawra, Iraq
Level XIII well
Tobler 1950: no. 173
Loaned by the University of Pennsylvania Museum of Archaeology and Anthropology: 38.13.75A
A portion of the seal impression partially preserved here was retained by the Iraq Museum, Baghdad, as part of the Iraqi division of finds from Tepe Gawra.

62. Cross with Quadrants Filled by Radial Lines

Flattened hemispherical stamp seal with flat circular face
Dark gray rock

Diam. seal face: 2.0 cm; H. seal: 0.9 cm
Minor abrasion at perforation holes
From Herzfeld's 1928 explorations at Tepe Giyan, Iran
Herzfeld 1933: 88 (fig. 15: TG 2366)
Kelsey Museum of Archaeology 1991.3.48
Gift of Dr. John Adams from the estate of Mrs. Jane Ford Adams

63. Linear Bifurcation with Radial Lines around Perimeter

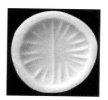

Hemispherical stamp seal with flat circular face
White rock with pink hues
Diam. seal face: 2.0; H. seal: 0.8 cm
Abrasion at perforation holes
From Herzfeld's 1928 explorations at Tepe Giyan, Iran
Herzfeld 1933: 88 (fig. 15: TG 2388)
Kelsey Museum of Archaeology 1991.3.50
Gift of Dr. John Adams from the estate of Mrs. Jane Ford Adams

64. Six-Segmented Starburst Defined by Nested Notches

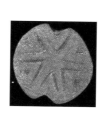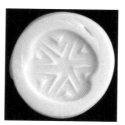

Hemispherical stamp seal with flat circular face
Gray rock
Diam. seal face: 2.7 cm; H. seal: 1.2 cm
Abrasion at perforation holes
From Herzfeld's 1928 explorations at Tepe Giyan/ Nihavand, Iran
Herzfeld 1933: 89 (fig. 16: Nih—no number)
Kelsey Museum of Archaeology 1991.3.61
Gift of Dr. John Adams from the estate of Mrs. Jane Ford Adams

65. Large Central Dot with Twelve Rays

Hemispherical stamp seal with flat circular face
Dark gray rock
Diam. seal face: 1.9 cm; H. seal: 0.9 cm
Condition excellent
From Herzfeld's 1928 explorations at Tepe Giyan/
 Nihavand, Iran
Herzfeld 1933: 90 (fig. 17: Nih—no number)
Kelsey Museum of Archaeology 1991.3.64
Gift of Dr. John Adams from the estate of Mrs. Jane Ford
 Adams

**66. Central Dot Ringed by Two Concentric Circles
and a Framing Ring of Twenty-two Rays**

Pointed hemispherical seal with flat circular face
Black rock
Diam. seal face: 2.3 cm; H. seal: 0.8 cm
Condition excellent
From Herzfeld's 1928 explorations at Tepe Giyan/
 Nihavand, Iran
Herzfeld 1933: 90 (fig. 17: Nih—no number)
Kelsey Museum of Archaeology 1991.3.65
Gift of Dr. John Adams from the estate of Mrs. Jane Ford
 Adams

**67. Ringed Central Dot Framed by Eight Torquing
Rays**

Hemispherical stamp seal with flat circular face
Dark gray rock
Diam. seal face: 1.7 cm; H. seal: 0.8 cm
Minor chips along edges and seal face; abrasion at
 perforation holes
From Herzfeld's 1928 explorations at Tepe Giyan/
 Nihavand, Iran
Herzfeld 1933: 90 (fig. 17: Nih—no number)
Kelsey Museum of Archaeology 1991.3.66
Gift of Dr. John Adams from the estate of Mrs. Jane Ford
 Adams

**68. Central Dot within Seven-Armed Starburst
Ringed by Two Concentric Circles**

Flattened hemispherical stamp seal with flat circular face
Dark gray rock
Diam. seal face: 2.9 cm; H. seal: 1.2 cm
Chips along edges; abrasion at perforation holes
From Herzfeld's 1928 explorations at Tepe Giyan, Iran
Herzfeld 1933: 90 (fig. 17: TG 2355)
Kelsey Museum of Archaeology 1991.3.67
Gift of Dr. John Adams from the estate of Mrs. Jane Ford
 Adams

**69. Cross with Two Lines Off Each Axial Arm (a
"Swastika" Pattern)**

Irregular hemispherical stamp seal with collar at one
 end; flat quasi-circular face
Gray rock
Diam. seal face: 2.3 cm; H. seal: 0.8 cm
Chips along edges; abrasion at perforation holes
From Herzfeld's 1928 explorations at Tepe Giyan, Iran
Herzfeld 1933: 90 (fig. 17: TG 2346)

Kelsey Museum of Archaeology 1991.3.68
Gift of Dr. John Adams from the estate of Mrs. Jane Ford
 Adams

Gallery Cross—Case 4

SNAKES

70. Snakes with Multiple Dots, Lines, and Notches

Hemispherical stamp seal with flat circular face
Black rock
Diam. seal face: 3.5 cm; H. seal: 1.1 cm
Deeply abraded around perforation holes
From Herzfeld's 1928 explorations at Tepe Giyan, Iran
Herzfeld 1933: 95 (fig. 20: TG 2508)
Kelsey Museum of Archaeology 1991.3.89
Gift of Dr. John Adams from the estate of Mrs. Jane Ford
 Adams

71. Schematic Animal with Snake Above

Flattened hemispherical stamp seal with flat circular face
Black rock
Diam. seal face: 4.7 cm; H. seal: 1.3 cm
Chips along edges; abrasion at perforation holes
From Herzfeld's 1928 explorations at Tepe Giyan, Iran
Herzfeld 1933: 95 (fig. 20: TG 2679)
Kelsey Museum of Archaeology 1991.3.90
Gift of Dr. John Adams from the estate of Mrs. Jane Ford
 Adams

72. Two Large Snakes Intertwined; Spade, Notch, and Animal in the Field

Flattened hemispherical stamp seal with flat circular face
Black rock
Diam. seal face: 5.1 cm; H. seal: 2.1 cm
Seal face broken off at top half; massive chipping along
 lower edge
From Herzfeld's 1928 explorations at Tepe Giyan, Iran
Herzfeld 1933: 101 (fig. 24: TG 2350)
Kelsey Museum of Archaeology 1991.3.95
Gift of Dr. John Adams from the estate of Mrs. Jane Ford
 Adams

73.
Side a): Meandering Snake

 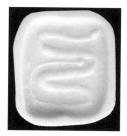

Side b): Cross with Chevron-Filled Quadrants

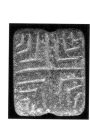 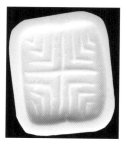

Rectangular plaque seal with flat rectangular faces
Black rock
L. seal face: 3.0 cm; W. seal face: 2.4 cm; H. seal: 1.0 cm
Minor chips and abrasions on seal faces and at
 perforation holes

From Herzfeld's 1928 explorations at Tepe Giyan, Iran
Herzfeld 1933: 102 (fig. 25: TG 2378)
Kelsey Museum of Archaeology 1991.3.99
Gift of Dr. John Adams from the estate of Mrs. Jane Ford
 Adams

74. Container Sealing
Front: Fragmentary Impression of a Circular Stamp
 Seal Showing Two Large Intertwined Snakes
 Encircling a Fallen Human

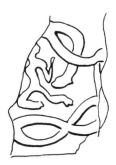

Back: Rope Marks

Clay
Sealing: Max. Pres. L. 7.5 cm; Max. Pres. W. 3.0 cm; Max.
 Pres. H. 2.0 cm
Seal face: Orig. Diam. c. 4.5 cm

Preserved: vertical section through center of seal
 impression
From 1927–31 University of Pennsylvania and Dropsie
 College excavations at Tepe Gawra, Iraq
Level XII. 4M
Tobler 1950: no. 179
Loaned by the University of Pennsylvania Museum of
 Archaeology and Anthropology: 36.6.305

75. Container Sealing
Front: Impression of a Rectangular Stamp Seal
 Showing an Ibex with Snake Above

Back: Rope Marks

Clay
Sealing: Max. Pres. L. 8.5 cm; Max. Pres. W. 4.5 cm; Max.
 Pres. H. 3.2 cm
Seal face: H. 1.7 cm; W. 2.0 cm
Impressed surfaces clearly legible
From 1927–31 University of Pennsylvania and Dropsie
 College excavations at Tepe Gawra, Iraq
Level XI. 10M
Tobler 1950: no. 120
Loaned by the University of Pennsylvania Museum of
 Archaeology and Anthropology: 38.13.15

Gallery Long Case

FERTILITY AND SYMBOLIC LANDSCAPES

76. Double-Line Bifurcation with Lines Radiating from the Vertical Axis to Form a Leaf Pattern

Hemispherical stamp seal with flat circular face
Gray rock
Diam. seal face: 1.7 cm; H. seal face: 0.9 cm
Minor chips along edges
From Herzfeld's 1928 explorations at Tepe Giyan, Iran
Herzfeld 1933: 92 (fig. 18: TG 2390)
Kelsey Museum of Archaeology 1991.3.38
Gift of Dr. John Adams from the estate of Mrs. Jane Ford
 Adams

77. Stacked Schematic Faces of Wild Sheep; Ladderlike Vegetal Elements Flanking the Faces

Hemispherical stamp seal with flat circular face
Brownish gray rock
Diam. seal face: 4.1 cm; H. seal: 1.3 cm
Minor chips along edge
From Herzfeld's 1928 explorations at Tepe Giyan, Iran
Herzfeld 1933: 101 (fig 24: TG 2678)
Kelsey Museum of Archaeology 1991.3.96
Gift of Dr. John Adams from the estate of Mrs. Jane Ford
 Adams

78.
Side a): Ibex (with Extra Appendages)

Side b): Two Animals Tête-Bêche (Head-to-Tail)

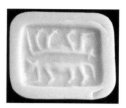

Rectangular plaque stamp seal with flat rectangular faces
Black rock
L. seal face: 2.5 cm; W. seal face: 2.0 cm; H. seal: 0.8 cm
Minor chips
From Herzfeld's 1928 explorations at Tepe Giyan, Iran
Herzfeld 1933: 102 (fig. 25: TG 2376)
Kelsey Museum of Archaeology 1991.3.105
Gift of Dr. John Adams from the estate of Mrs. Jane Ford
 Adams

79. Bifurcated Row of Six Dots Flanked by Parallel Lines Perpendicular to Bifurcation, Forming a Leaf Pattern

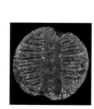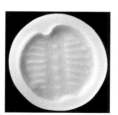

Hemispherical stamp seal with flat circular face
Brownish black rock
Diam. seal face: 2.3 cm; H. seal: 1.0 cm
Chips along edges; abrasion at perforation holes
From Herzfeld's 1928 explorations at Tepe Giyan/
 Nihavand, Iran
Herzfeld 1933: 92 (fig. 18: Nih—no number)
Kelsey Museum of Archaeology 1991.3.136
Gift of Dr. John Adams from the estate of Mrs. Jane Ford
 Adams

80.
Side a): Animal with Suckling Calf

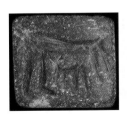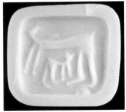

Side b): Animal with Snake Above

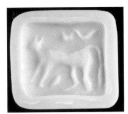

Rectangular plaque seal with flat rectangular faces
Black rock
L. seal face: 3.1 cm; W. seal face: 2.9 cm; H. seal: 1.1 cm
Minor chips
From Herzfeld's 1928 explorations at Tepe Giyan, Iran
Herzfeld 1933: 102 (fig. 25: TG 2507)
Kelsey Museum of Archaeology 1991.3.140
Gift of Dr. John Adams from the estate of Mrs. Jane Ford
 Adams

81. Animal with Bird, Snake (?), and Notch

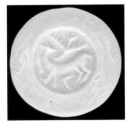

Hemispherical stamp seal with flat circular face
Black rock
Diam. seal face: 3.1 cm; H. seal: 1.4 cm
Minor chips along edges
From Herzfeld's 1928 explorations at Tepe Giyan, Iran
Previously unpublished (TG, as per Herzfeld inventory
 2849, Herzfeld Papers)

Kelsey Museum of Archaeology 1991.3.151
Gift of Dr. John Adams from the estate of Mrs. Jane Ford
 Adams

**82. Wild Sheep with Leaf Patterns of Ladderlike
 Elements, an Arrow, and a Notch**

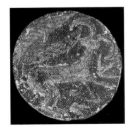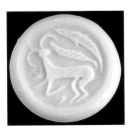

Hemispherical stamp seal with flat circular face
Black rock
Diam. seal face: 4.0 cm; H. seal: 1.8 cm
Minor chips at edges and back
From Herzfeld's 1928 explorations at Tepe Giyan, Iran
Herzfeld 1933: 99 (fig. 22: TG 2504)
Kelsey Museum of Archaeology 1991.3.154
Gift of Dr. John Adams from the estate of Mrs. Jane Ford
 Adams

**83. Ibex Framed by Four Dots and a Lined Half-
 Moon-Shaped Leaf Pattern**

Hemispherical stamp seal with flat circular face
Dark brownish gray rock
Diam. seal face: 3.8 cm; H. seal: 1.4 cm
Minor chips and abrasions
From Herzfeld's 1928 explorations at Tepe Giyan, Iran
Herzfeld 1933: 99 (fig. 22: TG 2332)
Kelsey Museum of Archaeology 1991.3.155
Gift of Dr. John Adams from the estate of Mrs. Jane Ford
 Adams

84. Two Lions (?) Attacking a Boar

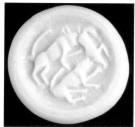

Flattened hemispherical stamp seal with flat circular face
Black rock
Diam. seal face: 4.2 cm; H. seal: 1.6 cm
Minor chips along edges
From Herzfeld's 1928 explorations at Tepe Giyan, Iran
Herzfeld 1933: 99 (fig. 22: TG 2677)
Kelsey Museum of Archaeology 1991.3.156
Gift of Dr. John Adams from the estate of Mrs. Jane Ford
 Adams

85. Ibex with Snake, Sun, and Notch

Conical hemispherical stamp seal with flat circular face
Dark gray rock
Diam. seal face: 3.0 cm; H. seal: 1.1 cm
Minor chips
From Herzfeld's 1928 explorations at Tepe Giyan, Iran
Herzfeld 1933: 99 (fig. 22: TG 2339)
Kelsey Museum of Archaeology 1991.3.158
Gift of Dr. John Adams from the estate of Mrs. Jane Ford
 Adams

86. Container Sealing
**Front: Impression of Rectangular Stamp Seal Showing
Two Animals before a Rectilinear Element**

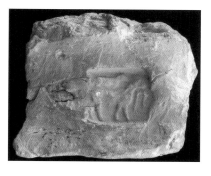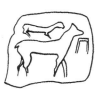

**Back: Massive Rope Mark and Textured Creases (of
 Leather?)**

Clay
Sealing: Max. Pres. L. 6.0 cm; Max. Pres. W. 5.2 cm; Max.
 Pres. H. 3.5 cm
Seal face: H. 1.75 cm; W. 2.25 cm
Seal impression damaged on two sides
From 1927–31 University of Pennsylvania and Dropsie
 College excavations at Tepe Gawra, Iraq
Level X. 8J
Tobler 1950: no. 149
Loaned by the University of Pennsylvania Museum of
 Archaeology and Anthropology: 35.10.18A

164

87. Container Sealing
Front: Impression of Circular Stamp Seal Showing an Ibex Framed by Four Leaf Patterns

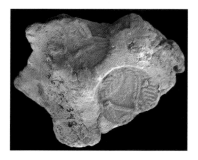

Back: Rope Marks and Creases of Leather; Fingerprints

Clay
Sealing: Max. Pres. L. 6.0 cm; Max. Pres. W. 5.0 cm; Max. Pres. H. 2.0 cm
Seal face: Diam. 2.25 cm
Seal impression well preserved
From 1927–31 University of Pennsylvania and Dropsie College excavations at Tepe Gawra, Iraq
Level XIII. 4M
Tobler 1950: no. 105
Loaned by the University of Pennsylvania Museum of Archaeology and Anthropology: 36.6.348

88. Two Fragmentary Container Sealings
Fronts: Impressions of a Circular Stamp Seal Showing Small Clothed Shaman Surrounded by Two Ibexes, One Wild Sheep, a Snake (?), and a Notch

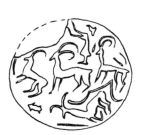

Backs: Smooth Reed Marks (not illustrated)
Clay
Sealing frag. (E): Max. Pres. L. 4.5 cm; Max. Pres. W. 5.0 cm; Max. Pres. H. 3.5 cm
Sealing frag. (F): Max. Pres. L. 5.2 cm; Max. Pres. W. 3.0 cm; Max. Pres. H. 1.5 cm
Seal face: Diam. 3.25 cm
Broken into fragments; surface abrasion
From 1927–31 University of Pennsylvania and Dropsie College excavations at Tepe Gawra, Iraq
Level XIII
Tobler 1950: no. 100
Loaned by the University of Pennsylvania Museum of Archaeology and Anthropology: 38.13.73 E–F
Another fragment was retained by the Iraq Museum, Baghdad, as part of the Iraqi division of finds from Tepe Gawra.

89. Herzfeld's Sketches of His Seals from Tepe Giyan, Iran

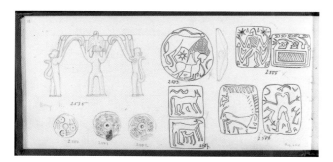

Seal A. Lion Attacking Ibex, with Snake, Sun, and Moon
Herzfeld 1933, 99 (fig. 22: TG 2503)
British Museum, 1936 acquisition: WA 128662
Seal B.
Side a) Shaman with Snakes, Notches, and Suns
Side b) Ibexes in a Pen, with Notches Above
Herzfeld 1933, 102 (fig. 25: TG 2505)
British Museum, 1936 acquisition: WA 128659
Herzfeld Sketchbook XXVIII, pages 12–13
Ernst Herzfeld Papers, Freer Gallery of Art and Arthur M. Sackler Gallery Archives, Smithsonian Institution

All other seals on these two pages are in the Kelsey Museum of Archaeology—C: 1991.3.140 (cat. no. 80); D: 1991.3.101 (cat. no. 34); E: 1991.3.154 (cat. no. 82); F: 1991.3.89 (cat. no. 70); G: 1991.3.111 (cat. no. 96); H: 1991.3 73 (cat. no. 42).

90. Displayed Female Flanked by Notches and Vegetal Elements

Hemispherical stamp seal with flat circular face
Black rock
Diam. seal face: 3.1 cm; H. seal: 1.2 cm
Minor chips and surface abrasion
From Herzfeld's 1928 explorations at Tepe Giyan, Iran
Herzfeld 1933: 92 (fig. 18: TG 2334)
Kelsey Museum of Archaeology 1991.3.74
Gift of Dr. John Adams from the estate of Mrs. Jane Ford Adams

91. Schematic Rendering of Displayed Female

 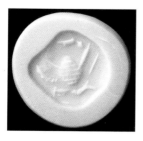

Irregular, flattened hemispherical stamp seal with rounded rectangular face
Black rock
L. seal face: 2.9 cm; W. seal face: 2.8 cm; H. seal: 1.1 cm
Chips and abrasion on seal face and at perforation holes
From Herzfeld's 1928 explorations at Tepe Giyan, Iran
Herzfeld 1933: 92 (fig. 18: TG 2338)
Kelsey Museum of Archaeology 1991.3.75
Gift of Dr. John Adams from the estate of Mrs. Jane Ford Adams

92. Scorpion and Notches

 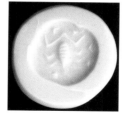

Hemispherical stamp seal with flat circular face
Dark gray rock
Diam. seal face: 2.7 cm; H. seal: 1.0 cm
Chipping and abrasion at perforation holes
From Herzfeld's 1928 explorations at Tepe Giyan, Iran
Herzfeld 1933: 92 (fig. 18: TG 2353)
Kelsey Museum of Archaeology 1991.3.76
Gift of Dr. John Adams from the estate of Mrs. Jane Ford Adams

93. Displayed Female/Tortoise with Notches

 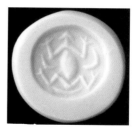

Hemispherical stamp seal with flat circular face
Dark gray rock
Diam. seal face: 2.9 cm; H. seal: 1.4 cm
Minor chips
From Herzfeld's 1928 explorations at Tepe Giyan, Iran
Previously unpublished (TG as per Herzfeld inventory 2851, Herzfeld Papers)
Kelsey Museum of Archaeology 1991.3.78
Gift of Dr. John Adams from the estate of Mrs. Jane Ford Adams

94.
Side a): Scorpion with Notch and Arrow/Spade

Side b): Fringed Cross with Quadrants Filled by Single Notches

Rectangular plaque stamp seal with flat rectangular faces
Black rock
L. seal face: 2.0 cm; W. seal face: 1.8 cm; H. seal: 0.7 cm
Chips along edges and Side b
From Herzfeld's 1928 explorations at Tepe Giyan, Iran
Herzfeld 1933: 102 (fig. 25: TG 2345)
Kelsey Museum of Archaeology 1991.3.103
Gift of Dr. John Adams from the estate of Mrs. Jane Ford
 Adams

95.
Side a): Schematic Displayed Female with Notches

Side b): Schematic Horned Animal with Snakes and Notches

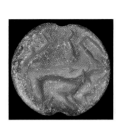 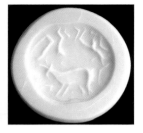

Flat disc stamp seal with flat circular faces
Black rock
Diam. seal face: 4.1 cm; H. seal: 1.2 cm
Chips off Side a; abrasion at perforation holes
From Herzfeld's 1920s–1934 collections, no provenance

Previously unpublished
Kelsey Museum of Archaeology 1991.3.106
Gift of Dr. John Adams from the estate of Mrs. Jane Ford
 Adams

96. Scorpion in Schematic Drilled Technique

Flattened hemispherical stamp seal with flat circular face
Dark gray rock
Diam. seal face: 2.8 cm; H. seal: 0.9 cm
Minor chips
From Herzfeld's 1928 explorations at Tepe Giyan
Previously unpublished (TG 2509 as per Herzfeld
 Sketchbook XXVIII, neg. 6386, Herzfeld Papers)
Kelsey Museum of Archaeology 1991.3.111
Gift of Dr. John Adams from the estate of Mrs. Jane Ford
 Adams

97. Central Dot Ringed by Two Displayed Females/ Frogs, a Boar, Birds, and Crosses

Conical hemispherical stamp seal with flat circular face
Black rock
Diam. seal face: 3.6 cm; H. seal: 1.5 cm
Minor chips
From Herzfeld's 1928 explorations at Tepe Giyan/
 Nihavand, Iran
Herzfeld 1933: 99 (fig. 22: Nih—no number)
Kelsey Museum of Archaeology 1991.3.157
Gift of Dr. John Adams from the estate of Mrs. Jane Ford
 Adams

98. Container Sealing
Front: Impression of a Circular Seal Showing Two Humans Coupling; Snakes and Spade

Back: Indeterminate
Clay
Sealing: Max. Pres. L. 4.0 cm; Max. Pres. W. 4.0; Max. Pres. H. 2.5 cm
Seal face: Diam. 3.0 cm
Chipping along edges of seal impression
From 1927–31 University of Pennsylvania and Dropsie College excavations at Tepe Gawra, Iraq
Level VIII. 9m
Speiser 1935: no. 41
Loaned by the University of Pennsylvania Museum of Archaeology and Anthropology: 32.21.515

99. Container Sealing
Front—Seal a): Impression of Rectangular or Square Seal Showing Scorpion, Naturalistically Rendered
Front—Seal b): Impression of Circular Seal Showing Quadruped (?)

Back: Prominent Rope Marks

Clay
Sealing: Max. Pres. L. 5.2 cm; Max. Pres. W. 3.0 cm; Max. Pres. H. 2.0 cm
Seal face (Seal a): Max. Pres. H. 2.0 cm; Max. Pres. W. 2.0 cm
Seal face (Seal b): Diam. 1.75 cm
Damage at edges of impression of Seal a
From 1927–31 University of Pennsylvania and Dropsie College excavations at Tepe Gawra, Iraq
Level X.8o
Tobler 1950: no. 184
Loaned by the University of Pennsylvania Museum of Archaeology and Anthropology: 33.3.186

100. Fragment of a Communication Envelope: Exterior Impression of a Scorpion Stamp Seal

Silty, tan clay
Max. Dim. envelope: c. 5.4 cm; Wall Th.: c. 1.5 cm; Diam. interior cavity: c. 2.0 cm; Dim. interior tetrahedral token: c. 0.85 cm on a side (based on indentation)
Broken into four pieces; surface very degraded
From 1968 University of Michigan and Archaeological Services of Iran excavations at Farukhabad, Iran
X 556, layer B 34, probably intrusive from earlier level
Wright 1981: 156, fig. 75d, and pl. 16e
University of Michigan Museum of Anthropology X 556
Drawing by Andrew Wilburn

101. Herzfeld's Sketches of His Seals from Tepe Giyan, Iran

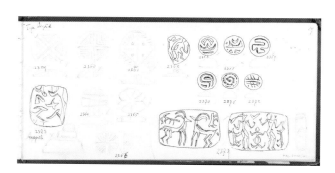

Seal A. Two Humans Coupling
> Herzfeld 1933: 87 (fig. 14: TG 2362)
> Current location of seal not yet established

Seal B.
> **Side a): Two Shamans Flanking a Displayed**
> **Female with Notches and Animals**
> **Side b): Two Ibexes with Smaller Animals**
> Herzfeld 1933: 102 (fig. 25: TG 2373)
> British Museum, 1936 acquisition: WA 128658

Herzfeld Sketchbook XXVII, page 29
Herzfeld Papers, Freer Gallery of Art and Arthur M.
> Sackler Gallery Archives Smithsonian Institution

All other seals on this page are now in the Kelsey Museum
> *of Archaeology. C: 1991.3.57 (cat. no. 49);*
> *D: 1991.3.56 (cat. no. 48); E: 1991.3.54 (cat. no. 47);*
> *F: 1991.3.36; G: 1991.3.35; H: 1991.3.82;*
> *I: 1991.3.142; J: 1991.3.131 (cat. no. 59);*
> *K: 1991.3.49; L: 1991.3.80; M: 1991.3.114 (cat. no.*
> *41); N: 1991.3.37; O: 1991.3.48 (cat. no. 62).*

Gallery Cases

PAINTED POTS FROM SUSA

102. Ibexes and Water Birds, with Stacked Zigzags (Water) and Spades (Earth)

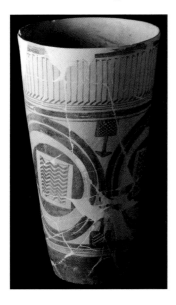

Painted clay beaker
Buff clay with brown paint
H. 24.0 cm; Diam. rim: 13.0 cm; Diam. base: 0.7 cm
Broken and restored with numerous losses; small chip in
> rim
From French excavations at Susa, Iran (early 1900s)
Hobbies 1939 (photo); Ackerman 1940, 515 (A)
Acquired in 1938 by Mr. Chauncey Hamlin for the
> Buffalo Museum of Science
Buffalo Museum of Science C 6890 (formerly Paris,
> Musée du Louvre AS 15474)

103. Central Cross and Sheep within Display Frame

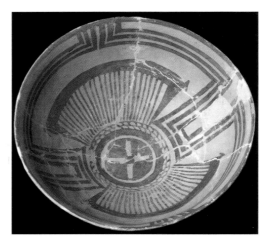

Painted clay bowl
Buff clay with brown paint
H. 7.0 cm; Diam. rim: 17.5 cm; Diam. foot ring: 5.5 cm
Broken and restored
From French excavations at Susa, Iran (early 1900s)
Ackerman 1940: 515 (B)
Acquired in 1938 by Mr. Chauncey Hamlin for the
> Buffalo Museum of Science
Buffalo Museum of Science C 6889 (formerly Paris,
> Musée du Louvre AS 15475)

104. Ibexes and Water Birds, with Stacked Zigzags (Water) and Spades (Earth)

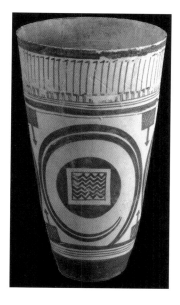

Painted clay beaker
Buff clay with brown paint
H. 23.3 cm; Diam. rim: 13.3 cm
Broken and mended
From French excavations at Susa, Iran (early 1900s)
After *Corpus Vasorum Antiquorum* 1925
Paris, Musée du Louvre, Département des Antiquités
 Orientales: Sb 14276

105. Central Tortoise, Sheep, and Quivers within Display Frame

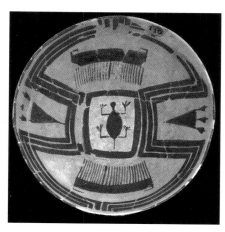

Painted clay bowl
Buff clay with brown paint
H. 8.1 cm; Diam. rim: 17.4 cm

Broken and restored
From French excavations at Susa, Iran (early 1900s)
Hole 1992: 37
Paris, Musée du Louvre, Département des Antiquités
 Orientales: Sb 3154

106. Central Nested Cross with Sheep, Stacked Zigzags, and Checkered Triangles within Display Frame

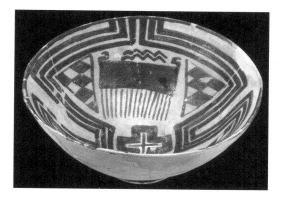

Painted clay bowl
Buff clay with brown paint
H. 6.3 cm; Diam. rim: 12.8–13.2 cm
Broken and mended
From French excavations at Susa, Iran (early 1900s)
Previously unpublished
Paris, Musée du Louvre, Département des Antiquités
 Orientales: Sb 3134

107. Central Nested Cross with Triangles within Triangular Frame; Sheep and Stacked Zigzags

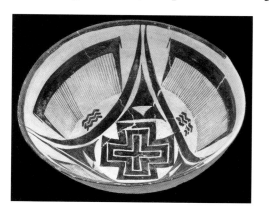

Painted clay bowl
Buff clay with brown paint
H. 9.7 cm; Diam rim: 22.6 cm

170 Broken and mended
From French excavations at Susa, Iran (early 1900s)
Hole 1992: 36
Paris, Musée du Louvre, Département des Antiquités
 Orientales: Sb 3178

Gallery Wall Display
A PAINTED POT FROM TAL-I BAKUN

108. Herzfeld's Watercolor Restoration of a Conical Pot from Tal-i Bakun, Iran: Two Wild Sheep with Crosses and Pendant Notched Triangles

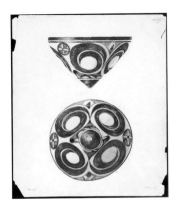

Herzfeld Drawing D-634
Ernst Herzfeld Papers, Freer Gallery of Art and Arthur M.
 Sackler Gallery Archives, Smithsonian Institution

Gallery Wall Didactics
IMAGES ON SEALINGS AND POTTERY FROM SUSA

109. Water Birds, Dogs, Ibex, and Emblem of Water

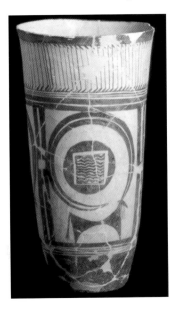

A clay beaker from French excavations at Susa, Iran
 (early 1900s)
National Museum of Iran, Tehran

110. Water Birds, Dogs, Ibex, and Emblem of Leaf and Land

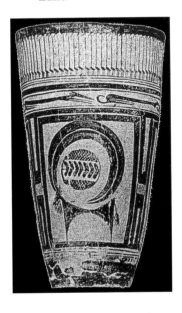

A clay beaker from French excavations at Susa, Iran
 (early 1900s)
Hole 1992: 32
After *Corpus Vasorum Antiquorum* 1925: pls 1.1 and 4.1
Paris, Musée du Louvre, Département des Antiquités
 Orientales: Sb 3174

111. Opposing Side-Winding Snakes with Stepped Structure

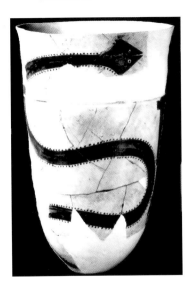

A clay beaker from French excavations at Susa, Iran
(early 1900s)
Hole 1992: 35
Rendered by Andrew Wilburn
Paris, Musée du Louvre, Département des Antiquités
Orientales: Sb 3168

**112. Cross, Notches, Vultures, Scorpion, Sheep,
Pendant Triangles, Spades, and a Human Figure**

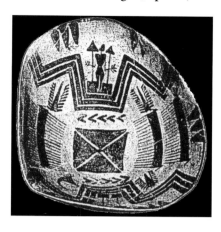

A clay bowl from French excavations at Susa, Iran
(early 1900s)
Hole 1992: 33
After *Corpus Vasorum Antiquorum* 1925: pls. 8.15 and
8.21
Paris, Musée du Louvre, Département des Antiquités
Orientales: Sb 3157

**113. Robed Shaman with Two Other Figures;
Sun, Birds, and Entwined Snake Standard**

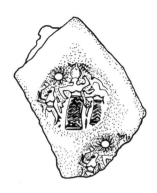

A jar sealing impressed with a stamp seal
From French excavations at Susa, Iran (early 1900s)
Aruz 1992: 43
Rendered by Jennifer E. Gates
Paris, Musée du Louvre, Département des Antiquités
Orientales: Sb 2107

**114. Shaman Wearing Stamp Seal and Holding Snakes;
Notch, Triangle, Multiple Standards, Sun(?)**

A jar sealing impressed with a stamp seal
From French excavations at Susa, Iran (early 1900s)
Aruz 1992: 45
Rendered by Jennifer E. Gates
Paris, Musée du Louvre, Département des Antiquités
Orientales: Sb 2050

**115. Shaman with Snakes; Multiple Notches and
Lozenges**

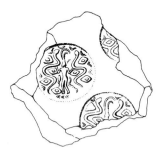

A jar sealing impressed with a stamp seal
From French excavations at Susa, Iran (early 1900s)
Aruz 1992: 45
Rendered by Jennifer E. Gates
Shush (Susa) Museum, Iran

172

Wall Panels

VIEWS OF IRAN AND IRAQ

116. Map of the Ancient Near East
Rendered by Lori Khatchadourian and Adam T. Smith

117. View of the Mehmeh River from Tepe Farukhabad, 1960s
Courtesy of Henry T. Wright III

118. A View of the Zagros Mountains, 1950s
Kelsey Museum of Archaeology Archives, Papers of George Cameron

119. Pebble-strewn Stream in the Zagros Mountains, 1950s
Kelsey Museum of Archaeology Archives, Papers of George Cameron

120. Agricultural Fields in the Central Zagros Mountains, 1990s
Courtesy of Kamyar Abdi

121. Herds of Sheep in the Central Zagros Mountains, 1990s
Courtesy of Kamyar Abdi

122. The Susiana Plain from Urban Ruins toward River and Cultivated Land, 1970s
Courtesy of Margaret Cool Root

123. Salt Lake in Iran, with Cultivated Land in Foreground, 1990s
Courtesy of Margaret Cool Root

124. Rock Relief and Landscape at Kurangun, Fars, 1975
Courtesy of Carol Bier and Lionel Bier

Concordance:
Artifacts (by Collection)
to Catalogue Numbers

Items in italics refer to occurrences in archival or didactic material in the exhibition rather than to displays of the actual artifacts.

KELSEY MUSEUM OF ARCHAEOLOGY

1991.3.1	cat. no. *10.d;* 11.a
1991.3.2	cat. no. 11.b
1991.3.3	cat. no. *10.o;* 11.c
1991.3.4	cat. no. 11.d
1991.3.5	cat. no. 11.e
1991.3.6	cat. no. 11.f; *12*
1991.3.7	cat. no. 11.g; *14; 15; 16*
1991.3.8	cat. no. 11.h; *14;15; 16*
1991.3.9	cat. no. 11.i
1991.3.10	cat. no. 11.j
1991.3.11	cat. no. 11.k
1991.3.12	cat. no. 11.l
1991.3.13	cat. no. 17
1991.3.15	cat. no. 18
1991.3.17	cat. no. 19
1991.3.18	cat. no. *10.e*
1991.3.19	cat. no. *10.n;* 20
1991.3.20	cat. no. *10.a*
1991.3.22	cat. no. *10.j*
1991.3.23	cat. no. *10.l*
1991.3.24	cat. no. *10.m*
1991.3.25	cat. no. *10.f*
1991.3.26	cat. no. *10.k*
1991.3.27	cat. no. 21
1991.3.28	cat. no. *10.b*
1991.3.29	cat. no. *10.c*
1991.3.38	cat. no. 76
1991.3.39	cat. no. *10.i*
1991.3.47	cat. no. 46
1991.3.48	cat. no. 62; *101*
1991.3.50	cat. no. 63
1991.3.51	cat. no. 22
1991.3.54	cat. no. 47; *101*
1991.3.55	cat. no. 23
1991.3.56	cat. no. 48; *101*
1991.3.57	cat. no. 49; *101*
1991.3.58	cat. no. 50
1991.3.59	cat. no. 51
1991.3.60	cat. no. 52
1991.3.61	cat. no. 64
1991.3.62	cat. no. 53
1991.3.64	cat. no. 65
1991.3.65	cat. no. *10.p;* 66
1991.3.66	cat. no. 67
1991.3.67	cat. no. 68
1991.3.68	cat. no. 69
1991.3.69	cat. no. 24
1991.3.72	cat. no. 56
1991.3.73	cat. no. 42; *89*
1991.3.74	cat. no. 90
1991.3.75	cat. no. 91
1991.3.76	cat. no. 92
1991.3.78	cat. no. 93
1991.3.87	cat. no. 57
1991.3.89	cat. no. 70; *89*
1991.3.90	cat. no. 71
1991.3.91	cat. no. 30
1991.3.92	cat. no. 31
1991.3.94	cat. no. 32
1991.3.95	cat. no. 72
1991.3.96	cat. no. 77
1991.3.97	cat. no. 25
1991.3.98	cat. no. 58
1991.3.99	cat. no. 73
1991.3.100	cat. no. 33
1991.3.101	cat. no. 34; *89*
1991.3.102	cat. no. 35
1991.3.103	cat. no. 94
1991.3.104	cat. no. 36
1991.3.105	cat. no. 78
1991.3.106	cat. no. 95
1991.3.109	cat. no. 39
1991.3.110	cat. no. 40
1991.3.111	cat. no. 96; *89*
1991.3.113	cat. no. 26
1991.3.114	cat. no. 41; *101*

1991.3.129	cat. no. 27
1991.3.131	cat. no. 59; *101*
1991.3.132	cat. no. 28
1991.3.136	cat. no. 79
1991.3.137	cat. no. 5; *8; 9*
1991.3.138	cat. no. *10.r*; 54
1991.3.139	cat. no. 60
1991.3.140	cat. no. 80; *89*
1991.3.141	cat. no. 29
1991.3.151	cat. no. 81
1991.3.153	cat. no. 6; *8; 9*
1991.3.154	cat. no. 82; *89*
1991.3.155	cat. no. 83
1991.3.156	cat. no. 84
1991.3.157	cat. no. 97
1991.3.158	cat. no. 85

BRITISH MUSEUM

WA 128658	cat. no. *101*
WA 128659	cat. no. *89*
WA 128662	cat. no. *89*
WA 128672	cat. no. *10.h*
WA 128673	cat. no. *10.g*
WA 128674	cat. no. *10.q*

UNIVERSITY OF PENNSYLVANIA MUSEUM OF ARCHAEOLOGY AND ANTHROPOLOGY

32.21.515	cat. no. 98
33.3.186	cat. no. 99
35.10.18A	cat. no. 86
35.10.171	cat. no. 55
36.6.305	cat. no. 74
36.6.309	cat. no. 44
36.6.348	cat. no. 87
37.16.76	cat. no. 43
37.16.357	cat. no. 37
38.13.15	cat. no. 75
38.13.18	cat. no. 38
38.13.73 E–F	cat. no. 88
38.13.75A	cat. no. 61

UNIVERSITY OF MICHIGAN MUSEUM OF ANTHROPOLOGY

60248	cat. no. 3
61222a–b	cat. no. 4
X-556 (in segments)	cat. no. 7; 45; 100

FREER GALLERY OF ART AND ARTHUR M. SACKLER GALLERY ARCHIVES, ERNST HERZFELD PAPERS

Herzfeld Sketchbook XXVII	cat. no. 101
Herzfeld Sketchbook XXVIII	cat. no. 89
Herzfeld Drawing D-634	cat. no. 108

BUFFALO MUSEUM OF SCIENCE

C 6889	cat. no. 103
C 6890	cat. no. 102

IRANIAN CENTER FOR ARCHAEOLOGICAL RESEARCH

Chogha Gavaneh Seal (cast)	cat. no. 1

MUSÉE DU LOUVRE, DÉPARTEMENT DES ANTIQUITÉS ORIENTALES

Sb 3134	cat. no. 106
Sb 3154	cat. no. 105
Sb 3178	cat. no. 107
Sb 14276	cat. no. 104

Works Cited

Abdi, K. 2001. "Nationalism, Politics, and the Development of Archaeology in Iran." *American Journal of Archaeology* 105.1:51–76.

———. 2002. "Strategies of Herding: Mobile Pastoralism in the Middle Chalcolithic Period of the West Central Zagros Mountains." Ph.D. dissertation, University of Michigan.

———. 2003a. "The Early Development of Pastoralism in the Central Zagros Mountains." *Journal of World Prehistory* 17.4:395–448.

———. 2003b. "From Écriture to Civilization: Changing Paradigms of Proto-elamite Archaeology." In N. F. Miller and K. Abdi, eds., *Yeki bud, yeki nabud: Essays on the Archaeology of Iran in Honor of William M. Sumner*, 140–151. Los Angeles: The Cotsen Institute of Archaeology, University of California, in Association with The American Institute of Iranian Studies and The University of Pennsylvania Museum of Archaeology and Anthropology.

———. Forthcoming. *Excavations at Operation W263 at Chogha Gavaneh, Central Zagros Mountains: Report on the 1998–1999 Seasons.* Tehran: Iranian Cultural Heritage Organization.

Ackerman, P. 1938. "Early Seals. B. Specific Problems." In A. U. Pope, ed., *A Survey of Persian Art from Prehistoric Times to the Present. I: Pre-Achaemenid, Achaemenid and Parthian Periods*, 290–298. London, New York, and Tehran: Oxford University Press.

———. 1940. *Guide to the Exhibition of Persian Art.* New York: The Iranian Institute.

Adams, R. M. 1974. "Anthropological Perspectives on Ancient Trade." *Current Anthropology* 15.3:239–258.

Akkermans, P. A., and M. Verhoeven. 1995. "An Image of Complexity: The Burnt Village at Late Neolithic Sabi Abyad, Syria. *American Journal of Archaeology* 99:5–32.

Albert, L. S., and J. F. Adams. 1951. *The Button Sampler.* New York: M. Barrows and Company, Inc.

Alden, J. R. 1982. "Trade and Politics in Proto-Elamite Iran." *Current Anthropology* 23:613–640.

Algaze, G. 1993. *The Uruk World System: The Dynamics of Expansion of Early Mesopotamian Civilization.* Chicago and London: University of Chicago Press.

Alizadeh, A. 1988. "Socio-Economic Complexity in Southwestern Iran during the Fifth and Fourth Millennia B.C.: Evidence from Tal-i Bakun A." *Iran* 26:17–34.

———. 2003. "Some Observations Based on the Nomadic Character of Fars Prehistoric Development." In N. F. Miller and K. Abdi, eds., *Yeki bud, yeki nabud: Essays on the Archaeology of Iran in Honor of William M. Sumner*, 83–97. Los Angeles: The Cotsen Institute of Archaeology, University of California, in association with The American Institute of Iranian Studies and The University of Pennsylvania Museum of Archaeology and Anthropology.

Alizadeh, A., M. Zeidi, A. Saskari, L. Niakan, and A. Atabaki. 2004. "Excavations at Tall-e Bakun A and B, Jari A and B, and Mushki: Reconstruction of the Prehistoric Environment in Marvdasht." *The Oriental Institute 2003–2004 Annual Report*, 94–106. Chicago: The Oriental Institute.

Amiet, P. 1966. *Elam.* Auvers-sur-Oise: Archée.

———. 1972. *La glyptique susienne: Des origines à l'époque des Perses achéménides.* Mémoires de la Délégation Perse en Iran 43. Paris: P. Guethner.

———. 1980. *La glyptique mésopotamienne archaïque* (2nd ed.). Paris: Éditions du Centre National de la Recherche Scientifique.

Amorai-Stark, S. 1997. *Wolfe Family Collection of Near Eastern Prehistoric Stamp Seals.* Orbis Biblicus et Orientalis 16. Göttingen: Vandenhoeck & Ruprecht.

Anderson, R. L. 1989. *Art in Small Scale Societies.* London: Prentice-Hall.

Arnheim, R. 1982. *The Power of the Center: A Study of Composition in the Visual Arts.* Berkeley, Los Angeles, and London: University of California Press.

Aruz, J. 1992. "Late Susa I Glyptic: Ritual Imagery, Practical Use." In P. O. Harper, J. Aruz, and F. Tallon, eds., *The Royal City of Susa: Ancient Near Eastern Treasures in the Louvre,* 43–46. New York: The Metropolitan Museum of Art.

Asher-Greve, J. 2004. "Gertrude L. Bell (1868–1926)." In G. M. Cohen and M. S. Joukowsky, eds., *Breaking Ground: Pioneering Women Archaeologists,* 142–182. Ann Arbor: University of Michigan Press.

Atran, S. 2002. *In Gods We Trust: The Evolutionary Landscape of Religion.* Oxford: Oxford University Press.

Azarpay, G. N.d. "Sasanian Seals from the Collection of the Late Edward Gans at the University of California, Berkeley." http://www.ecai.org/sasanianweb/docs/sasaniansealsWframe.html.

Azarpay, G., and J. Zerneke. 2002. "A Sasanian Seal Collection in Context: Electronic Cultural Atlas Initiative Publication of the Edward Gans Collection of the University of California, Berkeley." http://escholarship.cdlib.org/ecai/sasanian/sasanian_intro.html.

Bahn, P. G. 2001. "Save the Last Trance for Me." In H. P. Francfort, R. Hamayon, and P. G. Bahn, eds., *The Concept of Shamanism: Uses and Abuses,* 53–93. Budapest: Akadémiai Kiadó.

Bal, M., and N. Bryson. 1991. "Semiotics and Art History." *The Art Bulletin* 73:174–208.

Baldick, J. 2000. *Animal and Shaman: Ancient Religion of Central Asia.* London and New York: Tauris.

Barnett, R. D. 1966. "Homme masqué ou dieu-ibex?" *Syria* 43:259–276.

Bator, P. M. 1982. *The International Trade in Art.* Chicago: University of Chicago Press.

Benoit, A. 1992. "Stone Sculpture." In P. O. Harper, J. Aruz, and F. Tallon, eds., *The Royal City of Susa: Ancient Near Eastern Treasures in the Louvre,* 127–130. New York: The Metropolitan Museum of Art.

Black, J., and A. Green. 1992. *Gods, Demons and Symbols of Ancient Mesopotamia: An Illustrated Dictionary.* London: British Museum Press.

Borodkin, L. J. 1995. "The Economics of Antiquities: Looting and a Proposed Legal Alternative." *Columbia Law Review* 95 (March): 377–417.

Boyer, P. 1994. "Cognitive Constraints on Cultural Representations: Natural Ontologies and Religious Ideas." In L. A. Hirschfeld and S. A. Gelman, eds., *Mapping the Mind: Domain Specificity in Cognition and Culture.* Cambridge: Cambridge University Press.

———. 2001. Religion Explained: The Evolutionary Origins of Religious Thought. New York: Basic Books. Auckland: Doubleday.

Breasted, C. 1933. "Exploring the Secrets of Persepolis." *The National Geographic Magazine* 64:381–420.

British Museum Web site. http://www.thebritishmuseum.ac.uk/science/techniques/sr-tech-raman.html (accessed April 16, 2004).

Brodie, N., and D. Gill. 2003. "Looting: An International View." In L. J. Zimmerman, K. D. Vitelli, and J. Hollowell-Zimmer, eds., *Ethical Issues in Archaeology,* 31–44. New York: Altamira Press.

Brown, S. C. 2000. "The Social Dimensions of Pottery Analysis: Beyond Chronology, Typology and Function." *Bulletin of the Canadian Society for Mesopotamian Studies* 35:35–41.

Buchanan, B. 1967. "The Prehistoric Stamp Seal: A Reconsideration of Some Old Excavations." *Journal of the American Oriental Society* 87:265–279 (Part I); 525–540 (Part II).

———. 1981. *Early Near Eastern Seals in the Yale Babylonian Collection.* New Haven and London: Yale University Press.

Buchanan, B., and P. R. S. Moorey. 1984. *Catalogue of Ancient Near Eastern Seals in the Ashmolean Museum. II: The Prehistoric Stamp Seals.* Oxford: Ashmolean Museum.

Caldwell, D. H. 1976. "The Early Glyptic of Gawra, Giyan and Susa, and the Development of Long Distance Trade." *Orientalia* 45:227–250.

Callieri, P. 2001. "In the Land of the Magi: Demons and Magic in the Everyday Life of Pre-Islamic Iran." *Res Orientales* 13:11–36.

Canal, D. 1978. "La terrasse haute de l'Acropole de Suse." *Cahiers de la Délégation Archéologique Française en Iran* 9:11–56.

Carter, E. 1992. "A History of Excavations at Susa: Personalities and Archaeological Methodologies." In P. O. Harper, J. Aruz, and F. Tallon, eds., *The Royal City of Susa: Ancient Near Eastern Treasures in the Louvre,* 20–24. New York: Metropolitan Museum of Art.

Cassin, E. 1987. *Le semblable et le différent.* Paris: Éditions la Découverte.

Cauvin, J. 1994. *Naissance des divinités—Naissance de l'agriculture: La révolution des symboles au néolithique.* Paris: Éditions du Centre National de la Recherche Scientifique.

———. 2000. "The Symbolic Foundations of the Neolithic Revolution in the Near East." In A. Kuijt, ed., *Life in Neolithic Farming Communities: Social Organization, Identity, and Differentiation,* 235–251. New York, Boston, Dordrecht, London, and Moscow: Kluwer Academic/Plenum Publishers.

Charle, S. 2003. "Tiny Treasures Leave Big Void in Looted Iraq." *New York Times* (July 18).

Charvát, P. 1988. "Archaeology and Social History: The Susa Sealings, ca. 4000–2340 B.C." *Paléorient* 14:57–63.

Chase, A. F., D. Z. Chase, and H. W. Topsey. 1988. "Archaeology and the Ethics of Collecting." *Archaeology* 41.1:56–80. Reprinted in K. D. Vitelli, ed., *Archaeological Ethics.* Walnut Creek, CA: Altamira Press, 1996.

Chippindale, C., D. Gill, E. Salter, and C. Hamilton. 2001. "Collecting the Classical World: First Steps in a Quantitative History." *International Journal of Cultural Property* 10:19–20.

Christie's. 1989. *The Erlenmeyer Collection of Ancient Near Eastern Stamp Seals and Amulets. Tuesday 6 June 1989 at 10:30 a.m.* London: Christie, Manson & Woods Ltd.

Clottes, J., and D. Lewis-Williams. 1998. *The Shamans of Prehistory: Trance and Magic in the Painted Caves,* trans. S. Hawkes. New York: Harry N. Abrams, Inc.

Coggins, C. 1972. "Archaeology & the Art Market." *Science* 175:263–266.

Cohen, C. 2003. *La femme des origines. Images de la femme dans la préhistoire occidentale.* Paris: Belin-Herscher.

Collon, D. 1987. *First Impressions: Cylinder Seals in the Ancient Near East.* Chicago: University of Chicago Press.

———. 1990. *Near Eastern Seals.* Berkeley and Los Angeles: University of California Press.

———, ed. 1997. *7000 Years of Seals.* London: British Museum Press.

Conkey, M. W. 1987. "New Approaches in the Search for Meaning? A Review of Research in 'Paleolithic Art." *Journal of Field Archaeology* 14:413–428.

Contenau, G. 1927. *Manuel d'archéologie orientale. I.* Paris: A Picard.

———. 1938. "The Early Ceramic Art." In A. U. Pope, ed., *A Survey of Persian Art from Prehistoric Times to the Present. I: Pre-Achaemenid, Achaemenid and Parthian Periods*, 171–194. London, New York, and Tehran: Oxford University Press.

Contenau, G., and R. Ghirshman. 1935. *Fouilles de Tépé-Giyan près de Néhavend, 1931 et 1932.* Paris: P. Geuthner.

Corpus Vasorum Antiquorum. 1925. France, Part 4. Paris: Musée du Louvre, I.

Crawford, H. 1973. "Mesopotamia's Invisible Exports in the 3rd Millennium B.C." *World Archaeology* 5.2:232–241.

Crossette, B. 1996. "Hurt by Sanctions, Iraqis Sell Antiquities, Despite Export Laws," *New York Times* (June 23).

Cuno, J. 2001. "Ownership and Protection of Heritage: Cultural Property Rights for the 21st Century." *Connecticut Journal of International Law* 16 (Spring): 89–96.

Davidson, T. E., and H. McKerrel. 1976. "Pottery Analysis and Halaf Period Trade in the Khabur Headwaters Region." *Iraq* 38:45–56.

Davis, S. J. M. 1987. *The Archaeology of Mammals.* New Haven and London: Yale University Press.

Dawkins, R. M., and British School at Athens. 1929. *The Sanctuary of Artemis Orthia at Sparta, Excavated and Described by Members of the British School at Athens, 1906–1910.* London: Macmillan and Co.

Delougaz, P., and H. J. Kantor. 1996 *Chogha Mish. I: The First Five Seasons of Excavations, 1961–1971. Parts 1 and 2*, ed. A. Alizadeh. Oriental Institute Publications 101. Chicago: Oriental Institute Publications.

d'Errico, F. 1995. "A New Model and Its Implications for the Origins of Writing: The La Marche Antler Revisited." *Cambridge Archaeological Journal* 15:163–206.

Diamond, J. 1997. *Guns, Germs, and Steel: The Fates of Human Societies.* New York: W. W. Norton & Company.

Dittmann, R. 1986. "Seals, Sealings and Tablets: Thoughts on the Changing Pattern of Administrative Control from the Late-Uruk to the Proto-Elamite Period at Susa." In U. Finkbeiner and W. Röllig, eds., *Gamdat Nasr, Period or Regional Style?*, 332–366. Beihäfte zum Tübingen Atlas 62. Wiesbaden: Dr. Ludwig Reichert Verlag.

Dollfus, G., and P. Encrevé. 1982. "Marques sur poteries dans la Susiane du Ve millénaire, réflexions et comparisons." *Paléorient* 8:107–115.

Ehrenberg, E. 2002. "The Kassite Cross Revisited." In C. Wunsch, ed., *Mining the Archives: Festschrift for Christopher Walker on the Occasion of His 60th Birthday 4 October 2002*, 65–74. Dresden: ISLET.

Eliade, M. 1961. *Images and Symbols: Studies in Religious Symbolism.* New York: Harvill Press.

Epstein, D., and M. Safro. 1991. *Buttons.* New York: Harry N. Abrams, Inc.

Erlenmeyer, M.-L., and H. Erlenmeyer. 1958. "Über die Bildkunst im alten Orient und in der Agaïs zu Beginn des 3. Jahrtausends. I." *Orientalia* 27:351–372.

———. 1964. "Frühiranische Stempelsiegel I." *Iranica Antiqua* 4:85–88.

———. 1965. "Frühiranische Stempelsiegel II." *Iranica Antiqua* 5:1–16.

Esin, U. 1989. "An Early Trading Center in Eastern Anatolia." In K. Emre, B. Hrouda, M. Mellink, and N. Özgüe, eds., *Anatolia and the Ancient Near East: Studies in Honor of Tahsin Özgüç*, 135–141. Ankara: Türk Tarih Kurumu Basımevi.

———. 1994. "The Functional Evidence of Seals and Sealings of Değirmentepe." In *Archives before Writing: Proceedings of the International Colloquium Orlo Romano, October 23–25, 1991*, 59–81, plus response by M. Rothman, 82–85. Turin: Ministero per i beni culturali e ambientali, Ufficio centrale per i beni archivistici.

Ettinghausen, R. 1951. "In Memoriam Ernst Herzfeld." *Ars Islamica* 15/16:261.

Ferioli, P., E. Fiandra, G. G. Fissore, and M. Frangipane, eds. 1994. *Archives before Writing: Proceedings of the International Colloquium Orlo Romano, October 23–25, 1991.* Turin: Ministero per i beni culturali e ambientali, Ufficio centrale per i beni archivistici.

Fiandra, E., and P. Ferioli. 1981. "A Proposal for a Multi-stage Approach to Research on Clay Sealings in Protohistorical Administrative Procedures." *South Asian Archaeology* 124–127.

Firth, R. W. 1975. *Symbols: Public and Private.* Ithaca: Cornell University Press.

Foster, B. 1977. "Commercial Activity in Sargonic Mesopotamia." *Iraq* 39:31–43.

Foster, M. LeC., and S. H. Brandes, eds. 1980. *Symbol as Sense: Approaches to the Analysis of Meaning.* New York: Academic Press.

Francfort, H.-P., and R. N. Hamayon, eds., in collaboration with P. G. Bahn. 2001. *Shamanism: Uses and Abuses of a Concept.* Bibliotheca Shamanistica 10. Budapest: Akadémia Kiadó.

Frankfort, H. 1924. *Studies in Early Pottery of the Near East I.* Royal Anthropological Institute Occasional Papers 6. London: Royal Anthropological Institute.

———. 1939. *Cylinder Seals: A Documentary Essay on the Art and Religion of the Ancient Near East.* London: Macmillan and Co.

Fraser, D. 1966. "The Heraldic Woman: A Study in Diffusion." In D. Fraser, ed., *The Many Faces of Primitive Art*, 36–99. Englewood Cliffs, NJ: Prentice-Hall.

Frazer, J. G. 1990. *The Golden Bough: A Study in Magic and Religion* (3rd ed.). New York: St. Martin's Press.

Garrison, M. B., and M. C. Root. 2001. *Seals on the Persepolis Fortification Tablets. I: Images of Heroic Encounter.* Oriental Institute Publications 117. Chicago: Oriental Institute Publications.

Gell, A. 1975. *Metamorphosis of the Cassowaries: Umeda Society, Language and Ritual.* Monographs on Social Anthropology 51. London: Athlone Press. Atlantic Highlands, NJ: Humanities Press.

Ghirshman, R. 1938. *Fouilles de Tepe Sialk, près de Kashan, 1933, 1934, 1937.* Paris: Geuthner.

Gibson, M., and R. D. Biggs, eds. 1977. *Seals and Sealings in the Ancient Near East.* Bibliotheca Mesopotamica 6. Malibu: Undena Publications.

Gluck, J., and N. Silver, eds. 1996. *Surveyors of Persian Art: A Documentary Biography of Arthur Upham Pope & Phyllis Ackerman.* Ashiya, Japan: SoPA.

Goff, B. L. 1963. *Symbols of Prehistoric Mesopotamia.* New Haven: Yale University Press.

Gombrich, E. H. 1979. *The Sense of Order: A Study in the Psychology of Decorative Art.* Ithaca, NY: Cornell University Press.

Gottlieb, M., and B. Meier. 2003. "Aftereffects: The Plunder of 2,000 Treasures Stolen in the Gulf War of 1991, Only 12 Have Been Recovered." *New York Times* (May 1).

Gould, R. A., and P. J. Watson. 1982. "A Dialogue with Meaning and Use of Analogy in Ethnoarchaeological Reasoning." *Journal of Anthropological Archaeology* 1:355–381.

Greenfield, J. 1996. *The Return of Cultural Treasures.* New York: Cambridge University Press.

Groenewegen-Frankfort, H. A. 1978 [repr. of 1951 ed.]. *Arrest and Movement: An Essay on Space and Time in the Representational Art of the Ancient Near East.* New York: Hacker Art Books, Inc.

Gunter, A. C., and M. C. Root. 1998. "Replicating, Inscribing, Giving: Ernst Herzfeld and Artaxerxes' Silver *Phiale* in the Freer Gallery of Art." *Ars Orientalis* 28:1–38.

Gunter, A. C., and S. R. Hauser, eds. 2005. *Ernst Herzfeld and the Development of Near Eastern Studies, 1900–1950.* Leiden: E. J. Brill.

Haerinck, E. 1996. *The Chalcolithic Period, Parchinah and Hakalan: The Archaeological Mission in Iran. The Excavations in Luristan, Pusht-i Kuh (1965–1979)*. Brussels: Royal Museums of Art and History.

Hallo, W. W. 1981. "Introduction." In B. Buchanan, *Early Near Eastern Seals in the Yale Babylonian Collection*, ix–xv. New Haven and London: Yale University Press.

———. 1983. "'As the Seal upon Thine Arm': Glyptic Metaphors in the Biblical World." In L. Gorelick and E. Williams-Forte, eds., *Ancient Seals and the Bible*, 7–17. Malibu: Undena Press.

Hamayon, R. 1993. "Are 'Trance,' 'Ecstasy,' and Similar Concepts Appropriate for the Study of Shamanism?" *Shaman* 1.2:3–25.

———. 2001. "Shamanism: Symbolic System, Human Capability and Western Ideology." In H. P. Francfort, R. Hamayon, and P. G. Bahn, eds., *The Concept of Shamanism: Uses and Abuses*, 1–27. Budapest: Akadémiai Kiadó.

Harner, M. J. 1973. *Hallucinogens and Shamanism*. New York: Oxford University Press.

———. 2003. "Discovering the Way." In G. Harvey, ed., *Shamanism: A Reader*, 41–56. New York: Routledge.

Harper, P. O., J. Aruz, and F. Tallon, eds. 1992. *The Royal City of Susa: Ancient Near Eastern Treasures in the Louvre*. New York: The Metropolitan Museum of Art.

Harrington, F. A., Jr. 1977. *A Guide to the Mammals of Iran* (in collaboration with personnel of the Iran Department of the Environment). Tehran: Department of the Environment.

Hauser, S. R. In press. "The 'Lebensrecht' of Sumerian Studies: German Studies in the Ancient Near East and Their Relation to Political and Economic Interests from the Kaiserreich to World War II." In W. G. Schwanitz, ed., *Germany and the Middle East, 1919–1945*.

Henrickson, E. F. 1988. "Chalcolithic Seals and Sealings from Seh Gabi, Central Western Iran." *Iranica Antiqua* 23:1–19.

———. 1989. "Ceramic Evidence for Cultural Interaction between the 'Ubaid Tradition and the Central Zagros Highlands, Western Iran." In E. F. Henrickson and I. Thuesen, eds., *Upon This Foundation: The 'Ubaid Reconsidered. Proceedings from the 'Ubaid Symposium. Elsinore May 30th–June 1st 1988*, 369–399, plus comments, 399–403. Carsten Niebuhr Institute of Ancient Near Eastern Studies and Museum Publications 10. Copenhagen: Museum Tusculanum Press.

———. 1994. "The Outer Limits: Settlement and Economic Strategies in the Central Zagros Highlands during the Uruk Era." In G. Stein and M. S. Rothman, eds., *Chiefdoms and Early States in the Near East: The Organizational Dynamics of Complexity*, 85–102. Monographs in Old World Archaeology 18. Madison: Prehistory Press.

Henrickson, E. F., and I. Thuesen, eds. 1989. *Upon This Foundation: The 'Ubaid Reconsidered. Proceedings from the 'Ubaid Symposium. Elsinore May 30th–June 1st 1988*. Carsten Niebuhr Institute of Ancient Near Eastern Studies and Museum Publications 10. Copenhagen: Museum Tusculanum Press.

Herrmann, G. 1968. "Lapis Lazuli: The Early Phases of Its Trade." *Iraq* 30:21–57.

Herscher, E. 1989. "International Control Efforts: Are There Any Good Solutions?" In P. M. Messenger, ed., *The Ethics of Collecting Cultural Property: Whose Culture? Whose Property?*, 117–128. Albuquerque: University of New Mexico Press.

Hertz, A. 1929. "Le décor des vases de Suse et les écritures de l'Asie antérieure." *Revue Archéologique* (5e série) 29:219–234.

Herzfeld Papers. Ernst Herzfeld Papers, Freer Gallery of Art and Arthur M. Sackler Gallery Archives. Washington, DC: Smithsonian Institution.

Herzfeld, E. E. 1930. "Bericht über archäologische Beobachtungen in südlichen Kurdistan und in Luristan." *Archaeologische Mitteilungen aus Iran* 1:65–75.

Herzfeld, E. E.. 1932. *Iranische Denkmäler I. Steinzeitlichen Hügel bei Persepolis*. Berlin: D. Reimer.

———. 1933. "Aufsätze zur altorientalischen Archäologie 2: Stempelsiegel." *Archaeologische Mitteilungen aus Iran* 5:49–103.

———. 1935. *Archaeological History of Iran*. London: Published for the British Academy by H. Milford, Oxford University Press.

———. 1941. *Iran in the Ancient East: Archaeological Studies Presented in the Lowell Lectures at Boston by Ernst E. Herzfeld*. New York and London: Oxford University Press.

———. N.d. Sketchbooks XXVII and XXVIII. Ernst Herzfeld Papers, Freer Gallery of Art and Arthur M. Sackler Gallery Archives. Washington DC: Smithsonian Institution.

Herzfeld, E. E., and Sir A. Keith. 1938. "Iran as a Prehistoric Centre." In A. U. Pope, ed., *A Survey of Persian Art from Prehistoric Times to the Present. I: Pre-Achaemenid, Achaemenid and Parthian Periods*, 42–58. London, New York, and Tehran: Oxford University Press.

Hingston, A. G. 1989. "U.S. Implementation of the UNESCO Cultural Property Convention." In P. M. Messenger, ed., *Ethics of Collecting Cultural Property: Whose Culture? Whose Property?*, 129–147. Albuquerque: University of New Mexico Press.

Hobbies. 1939. *The Magazine of the Buffalo Museum of Science*. 19.5 (June).

Hodder, I. 1982. *Symbols in Action: Ethnoarchaeological Studies of Material Culture*. Cambridge, London, New York, New Rochelle, Melbourne, and Sydney: Cambridge University Press.

Hole, F. 1983. "Symbols of Religion and Social Organization at Susa." In T. C. Young, Jr., P. E. L. Smith, and P. Mortensen, eds., *The Hilly Flanks and Beyond: Essays on the Prehistory of Southwestern Asia Presented to Robert J. Braidwood, November 15, 1982*, 315–333. Studies in Ancient Oriental Civilization 36. Chicago: University of Chicago Press.

———. 1984. "Analysis of Structure and Design in Prehistoric Ceramics." *World Archaeology* 15:326–347.

———. 1989. "Patterns of Burial in the Fifth Millennium." In E. F. Henrickson and I. Thuesen, eds., *Upon This Foundation: The 'Ubaid Reconsidered. Proceedings from the 'Ubaid Symposium. Elsinore May 30th–June 1st 1988*, 149–180, plus comments, 194–198. Carsten Niebuhr Institute of Ancient Near Eastern Studies and Museum Publications 10. Copenhagen: Museum Tusculanum Press.

———. 1990. "Cemetery or Mass Grave? Reflections on Susa I." In F. Vallat, ed., *Contribution à l'histoire de l'Iran. Mélanges offerts à Jean Perrot*, 1–13. Paris: Éditions Recherche sur les Civilisations.

———. 1992. "The Cemetery of Susa: An Interpretation" and "Susa I Pottery." In P. O. Harper, J. Aruz, and F. Tallon, eds., *The Royal City of Susa: Ancient Near Eastern Treasures in the Louvre*, 26–41. New York: The Metropolitan Museum of Art.

Hole, F., K. Flannery, and J. A. Neely, eds. 1969. *Prehistory and Human Ecology of the Deh Luran Plain*. Memoirs 1. Ann Arbor: University of Michigan Museum of Anthropology.

Homès-Fredericq, D. 1970. *Les cachets mésopotamiens protohistoriques*. Leiden: E. J. Brill.

Jacobsen, T. 1976. *The Treasures of Darkness: A History of Mesopotamian Religion*. New Haven: Yale University Press.

Johnson, G. A. 1973. "Local Exchange and Early State Development in Southwestern Iran." Museum of Anthropology, University of Michigan, Anthropological Papers 51. Ann Arbor: Museum of Anthropology, University of Michigan.

Johnson, K. 2004. "Primary Emergence of the Doctrinal Mode of Religiosity in Prehistoric Southwestern Iran." In H. Whitehouse and L. H. Martin, eds., *Theorizing Religions Past: Archaeology, History, and Cognition*, 45–66. Walnut Creek, CA: AltaMira Press.

Keel-Leu, H. 1991. *Vorderasiatische Stempelsiegel. Die Sammlung des Biblischen Instituts der Universität Freiburg Schweitz*. Orbis Biblicus et Orientalis 110. Göttingen: Vandenhoeck & Ruprecht.

Kent, R. G. 1953. *Old Persian Grammar, Texts, Lexicon* (2nd ed., revised). American Oriental Series 33. New Haven: Yale University Press.

Kippenberg, H. G. 1990. "Introduction." In H. G. Kippenberg, ed., *Genres in Visual Representations. Proceedings of a Conference Held in 1986 by Invitation of the Werner-Reimers-Stiftung in Bad Homburg (Federal Republic of Germany)*, vii–xix. Leiden, New York, Copenhagen, Cologne: E. J. Brill.

Klengel-Brandt, E., ed. 1997. *Mit Sieben Siegeln versehen. Das Siegel in Wirtschaft und Kunst des Alten Orients*. Mainz: Philipp von Zabern.

Knight, C., C. Power, and I. Watts. 1995. "The Human Symbolic Revolution: A Darwinian Account." *Cambridge Archaeological Journal* 5:75–114.

Kohl, P. L. 1978. "The Balance of Trade in Southwestern Asia in the Mid-Third Millennium, B.C." *Current Anthropology* 19:463–492.

Kouchoukos, N., and F. Hole. 2003. "Changing Estimates of Susiana's Prehistoric Settlement." In N. F. Miller and K. Abdi, eds., *Yeki bud, yeki nabud: Essays on the Archaeology of Iran in Honor of William M. Sumner*, 53–60. Los Angeles: The Cotsen Institute of Archaeology, University of California, in association with The American Institute of Iranian Studies and The University of Pennsylvania Museum of Archaeology and Anthropology.

Kramer, C., ed. 1979. *Ethnoarchaeology: Implications of Ethnography for Archaeology*. New York: Columbia University Press.

Kress, G., and T. van Leeuwen. 1996. *Reading Images: The Grammar of Visual Design*. London and New York: Routledge.

Lamberg-Karlovsky, C. C. 1972. "Trade Mechanisms in Indus-Mesopotamian Relations." *Journal of the American Oriental Society* 92:222–230.

Langdon, S. 1914. *Tammuz and Ishtar*. Oxford: Oxford University Press.

Langsdorff, A., and D. E. McCown. 1942. *Tall-i Bakun A, Season of 1932*. Oriental Institute Publications 59. Chicago: University of Chicago Press.

Larsen, M. T. 1974. "The Old Assyrian Colonies in Anatolia." *Journal of the American Oriental Society* 94.4:119–145.

Latifi, M., E. Leviton, and the Society for the Study of Amphibians and Reptiles. 1991. *The Snakes of Iran*. Contributions to Herpetology 7. Oxford, OH: Society for the Study of Amphibians and Reptiles.

Le Breton, L. 1957. "The Early Periods at Susa, Mesopotamian Relations." *Iraq* 19:79–124.

Le Brun, A. 1971. "Recherches stratigraphiques à l'acropole de Suse (1969–1971)." *Cahiers de la Délégation Archéologique Française en Iran* 1:163–216.

Leemans, W. F. 1968. "Foreign Trade in the Time of Rim-Sin." In *Old Babylonian Letters and Economic History*. Leiden: E. J. Brill.

Legrain, L. 1936. *Ur Excavations: Archaic Seal Impressions*. Volume III. Oxford: Oxford University Press.

Lehman, J. H. 1997. "The Continued Struggle with Stolen Cultural Property: The Hague Convention, the UNESCO Convention, and the UNIDROIT Draft Convention." *Arizona Journal of International & Comparative Law* (Spring) 527–549.

Levine, L. D. 1977. "East-West Trade in the Late Iron Age: A View from the Zagros." In *Le Plateau iranien et l'Asie centrale des origines à la conquête islamique:leurs relations à la lumière des documents archéologiques: [actes du colloque], Paris, 22–24 mars, 1976*, 171–186. Paris: Éditions du Centre National de la Recherche Scientifique.

Magness-Gardiner, B. 1997 "Seals." In E. M. Meyers, ed, *The Oxford Encyclopedia of the Ancient Near East*, 4:509–512. Oxford: Oxford University Press.

Maguire, E. D., H. P. Maguire, and M. J. Duncan-Flowers, eds. 1989. *Art and Holy Powers in the Early Christian House*. Illinois Byzantine Studies 2. Urbana and Chicago: University of Illinois Press.

Majd, M. G. 2003. *The Great American Plunder of Persia's Antiquities 1925-1941*. New York: University Press of America.

Malbran-Labat, F. 1995. *Les inscriptions royales de Suse: Briques de l'époque Paléo-Élamite à l'empire Néo-Élamite*. Paris: Éditions de la Réunion des Musées Nationaux.

Manovich, L. 1991. Review of F. Sainte-Martin, *Semiotics of Visual Language* (1987), and G. Sonesson, *Pictorial Concepts: Inquiries into the Semiotic Heritage and Its Relevance to the Analysis of the Visual World* (1989). *The Art Bulletin* 73:500–502.

Marcus, M. I. 1994. "In His Lips He Held a Spell." *Source* 13:10–14.

———. 1996. *Emblems of Identity and Prestige: The Seals and Sealings from Hasanlu, Iran. Commentary and Catalogue*. University Museum Monograph 84. Hasanlu Special Studies 3. Philadelphia: University Museum, University of Pennsylvania.

McClenon, J. 2002. *Wondrous Healing: Shamanism, Human Evolution, and the Origin of Religion*. Dekalb: Northern Illinois University Press.

McIntosh, S. K. 2002. "Reducing Incentives for Illicit Trade in Antiquities: The U.S. Implementation of the 1970 UNESCO Convention." In N. Brodie and K. W. Tubb, eds., *Illicit Antiquities: The Theft of Culture and the Extinction of Archaeology*, 241–249. New York: Routledge.

Mecquenem, R. de. 1912. "Catalogue de la céramique peinte susienne conservée au Musée du Louvre." *Mémoires de la Délégation Perse* 13:105–166. Paris: Ernest Leroux.

———. 1927. "Inventaire de cachets et cylindres—Susa 1925–1926." *Revue d'Assyriologie* 24:7–22.

———. 1928. "Notes sur la céramique peinte archaïque en Perse." *Mémoires de la Délégation Perse en Iran* 20:99–132. Paris: Ernest Leroux.

Mellaart, J. 1967. *Çatal Hüyük: A Neolithic Town in Anatolia*. London: Thames and Hudson Ltd.

———. 1970. *Excavations at Hacilar*. Volumes I–II. Edinburgh: Edinburgh University Press.

Merryman, J. H., and A. E. Elsen. 1998. *Law, Ethics and the Visual Arts*. Boston: Luwer Law International.

Meyers, C. 1983. "Gender Roles and Genesis 3:16 Revisited." In C. Meyers and M. O'Connor, eds., *The Word of the Lord Shall Go Forth: Essays in Honor of David Noel Friedman in Celebration of His Sixtieth Birthday*, 337–354. Winona Lake: Eisenbrauns.

Michalowski, P. 1990. "Early Mesopotamian Communicative Systems: Art, Literature, and Writing. In A. C. Gunter, ed., *Investigating Artistic Environments in the Ancient Near East*, 53–69. Washington, DC: Arthur M. Sackler Gallery, Smithsonian Institution.

Miller, D., and C. Tilley, eds. 1984. *Ideology, Power and Prehistory*. Cambridge, London, New York, New Rochelle, Melbourne, and Sydney: Cambridge University Press.

Miroschedji, P. de. 1981. "Le dieu élamite au serpent et aux eaux jaillisantes." *Iranica Antiqua* 16:1–25.

Mitchell, W. J. T. 2003. "Word and Image." In R. S. Nelson and R. Shiff, eds., *Critical Terms for Art History* (2nd ed.), 51–61. Chicago and London: University of Chicago Press.

Moorey, P. R. S. 1984. "Editor's Preface." In B. Buchanan and P. R. S. Moorey, *Catalogue of Ancient Near Eastern Seals in the Ashmolean Museum. II: The Prehistoric Stamp Seals*, vii–x. Oxford: Clarendon Press.

———. 1994. *Ancient Mesopotamian Materials and Industries: The Archaeological Evidence*. Oxford: Clarendon Press.

Morgan, J. de. 1912. "Observations sur les couches profondes de l'acropole à Suse." *Mémoires de la Délégation Perse* 13:1–25. Paris: Ernest Leroux.

Mousavi, A. 1996. "Early Archaeological Adventures and Methodological Questions in Iranian Archaeology: Evidence from Susa." *Iranica Antiqua* 31:1–17.

———. 2002. "Persepolis in Retrospect: Histories of Discovery and Archaeological Exploration at the Ruins of Ancient Parseh." In M. C. Root, ed., *Medes and Persians: Reflections on Elusive Empires* [*Ars Orientalis* 32], 209–251.

Moynihan, E. B. 1979. *Paradise as a Garden in Persia and Mughal India*. New York: G. Braziller.

Muehsam, G. 1947. "The Earliest Buttons." *Just Buttons* 5.8:203–210.

Mundkur, B. 1983. *The Cult of the Serpent: An Interdisciplinary Survey of Its Manifestations and Origins*. Albany: State University of New York Press.

Muscarella, O. W. 1984. "On Publishing Unexcavated Objects." *Journal of Field Archaeology* 11:62–66.

———. 2000. *The Lie Became Great: The Forgery of Ancient Near Eastern Cultures*. Studies in the Art and Archaeology of Antiquity 1. Groningen: STYX Publications.

National Archives Publications, M715, Rolls 10 and 37; M1202 Rolls 22–24; T1180, Roll 14, National Archives at College Park, College Park, MD.

Neely, J. A., and H. T. Wright. 1994. *Early Settlement and Irrigation on the Deh Luran Plain: Village and Early State Societies in Southwestern Iran*. University of Michigan Museum of Anthropology Technical Report 26. Ann Arbor: University of Michigan Museum of Anthropology.

Negahban, E. O. 1967. "Archaeological Activity in Iran, 1935–1960." In A. U. Pope, ed., *A Survey of Persian Art from Prehistoric Times to the Present*, 2930–2932. London, New York, and Tehran: Oxford University Press.

Nissen, H. J. 1977. "Aspects of the Development of Early Cylinder Seals." In M. Gibson and R. D. Biggs, eds. *Seals and Sealing in the Ancient Near East*, 15–24. Biblica Mesopotamica 6. Malibu: Undena Publications.

———. 1986. "The Development of Writing and of Glyptic Art." In U. Finkbeiner and W. Röllig, eds., *Ǧamdat Naṣr, Period or Regional Style?*, 316–331. Wiesbaden: Ludwig Reichert Verlag.

Noel, D. C. 1997. *The Soul of Shamanism: Western Fantasies, Imaginal Realities*. New York: Continuum.

Noveck, M. 1975. *The Mark of Ancient Man: Ancient Near Eastern Stamp Seals and Cylinder Seals: The Gorelick Collection*. New York: The Brooklyn Museum.

Orerelle, E., and A. Gopher. 2000. "The Pottery Neolithic Period. Questions about Pottery Decoration, Symbolism, and Meaning." In A. Kuijt, ed., *Life in Neolithic Farming Communities: Social Organization, Identity, and Differentiation*, 295–308. New York, Boston, Dordrecht, London, and Moscow: Kluwer Academic/Plenum Publishers.

Ortner, D. J. 1996. "Artificial Cranial Deformation of a Human Skull from Chogha Mish." In P. Delougaz and H. J. Kantor, *Chogha Mish: The First Five Seasons of Excavations, 1961–1971*, ed. A. Alizadeh, 319–322. Oriental Institute Publications 101. Chicago: Oriental Institute Publications.

Oyer, H. E., III. 1999. "The 1954 Hague Convention for the Protection of Cultural Property in the Event of Armed Conflict—Is It Working? A Case Study: The Persian Gulf War Experience." *Columbia VLA-Journal of Law & Arts* 23 (Winter): 45–65.

Pearson, J. L. 2002. *Shamanism and the Ancient Mind: A Cognitive Approach to Archaeology.* Walnut Creek, CA: Altamira Press.

Peirce, C. S. 1991. *Peirce on Signs: Writing on Semiotics by Charles Sanders Peirce*, ed. J. Hoopes. Chapel Hill: University of North Carolina Press.

Perrot, M. 1980. *Le symbolisme de la roue.* Paris: Les Éditions Philosophiques.

Pézard, M. 1913. *Catalogue des antiquités de la Susianne.* Paris: Ernest Leroux.

Pinch, G. 1994. *Magic in Ancient Egypt.* Austin: University of Texas Press.

Pinchbeck, D. 2002. *Breaking Open the Head: A Psychedelic Journey into the Heart of Contemporary Shamanism.* New York: Broadway Books.

Pittman, H. 1992. "The Late Uruk Period" and catalogue selections. In P. O. Harper, J. Aruz, and F. Tallon, eds., *The Royal City of Susa: Ancient Near Eastern Treasures in the Louvre*, 48–57. New York: The Metropolitan Museum of Art.

———. 1994a. "Response" [to Rothman]. In P. Ferioli, E. Fiandra, G. G. Fissore, and M. Frangipane, eds., *Archives before Writing: Proceedings of the International Colloquium Orlo Romano, October 23–25, 1991*, 120–122. Turin: Ministero per i beni culturali e ambientali, Ufficio centrale per i beni archivistici.

———. 1994b. *The Glazed Steatite Glyptic Style: The Structure and Function of an Image System in the Administration of Protoliterate Mesopotamia.* Berlin: Dietrich Reimer Verlag.

———. 1997. "The Administrative Function of Glyptic Art in Proto-Elamite Iran." *Res Orientales* 10:1–30.

———. 2001. "Mesopotamian Intraregional Relations Reflected through Glyptic Evidence in the Late Chalcolithic 1–5 Periods." In M. S. Rothman, ed., *Uruk Mesopotamia & Its Neighbors: Cross-Cultural Interactions in the Era of State Formation*, 403–443. Sante Fe and Oxford: School of American Research Press.

Pollock, D. 1995. "Masks and the Semiotics of Identity." *Journal of the Royal Anthropological Institute* 1.3:581–597.

Pollock, S. 1983. "Style and Information: An Analysis of Susiana Ceramics." *Journal of Anthropological Archaeology* 2:354–390.

———. 1989. "Power Politics in the Susa A Period." In E. F. Henrickson and I. Thuesen, eds., *Upon This Foundation: The 'Ubaid Reconsidered. Proceedings from the 'Ubaid Symposium. Elsinore May 30th–June 1st 1988*, 281–88, plus comments, 289–292. Carsten Niebuhr Institute of Ancient Near Eastern Studies and Museum Publications 10. Copenhagen: Museum Tusculanum Press.

———. 1999. *Ancient Mesopotamia: The Eden That Never Was.* Cambridge: Cambridge University Press.

———. 2001 [repr. of 1999]. *Ancient Mesopotamia: The Eden That Never Was.* Cambridge and New York: Cambridge University Press.

Pope, Sir A. U., ed. 1938. *A Survey of Persian Art from Prehistoric Times to the Present. I: Pre-Achaemenid, Achaemenid and Parthian Periods.* London, New York, and Tehran: Oxford University Press.

Porada, E. 1948. *Corpus of Ancient Near Eastern Seals in North American Collection. I: The Collection of the Pierpont Morgan Library.* New York: Pantheon Books.

———. 1990. "Animal Subjects of the Ancient Near Eastern Artist." In A. C. Gunter, ed., *Investigating Artistic Environments in the Ancient Near East*, 71–79. Washington, DC: Arthur M. Sackler Gallery, Smithsonian Institution.

———. 1995. *Man and Images in the Ancient Near East.* Anshen Transdisciplinary Lectureships in Art, Science, and the Philosophy of Culture Monograph 4. Wakefield, RI: Moyer Bell.

Porada, E., D. P. Hansen, S. Dunham, and S. H. Babcock. 1992. "The Chronology of Mesopotamia, ca. 7000–1600 B.C." In R. W. Ehrich, ed., *Chronologies in Old World Archaeology*, I (3rd ed.), 77–121. Chicago: University of Chicago Press.

Pottier, E. 1912. Étude historique et chronologique sur les vases peints de l'acropole de Suse." *Mémoires de la Délégation Perse* 13:27–103. Paris: Ernest Leroux.

———. 1932. "L'écriture primitive sur les vases peints de Suse et les origines du style géometric." *Mélanges Gustave Glotz II*, 739–750. Paris: Les Presses Universitaires de France.

Potts, A. 2003. "Sign." In R. S. Nelson and R. Shiff, eds., *Critical Terms for Art History* (2nd ed.), 20–34. Chicago and London: University of Chicago Press.

Potts, D. T. 1999. *The Archaeology of Elam. Formation and Transformation of an Ancient Iranian State.* Cambridge: Cambridge University Press.

Prott, L. V., and P. J. O'Keefe. 1984. *Law and the Cultural Heritage.* New York: Professional Books.

Rappaport, R. A. 1999. *Ritual and Religion in the Making of Humanity.* Cambridge: Cambridge University Press.

Rashad, M. 1990. *Die Entwicklung der vor- und frühgeschichtlichen Stemplsiegel in Iran.* Berlin: D. Reimer.

Rempel, J. 1997. "Symbolic Systems and the Crossed-Line Motif in Mesopotamian Stamp Seals." Unpublished research paper (December 1997). Ann Arbor: University of Michigan.

Renfrew, C. 1969. "Trade and Culture Process in European Prehistory." *Current Anthropology* 10:151–160.

———. 1994. "The Archaeology of Religion." In C. Renfrew and E. B. W. Zubrow, eds., *The Ancient Mind: Elements of Cognitive Religion.* Cambridge: Cambridge University Press.

———. 1996. "Obsidian and Early Culture Contact in the Near East." *Proceedings of the Prehistoric Society* 32:30–72.

———. 2000. *Loot, Legitimacy and Ownership: The Ethical Crisis in Archaeology.* London: Duckworth.

Riegl, A. 1985 [repr. of 1893 ed.]. *Stilfragen, Grundlegungen zu einer Geschichte der Ornamentik, Kunsttwissenshaftliche Studientexte*, Bd. 1. Munich: Mäander.

———. 1992. *Problems of Style: Foundations for a History of Ornament*, trans. E. Kain, intro. and annot. D. Castriota. Princeton: Princeton University Press.

Roberts, J. J. M. 1972. *The Earliest Semitic Pantheon: A Study of the Semitic Deities Attested in Mesopotamia before Ur III.* Baltimore: Johns Hopkins University Press.

Root, M. C. 1976. "The Herzfeld Archive of the Metropolitan Museum of Art." *Journal of the Metropolitan Museum of Art* 11:119–124.

———. 2000. "The Adams (ex-Herzfeld) Collection of Prehistoric Stamp Seals: Prospects and Quandaries." *Bulletin of the Museums of Art and Archaeology, the University of Michigan 1997–2000* 12:9–40.

———. 2002. "Animals in the Art of Ancient Iran." In B. J. Collins, ed., *A History of the Animal World in the Ancient Near East*, 169–204. Leiden: E. J. Brill.

———. 2004. "Jane Ford Adams's 'Buttons' from Ancient Iran: Exhibition Diaries." *Kelsey Museum Newsletter*, 1–4. Ann Arbor: The Kelsey Museum of Archaeology.

———. 2005. "Prismatic Prehistory. Ernst Herzfeld on Early Iran." In A. C. Gunter and S. R. Hauser, eds., *Ernst Herzfeld and the Development of Near Eastern Studies, 1900–1950*, 215–260. Leiden: E. J. Brill.

———. In press. *Handbook to Life in the Persian Empire.* New York: Facts On File, Inc.

Rothman, M. S. 1994a. "Sealings as a Control Mechanism in Prehistory: Tepe Gawra." In G. Stein and M. S. Rothman, eds., *Chiefdoms and Early States in the Near East: The Organizational Dynamics of Complexity*, 103–120. Monographs in Old World Archaeology 18. Madison: Prehistory Press.

———. 1994b. "Seal and Sealing Findspot, Design, Audience, and Function: Monitoring Changes in Administrative Oversight and Structure at Tepe Gawra during the Fourth Millennium B.C." In *Archives before Writing: Proceedings of the International Colloquium Orlo Romano, October 23–25, 1991*, 97–119. Turin: Ministero per i beni culturali e ambientali, Ufficio centrale per i ben archivistici.

Rothman, M. S. 1997. "Tepe Gawra." In E. M. Meyers, ed., *The Oxford Encyclopedia of Archaeology in the Near East*, 5:183–186. New York and Oxford: Oxford University Press.

———, ed. 2001. *Uruk Mesopotamia & Its Neighbors. Cross-Cultural Interactions in the Era of State Formation*. Sante Fe and Oxford: School of American Research Press.

———. 2002. *Tepe Gawra: The Evolution of a Small, Prehistoric Center in Northern Iraq*. University Museum Monograph 112. Philadelphia: Museum of Archaeology and Anthropology, University of Pennsylvania.

Ruggles, A. L. N., and N. J. Saunders. 1993. "The Study of Cultural Astronomy." In A. L. N. Ruggles and N. J. Saunders, *Astronomies and Cultures*, 1–31. Niwot, CO: University of Colorado Press.

Rutten, A. 1938. "Early Seals. A. Glyptic Types." In A. U. Pope, ed., *A Survey of Persian Art from Prehistoric Times to the Present*, 1:286–289. London, New York, and Tehran: Oxford University Press.

Sax, M. 2001. "The Seal Materials, Their Chronology and Sources." In D. Collon, *Catalogue of Western Asiatic Seals in the British Museum. Cylinder Seals V: Neo-Assyrian and Neo-Babylonian Periods*, 18–34. London: British Museum Press.

Schapiro, M. 1969. "On Some Problems in the Semiotics of Visual Art: Field and Vehicle in Image-Signs." Reprinted in M. Schapiro, *Theory and Philosophy of Art: Style, Artist, and Society: Selected Papers*, 1–32. New York: George Braziller 1994.

———. 1973. *Words and Pictures: On the Literal and Symbolic in the Illustration of a Text*. The Hague: Mouton.

Schmandt-Besserat, D. 1977. "An Archaic Recording System and the Origin of Writing." *Syro-Mesopotamian Studies* 1:31–70.

———. 1992. *Before Writing: From Counting to Cuneiform*. Austin: University of Texas Press.

———. 1996a. *How Writing Came About*. Austin: University of Texas Press.

———. 1996b. "Art, Writing and Narrative in Mespotamia." In H. Gasche and B. Hrouda, eds., *Collectanea Orientalia: Histoire, arts de l'espace et industrie de la terre. Études offertes en hommage à Agnès Spycket*, 315–321. Civilisations du Proche Orient Serie I. Archéologie et Environnement 3. Neuchâtel: Recherches et Publications.

Schmidt, E. F. 1937. *Excavations at Tepe Hissar Damghan*. Philadelphia: University of Pennsylvania Museum.

Seidl, U. 1989. *Die Babylonischen Kudurru-Reliefs*. Freiburg Schweiz: Universitätsverlag Freiburg.

Shaw, I., and P. Nicholson. 1995. *British Museum Dictionary of Ancient Egypt*. London: British Museum Press.

Shendge, M. J. 1983. "The Use of Seals and the Invention of Writing," *Journal of the Economic and Social History of the Orient* 26:113–136.

Speiser, E. A. 1935. *Excavations at Tepe Gawra. I: Levels I–VIII*. Philadelphia: University of Pennsylvania Press.

Spiegler, H. N., and L. M. Kaye. 2001. "American Litigation to Recover Cultural Property: Obstacles, Options, and a Proposal." In N. Brodie, J. Doole, and C. Renfrew, eds., *Trade in Illicit Antiquities: The Destruction of the World's Archaeological Heritage*, 121–132. Cambridge: McDonald Institute for Archaeological Research.

Stein, G. 1994 "Economy, Ritual, and Power in 'Ubaid Mesopotamia." In G. Stein and M. S. Rothman, eds. *Chiefdoms and Early States in the Near East*, 35–46. Monographs in World Archaeology 18. Madison: Prehistory Press.

Steve, M.-J., and H. Gasche. 1973. *L'Acropole de Suse*. Mémoires de la Délégation Archéologique Française en Iran 66. Paris: P. Guethner.

Sumner, W. M. 1977. "Early Settlements in Fars Province, Iran." In L. D. Levine and T. C. Young, Jr., eds., *Mountains and Lowlands: Essays in the Archaeology of Greater Mesopotamia*, 291–305. Bibliotheca Mesopotamica 7. Malibu: Unden Publications.

Sumner, W. M. 1994. "Evolution of Tribal Society in the Southern Zagros Mountains, Iran." In G. Stein and M. S. Rothman, eds., *Chiefdoms and Early States in the Near East: The Organizational Dynamics of Complexity*, 47–65. Monographs in World Archaeology 18. Madison: Prehistory Press.

Talalay, L. 1991. "In the Beginning . . . : Views on the Origins of Writing." In M. L. Allen and T. K. Dix, eds., *The Beginning of Understanding: Writing in the Ancient World*, 11–14. Ann Arbor: Kelsey Museum of Archaeology.

Tambiah, S. J. 1990. *Magic, Science, Religion and the Scope of Rationality*. New York: Cambridge University Press.

Thunderhorse, I. 1990. *Return of the Thunderbeings: A New Paradigm of Ancient Shamanism*. Santa Fe: Bear & Co.

Tobler, A. J. 1950. *Excavations of Tepe Gawra. II: Levels IX–XX*. Philadelphia: University of Pennsylvania Press.

Tonkin, E. 1979. "Masks and Powers." *Man* 14.2:237–248.

Ucko, P. J., and A. Rosenfeld. 1971. "Critical Analysis of Interpretations, and Conclusions and Problems from Paleolithic Cave Art." In C. M. Otten, ed., *Anthropology and Art: Readings in Cross-cultural Aesthetics*, 248–281. New York: The Natural History Press.

United States Defense Intelligence Agency. 1991. *Venomous Snakes of the Middle East: Identification Guide*. Washington DC: Defense Intelligence Agency.

Van Buren, E. D. 1935–1936 "Entwined Serpents." *Archiv für Orientforschung* 10:53–65.

———. 1936. "Mesopotamian Fauna in the Light of the Monuments." *Archiv für Orientforschung* 11:1–37.

———. 1937–1939. "The Scorpion in Mesopotamian Art and Ritual." *Archiv für Orientforschung* 12:1–28.

———. 1939. *The Fauna of Ancient Mesopotamia as Represented in Art*. Analecta Orientalia 18. Rome: Pontificium institutum biblicum.

———. 1945. *Symbols of the Gods in Mesopotamian Art*. Analecta Orientalia 23. Rome: Pontificium institutum biblicum.

———. 1955. "Representations of Fertility Divinities in Glyptic Art." *Orientalia* 24:345–376.

Van Leeuwen, T., and C. Jewitt, eds. 2001. *Handbook of Visual Analysis*. London, Thousand Oaks, and New Delhi: SAGE Publications.

Vitelli, K. D. 1984. "The International Traffic in Antiquities: Archaeological Ethics and the Archaeologist's Responsibility." In E. L. Green, ed., *Ethics and Values in Archaeology*, 143–155. New York: The Free Press.

Voigt, M. M. 2000. "Çatal Hüyük in Context: Ritual at Early Neolithic Sites in Central and Eastern Turkey." In I. Kuijt, ed., *Life in Neolithic Farming Communities: Social Organization, Identity, and Differentiation*, 253–293. New York, Boston, Dordrecht, London, Moscow: Kluwer Academic/Plenum.

Voigt, M. M., and R. H. Dyson, Jr. 1992. "The Chronology of Iran, ca. 8000–2000 BC." In R. W. Ehrich, ed., *Chronologies in Old World Archaeology* (3rd ed.), 122–178. Chicago and London: University of Chicago Press.

Von Wickede, A. 1990. *Prähistorische Stempelglyptik in Voderasien*. Vorderasiatische Studien 6. Munich: Profil.

Walker, C. B. F. 1987. *Reading the Past: Cuneiform*. Berkeley and Los Angeles: University of California Press.

Watanabe, C. E. 2002. *Animal Symbolism in Mesopotamia: A Contextual Approach*. Wiener Offene Orientalistik 1. Vienna: Institut für Orientalistik.

Wellman, H. M., and S. A. Gelman. 1998. "Knowledge Acquisition in Foundational Domains." In D. Kuhn and R. Siegler, eds., *Cognition, Perception, and Language*. Volume 2 of the *Handbook of Child Psychology* (5th ed.). New York: Wiley.

Whitehouse, H. 2000. *Arguments and Icons: Divergent Modes of Religiosity.* Cambridge: Cambridge University Press.

———. 2001. "Modes of Religiosity: Towards a Cognitive Explanation of the Sociopolitical Dynamics of Religion." Circulated pre-conference reading for "Modes of Religiosity: The Historical Evidence," 1–5 August 2002, The University of Vermont.

Wilkinson, R. H. 1994. *Symbol & Magic in Egyptian Art.* London: Thames and Hudson.

Wilkinson, T. J. 2003. "Archaeological Survey and Long-Term Population Trends in Upper Mesopotamia and Iran." In N. F. Miller and K. Abdi, eds., *Yeki bud, yeki nabud: Essays on the Archaeology of Iran in Honor of William M. Sumner*, 39–51. Los Angeles: The Cotsen Institute of Archaeology, University of California, in association with The American Institute of Iranian Studies and The University of Pennsylvania Museum of Archaeology and Anthropology.

Wolinski, A. E. 1987. "Egyptian Masks: The Priest and His Role." In *Archaeology* 40.1:22–29.

———. 1996. "The Case for Ceremonial Masking in Ancient Egypt." In T. Celenko, ed., *Egypt in Africa*, 71–74. Bloomington: Indiana University Press.

Wolkstein, P., and S. N. Kramer. 1983. *Inanna: Queen of Heaven and Earth.* New York: Harper and Row Inc.

Wright, H. T. 1977. "Recent Research on the Origin of the State." *Annual Review of Anthropology* 6:379–397.

———, ed. 1981. *An Early Town on the Deh Luran Plain. Excavations at Tepe Farukhabad.* Memoirs of the Museum of Anthropology, University of Michigan 13. Ann Arbor: Museum of Anthropology.

———. 1994. "Prestate Political Formations." In G. Stein and M. S. Rothman, eds., *Chiefdoms and Early States in the Near East: The Organizational Dynamics of Complexity*, 67–84. Monographs in World Archaeology 18. Madison: Prehistory Press.

Wright, H. T., and G. A. Johnson. 1975. "Population, Exchange and Early State Formation in Southwestern Iran." *American Anthropologist* 77:267–289.

Wright, H. T., J. A. Neely, G. A. Johnson, and J. Speth. 1975. "Early Fourth Millennium Developments in Southwestern Iran." *Iran* 13:129–141.

Wright, H., N. Miller, and R. Redding. 1978. "Time and Process in an Uruk Rural Center. In *L'archéologie de l'Iraq du début de l'époque néolithique à 333 avant notre ère*, 265–284. Paris: Éditions du Centre National de la Recherche Scientifique.

Wright, H. T., and E. Carter. 2003. "Archaeological Survey on the Western Ram Hormuz Plain 1969." In N. F. Miller and K. Abdi, eds., *Yeki bud, yeki nabud: Essays on the Archaeology of Iran in Honor of William M. Sumner*, 61–82. Los Angeles: The Cotsen Institute of Archaeology, University of California, in association with The American Institute of Iranian Studies and The University of Pennsylvania Museum of Archaeology and Anthropology.

Zeder, M. A. 1991. *Feeding Cities: Specialized Animal Economy in the Ancient Near East.* Washington, DC: Smithsonian Institution Press.

Zeder, M. A., and B. Hesse. 2000. "The Initial Domestication of Goats (*Capra hircus*) in the Zagros Mountains 10,000 Years Ago." *Science* 287:2254–2257.

Zimansky, P. E. 1993. "Review of Schmandt-Besserat 1992." *Journal of Field Archaeology* 20:513–517.

Selected Index of Signs, Symbols, and Their Associations